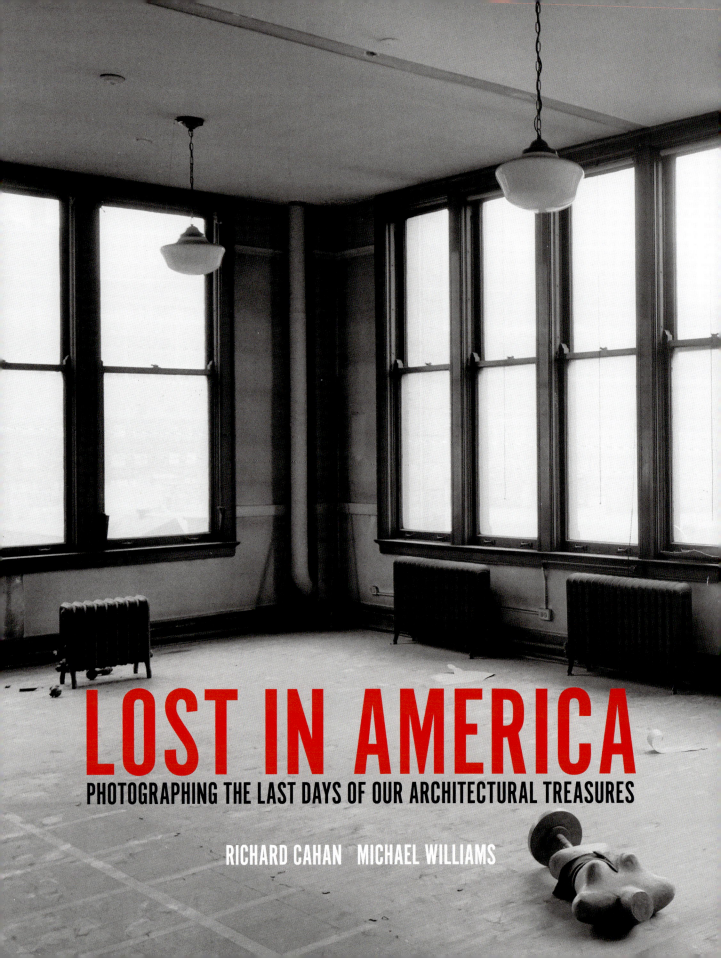

LOST IN AMERICA

PHOTOGRAPHING THE LAST DAYS OF OUR ARCHITECTURAL TREASURES

RICHARD CAHAN MICHAEL WILLIAMS

CITYFILES PRESS, CHICAGO

© 2023 CityFiles Press

All rights reserved. No part of this book may be reproduced in any form or by an electronic or mechanical means, including information storage and retrieval systems, without permission in writing from the publisher, except by a reviewer who may quote brief passages.

FIRST EDITION

ISBN-13 :978-1-7338690-5-8

Printed in China

Written, edited, produced and designed by Richard Cahan and Michael Williams

Also by Richard Cahan and Michael Williams

Vivian Maier: *Out of the Shadows* (2012)

Richard Nickel Dangerous Years: *What He Saw and What He Wrote* (2015)

Un-American: *The Incarceration of Japanese Americans During World War II: Images by Dorothea Lange, Ansel Adams and Other Government Photographers* (2016)

Revolution in Black and White: *Photographs of the Civil Rights Era by Ernest Withers* (2019)

River of Blood: *American Slavery from the People Who Lived It* (2020)

This publication is made possible through support from the Richard H. Driehaus Foundation.

Cover photo: Ulysses S. Grant Cottage, Long Branch, New Jersey
Endsheets: Republic Building, Chicago, Illinois
Page 1: Store entrance, Detroit, Michigan
Pages 2-3: Columbian School, Cincinnati, Ohio
Pages 4-5: Republic Building, Chicago, Illinois
Pages 6-7: Ellis Island Water Tower, New York

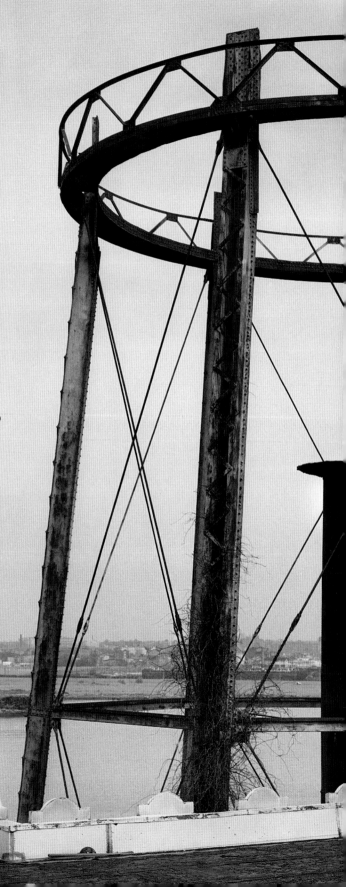

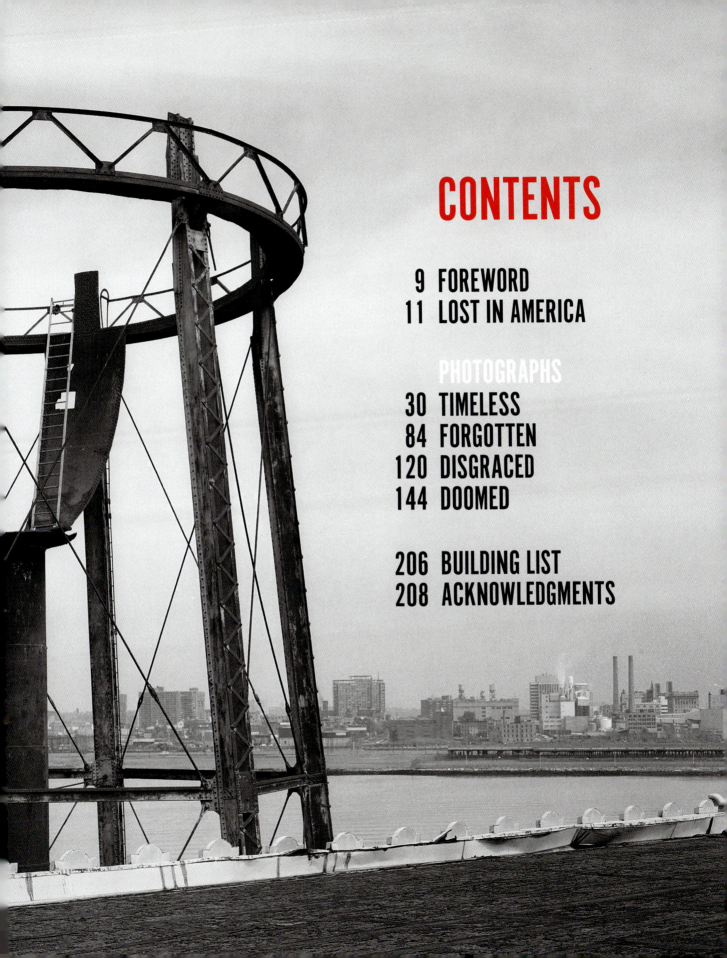

CONTENTS

9 FOREWORD
11 LOST IN AMERICA

PHOTOGRAPHS

30 TIMELESS
84 FORGOTTEN
120 DISGRACED
144 DOOMED

206 BUILDING LIST
208 ACKNOWLEDGMENTS

FOREWORD
Catherine Lavoie
Chief, Historic American Buildings Survey, National Park Service

As *Lost in America* so poignantly points out, buildings can be powerful conveyors of our collective stories. Buildings mark who we are as a society. Our monuments speak of shared experiences. Our skyscrapers and bridges highlight our technological acumen. Buildings have the ability to inspire change, facilitate social reform, fuel cultural movements, or simply help us envision better ways of living.

Think of Independence Hall, Ellis Island and the Statue of Liberty, Hoover Dam, a NASA rocket test stand, Central Park, the Gettysburg Battlefield, Sixteenth Street Baptist Church or Frank Lloyd Wright's innovative designs.

Our buildings also reflect the regional and ethnic diversity of our vast nation through the use of local materials and building traditions inspired by centuries of immigrants and Indigenous peoples. The Historic American Buildings Survey (HABS) spans everything from sod and log cabins to steel-frame skyscrapers. It includes European-inspired styles as well as our own homegrown architecture. It embraces Native American pueblos and cliff dwellings, urban tenements and the White House. And although some sites represented in the collection tell a more tragic story—such as those related to the Civil War, labor unrest, Japanese incarceration and civil rights—they help us in finding a better path.

The measured drawings, painstaking reports and photographs of the Historic American Buildings Survey—together with the work of its companion programs, the Historic American Engineering Record (HAER) and the Historic American Landscapes Survey (HALS)—constitute one of the world's most substantial archives of the built environment.

The strength of the HABS collection lies in its ability to tell all American stories. Our humble vernacular buildings speak of lives of the past that might otherwise be lost. Recording them as HABS has done for ninety years ensures a lasting legacy.

In the throes of the Great Depression, architects, historians and everyday people were dismayed by the rapid destruction of the most tangible evidence of our Colonial-era buildings. Three separate organizations—the American Institute of Architects, Library of Congress and National Park Service—came together in a unique public-private partnership to create a hedge against inevitable loss. If buildings significant to our historical and architectural heritage were to be lost, then HABS would create a record for future generations.

HABS was a call to action focused on endangered resources.

That concern remains as real today as it was when the program was created. If anything, our architectural, industrial and landscape heritage is being lost at an even faster pace. Meanwhile, new building types and styles are created, periods and styles once ignored are now in vogue, and our recognition of what constitutes significant architecture expands to recognize greater diversity.

The importance of this collection is borne out by its use. Available online and copyright-free through the Library of Congress website, it was among the first collections to be digitized and is among the most frequently accessed of the library's vast archives. Its images appear in books, scholarly journals and exhibitions, and are used by many organizations to advocate for preservation or rehabilitation. And it has been an asset to historians, restoration architects as well as architects in search of motifs for the design of new buildings based on historical styles. There is no other architectural collection in the world that meets its standards for quality, uniformity and scope, searchable under hundreds of categories.

We would be hard-pressed to create such an archive today. The collection is truly a national treasure—a reflection of the building traditions, the architectural and engineering achievements, and the dreams of a diverse people joined as a nation. This book provides a welcome glimpse into an important aspect of the collection, its role in preserving our uniquely American architectural legacy.

LEFT: The Richfield Oil Building in Los Angeles, photographed by Marvin Rand before it was razed in 1969.

LOST IN AMERICA

Every building and every bridge in this book is long gone. Some were destroyed to make way for new highways or business districts. Others fell to neglect or carelessness.

In these pages you'll find echoes of America's broad architectural heritage: adobe huts, armories, plantations, skyscrapers, courthouses, castles, movie palaces and concert halls. A few designed by famous architects, the rest by unknowns.

A number of these structures were fought for. Some were mourned. Most slipped away unnoticed.

But none of them really disappeared. Instead, they were saved on film by an intrepid team of photographers from a government agency called the Historic American Buildings Survey, known as HABS. Theirs was a largely uncelebrated mission. They woke before sunrise to catch the morning light and scale bridges. They climbed cornices and roamed rooftops lugging loads of equipment to create enduring images. Over the past ninety years, HABS photographers have taken more than 325,000 photos at 45,000 sites. Many of their subjects, the most meaningful architecture in America, stand today. Yet their most powerful images are of structures that have been demolished. This book focuses on what's been lost.

Some days the photographers wandered through grand structures documenting delicate details or handcrafted ornament before a structure was torn down. Other days they waded across flooded basements to reveal the engineering of a building's structure. More than once they revisited a site to show the weeds that took over long after wreckers left the scene. It was all part of the record.

When gathered together, these pictures tell a story—about the nation we have created and about what we as a nation have let come to an end. It's a bittersweet story that we should not ignore. *New York Times* architectural critic Ada Louise Huxtable said it best when she wrote: "We will probably be judged not by the monuments we build but by those we have destroyed."

LEFT: Photographer Richard Nickel looked out at the city from the doomed Republic Building in Chicago.

IT'S NOVEMBER 1933. The Great Depression. Thirteen million Americans are out of work. President Franklin D. Roosevelt has taken office promising to create jobs. He's looking desperately for government employment programs—ditch digging, teaching, trades—just about anything that would help put people back to work.

On November 13, Charles E. Peterson, a 26-year-old architect with the National Park Service, submits a memo suggesting the government hire jobless architects and draftspeople to roam the country and make a record of "interesting and important architectural specimens." Peterson knows the value of documentation. He helped restore the Moore House in Yorktown, Virginia, where the British surrender was negotiated after the last major battle of the Revolutionary War. Peterson watched with dread as several historic outbuildings near the house were torn down during the early 1930s.

Documenting buildings would serve three purposes. This relief program would provide jobs and create a study that would be "an enormous contribution to the history and aesthetics of American life," Peterson writes. Yet its greatest value would be saving information about buildings "in imminent danger of destruction." More structures than ever were being lost during the first years of the Depression. "Our architectural heritage of buildings from the last four centuries diminishes daily at an alarming rate," Peterson writes. "The ravages of fire and the natural elements, together with the demolition and alterations caused by real estate 'improvements' form an inexorable tide of destruction destined to wipe out the great majority of the buildings which knew the beginning and first flourish of the nation."

Peterson understands that only a fraction of endangered structures can actually be saved. "It is the responsibility of the American people that if the great number of our antique buildings must disappear through economic causes, they should not pass into unrecorded oblivion."

Peterson hands the six-page memo to his Park Service boss, who immediately sends it up the chain to the secretary of the Interior Department. Peterson's idea has the legs of a sprinter. Amazingly, four days later his proposed national survey is approved by Secretary Harold L. Ickes. Within a week, staff members for the new survey are hired. And by the end of the year, teams of architects and photographers are being sent to assess and photograph the nation's finest pre-Civil War buildings. The Historic American Buildings Survey is born.

FIELD WORK BEGAN on the first day of 1934. Like most new government projects of the era, the Historic American Buildings Survey was initially authorized for a short time.

A seven-member national advisory committee met in January 1934 to identify buildings worthy of documentation. State committees added local landmarks. Instead of focusing only on grand structures, such as the homes of the wealthy, teams set out to cover "a complete resume of the builder's art." That broad vision made HABS unique; this was not a project to only collect images of classical architecture. The national committee set out to create a lasting record of the country's history, balanced by region and style of architecture. Wrote Peterson: "It is intended that the survey shall cover structures of all types, from the smallest utilitarian structures to the largest and most monumental. Barns, bridges, mills, toll houses, jails, and, in short, buildings of every description are to be included so that a complete picture of the culture of the time as reflected in the buildings of the period may be put on record."

The Historic American Buildings Survey was based in Washington, but 39 field offices—each with a director, clerk-secretary and stenographer—were soon opened. The "privates" of this army of workers were architectural professionals, hired to create drawings and gather historical information about each building that was chosen. Photographers were hired to supplement the architectural drawings. The rules were basic. Architects must bring their own equipment: T-squares and triangles. Paper, pencils and erasers would be provided. And photographers must bring their own cameras. Film to be supplied by the government.

A group of nearly 800—administrators, architects, draftspeople, photographers and office workers—worked at full tilt during the first months of 1934 to make drawings and take photographs of their "architectural specimens." Pushing the idea of a national architectural survey

Certificate awarded to building owners whose structures were chosen for documentation.

was Leicester B. Holland, an architect and curator at the Library of Congress who helped HABS connect with the Washington-based library and with architects across the country.

At each site, architects and draftspeople made detailed renderings of the four exterior elevations of each building and then determined the exact size of every room, creating what is called measured drawings. They noted key details such as wood paneling, sash bars that divide windows, balusters and handrails that form stairways.

The drawings were both technical and unusual. They weren't the type of documents architects might prepare for construction—with instructions to builders. These drawings, instead, captured what was there.

Photographers did similar work, usually focusing first on exteriors and then taking interior shots and details. Because they were armed with cameras, they could record at a much more rapid pace.

The new HABS program foreshadowed the government's later interest in regional history through the American Guide Series, a collection of books and pamphlets published from 1937 to 1941 under the Federal Writers' Project. That program enlisted out-of-work writers to record the history of each state.

THE MEN AND WOMEN of the Historic American Buildings Survey documented close to 900 structures during the first months. Many of the photos were taken by architects on the "measuring squad," but professional photographers hit the the ground as well. Photographer Alex Bush and architect W.N. Manning took nearly 1,000 pictures in Alabama during 1934. Roger Sturtevant, who had worked as an assistant to photographer Dorothea Lange, sent in more than 500 images from California.

The American public embraced the idea of a nationwide building survey as did local newspapers. "The New Deal Administration does not intend that men shall live by bread alone," wrote the *Belleville (Illinois) News-Democrat* on January 4, 1934, just a few days into the project. "Art has its place in this preservation of ancient landmarks." A few days later, the *Richmond (Indiana) Palladium-Item* wrote that the survey would provide work to architects and unearth valuable information about the "pioneer period." The arrival of surveyors was news. The *St. Louis (Missouri) Globe-Democrat* reported that "architectural workers" arrived to make a permanent record of two buildings there. The *Wilmington (Delaware) News Journal* called the survey "the nation's 'Blue Book' of historic American structures."

Across the country, Americans reflected on their architectural largesse. "Kentucky has an 'embarrassment of riches' in historic old homes, institutions and other structures of pioneer and ante-bellum days," boasted the *Lexington Herald*. Other states were more modest. "Though Wisconsin probably hasn't as many historic buildings as some of the eastern states, it has many buildings with a historic background," wrote the *Appleton Post-Crescent*.

The outpouring of enthusiasm must have surprised Washington officials. Americans had seldom shown much interest in the idea of

historic preservation. The Mount Vernon Ladies' Association rescued George Washington's home in 1858, several Civil War battle sites were marked to be saved in the mid-1880s, and Colonial Williamsburg was restored and recreated in the 1920s. But the start of HABS in 1933 was sixteen years before the creation of the National Trust for Historic Preservation and thirty-three years before the National Register of Historic Places. At the time, the only preservation-oriented law that had ever been passed by Congress was the Antiquities Act of 1906, which made it a crime to deface national monuments on federal property.

With such a welcome reception, HABS was extended past its three-month trial.

In April 1934, selections of HABS photographs and measured drawings were put on display at the National Museum in Washington, D.C., and in museums across the country. The exhibition was billed as "the biggest collection of drawings on American architecture ever assembled." The reaction matched the billing. When the show moved to the Arts and Crafts Club in New Orleans, the *Opelousas (Louisiana) Clarion-News* marveled. "Every detail in every individual building is being noted in its entirety. Nothing is overlooked in the listing. Even the nails, pegs, hinges, pivot pins, beams and foundations are given the fullest considerations."

The *Morning Call* in Paterson, New Jersey, called the display a "splendid exhibit," and wrote, "One who would go there will enjoy the artistic as well as the sentimental patriotism." The *Los Angeles Times* echoed the enthusiasm when photographs by HABS photographer Roger Sturtevant were to be shown at the Los Angeles County Museum of History, Science, and Art. "Lovers of California history and honest building will relish them."

People appreciated that the survey "saved" structures—even if only in two-dimensional form. And they were delighted when HABS proudly announced in 1934 that the Library of Congress would store its drawings and photographs in perpetuity and make the work available to anyone who visited. That greatly enhanced the value of the work.

THE EXPERIENCES OF John O. Brostrup, who documented about two hundred structures in 1936 and 1937, show what the HABS work life was like. Brostrup moved from Omaha, Nebraska, to Washington, D.C., in search of work. He had been a photographer apprentice for almost two years in Omaha. When Brostrup read about HABS in a D.C. newspaper, he said, "I went down right away to investigate and was almost hired on the spot for the photography position."

HABS gave him no formal training. The 20-year-old Brostrup owned a four-door sedan, large-format camera, photo lights and cords. He was ready to go. He sometimes worked alone and sometimes as part of a team. When photographing Prince George's County in Maryland, just east of Washington, D.C., Brostrup would pick up architect Forrest Bowie. "He knew all the roads and he had the contacts through his family with many of the owners of the properties, aunts and uncles and so forth. So we were able to gain entrée into these houses," Brostrup later said. "We are talking about the days before expressways, so I'd leave pretty early in the morning to get to Forrest's house." The D.C. office staff would decide what buildings should be photographed, Brostrup said, and his architect partners would every so often instruct him on exactly what to take.

The Depression years were hard on the structures that Brostrup was sent out to document. Many seemed ready to collapse. "Even the so-called wealthy people were neglecting their homes," he said. "Nobody had the money to keep them up."

Knowing the structures could soon be gone pushed Brostrup and the teams. Day after day, he carted his 5x7-inch folding field camera, set it on a tripod, and disappeared beneath the heavy dark cloth at the back of his camera so that he could make out the dim image of his (upside down) subject in the camera's ground-glass focusing screen. Brostrup took photos all day—seldom more than one picture of each scene—and developed the film at home. Guided by HABS' purpose, the work was well-composed, informational but not high art.

"I knew the buildings were important," Brostrup said. "I could sense the importance of the major buildings, of course, but even the minor buildings—the kitchens, the slave quarters—they served an important part of the economics of running the plantation or even a private home."

Temporary funding for HABS came through the Civil Works Administration until 1935, when

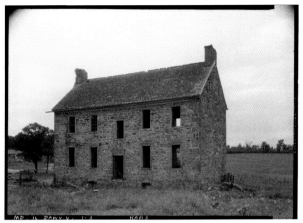
Dawson House, Dawsonville, Maryland

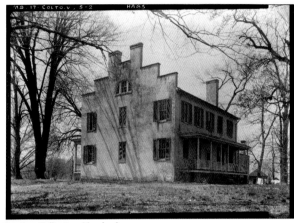
Fairview, Collington, Maryland

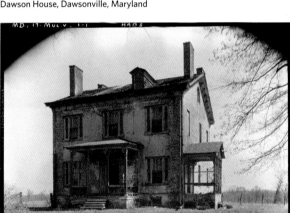
Elverton Hall, Collington, Maryland

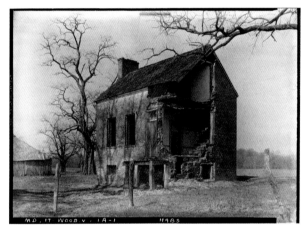
Bermondsey, Woodmore, Maryland

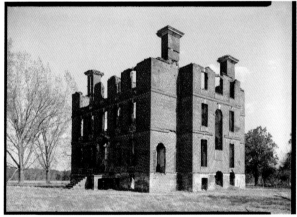
Rosewell, White Marsh, Virginia

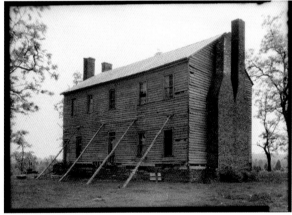
Chinn House, Groveton, Virginia

John O. Brostrup took hundreds of photographs during the early years of the Historic American Buildings Survey. Most homes were torn down. "It speaks to the importance of preservation," he said years later.

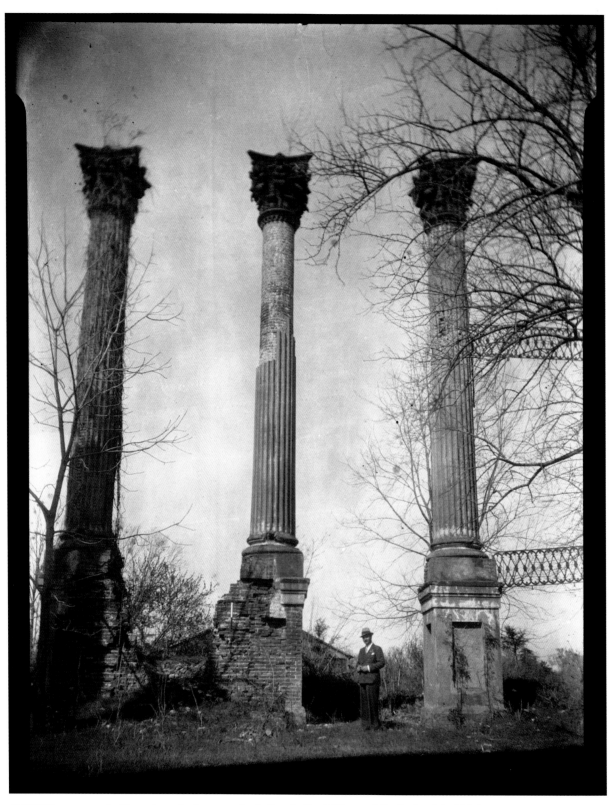

A HABS surveyor in the ruins of a former plantation in Port Gibson, Mississippi, in 1936.

Congress passed the Historic Sites Act. That directed the National Park Service to "secure, collate and preserve drawings, plans, photographs and other data of historic and archaeological sites, buildings and objects." With the Works Progress Administration as the new funder, HABS became an authorized government agency.

Work continued at a rapid pace through the start of World War II in 1941. That year, a HABS catalog reported the project had taken 23,000 photographs of 6,000 structures—all deposited in the Library of Congress.

From the start, some thought HABS should prioritize the nation's most monumental structures. Instead, the photographers were sent first to buildings on the verge of destruction. "Only buildings that have remained essentially unaltered and which are in a serious condition of deterioration will be considered," said Thomas Vint, National Park Service administrator.

That was also the priority of Interior Secretary Harold Ickes, who oversaw the National Park Service.

"Unfortunately, a large part of our early American architecture has disappeared," Ickes wrote. "It is inevitable that the majority of structures at some point outlive their ultimate usefulness, and it is admittedly impracticable to preserve all buildings or sites associated with events of incontestable historic importance. It is possible, however, to record in a graphic manner and by photography, before it is too late, the exact appearance of these buildings and their surroundings."

So it was a race against the wrecking crews. In 1936, HABS photographers were dispatched to Long Island, New York, to document the birthplace of Walt Whitman after the building owner announced the cottage was for sale. "A complete pictorial record of the Whitman home will be preserved no matter the fate of the building," the *New York Daily News* reported. Four months later, HABS officials persuaded a contractor in Richmond, Virginia, to call off his wreckers so that architects and photographers could make a final record of the two-story Belvin House, built in 1810. Photographers arrived just in time. The roof had already been removed.

Later that year, HABS officials found an eighteenth-century Dutch townhouse, probably the oldest standing residence in Manhattan, gutted and abandoned. "Located at 29½ Cherry Street in the shadow of the Brooklyn Bridge, it is scheduled for destruction unless the survey is successful in efforts to arouse interest in its preservation," the *Daily News* in Burlington, Vermont, reported in 1936.

This was the first indication that HABS was becoming a force in the nation's early preservation movement.

The HABS report on the townhouse indicates that the National Park Service considered restoring and preserving the home, known as the John Beekman House. "They were unable, however, to find anyone to finance the undertaking and take the responsibility for future maintenance," wrote HABS district officer Wakefield Worcester. The three-story Beekman House was carefully measured and photographed by Arnold Moses in early 1937 before it was torn down.

In those years, HABS gave owners an inscribed "Certificate of Merit," an informal recognition that predated the National Register. "That helped start the historic preservation movement that we know today," said architectural historian Robert Bruegmann, who worked for HABS decades later. Being recognized for owning a home of "exceptional historic or architectural interest" was a matter of pride.

Newspapers chronicled HABS' work throughout the 1930s. The *Evening Star* in Washington, D.C., kept count of how many buildings were lost after being documented by HABS. The paper reported in August 1934 that nine buildings in Massachusetts had already been demolished, one building in Kentucky had burned, and one covered bridge in Illinois had collapsed. A house in Maryland named "Mulberry Hill" burned to the ground after being struck by lightning. "Unfortunately the Marylanders had not yet measured it, so it is a loss without a record," the paper wrote.

The bridge near Homer, Illinois, collapsed just two weeks after it was measured.

"It makes my hair stand on end when I think of how we galloped across that bridge, stamping vigorously to keep warm, and what might have happened as a result of that vibration," wrote Ralph Varney, who was in charge of documenting the bridge. "It had quite a snow load at that time.

"I believe it is a good example of the 'fatigue of materials.' It was built mostly of poplar, which is not a very tough material, and I think it just got tired after standing there for close to a century and just crumpled up. No doubt it thought that after all it had been measured and was to go down to posterity in the archives of Washington, so its life's work was done."

Varney returned to take a photo of the bridge's remains.

THE HABS STYLE of photography reflected the survey's no-nonsense attitude. HABS Bulletin No. 11, released in early 1934, stated: "The photographs are for the purpose of record, so that it is more important that they be clear and sharp in their delineation of detail than that they are artistically composed or effective from a pictorial point of view."

That's how HABS photographers were instructed. The goal: show what's in front of the camera in as straightforward a way as possible. The camera of choice was the 4x5-inch view camera, the industry standard for architectural photography. It captured far more detail and sharpness than smaller cameras and had tilts and swings, adjustments that made it possible to control perspective. Without these features, the camera would warp and distort the edges of a building, something unacceptable to the HABS aesthetic.

Photographers followed a broad set of rules handed down by HABS over the decades. Each building required views of the exterior and the interior as well as architectural details. In fact, at least two photos were needed to record each side of a structure: a straight-on elevation and oblique view to show proportion. "The rear of a building may not be attractive, but it is part of the whole and should not arbitrarily be excluded from the record," a HABS manual advised.

More pictures, of course, were needed for larger, more complex buildings and structures with unusual or special features. On the inside, photographers were instructed to take at least one picture that showed a "typical unpretentious room" and the character of the interior. They were directed to record the permanent elements of the room, not the furnishings. So a photographer might ask a building owner to move furniture so as not to obscure architectural details. Yet sometimes, furnishings were important.

"A general photograph, 4-by-5-inch or larger, contains much informative detail," one guidebook stated. "When the details of a structure are bold, simple, or of a conventional nature, it will not usually be necessary to take separate photographs of these items. Likewise, when funds for recording are severely limited, details of common character may receive a low priority."

Joseph E.B. Elliott, a longtime HABS photographer, said the rules made for static, formal photos. "They are large-format black-and-whites," he said. "The lens is raised or lowered to keep the vertical lines straight." And photographers tend to look for what he calls "HABS light"—overcast, flat, with no deep shadows that cover relevant details. "We are trying to be objective, so what you get might be considered boring," Elliott said. "We are trying to give a full record designed for the public to use it."

Martin Stupich, who took more than 2,000 photos for the survey, considered the HABS aesthetic more about "recording" than art. "Making a historical photographic record of a historic site sounds daunting, but the chore is made simple (if not easy) by a set of pragmatic guidelines dating from 1933," he wrote. "Essentially: big negative, small aperture, lose nothing to highlights or shadows, process the image for posterity."

Assignments took Stupich to places few people ever see. He writes:

"Standing at 3:00 a.m. behind my view camera in a Long Island Railroad tunnel under New York's East River, straddling the tracks (a third rail inches away), in the dank, dripping silence shared by rodents the size of house cats. Or its visual opposite: in blazing daylight rubbing elbows with the massive and flawless jewel-like Fresnel lens atop New England's iconic Block Island Light House. Beyond a low railing and 40 feet below me, a 360-degree panoramic backdrop, sprawled scrub oak and sawgrass, sand, Long Island Sound, surf and the Atlantic Ocean. A job does not get sweeter than this."

Even the simplest assignments, he wrote, "reveal small miracles—rich visual moments luminous enough to shed light on the history of a place and the story of its people."

BY THE LATE 1930s, America's focus was changing.

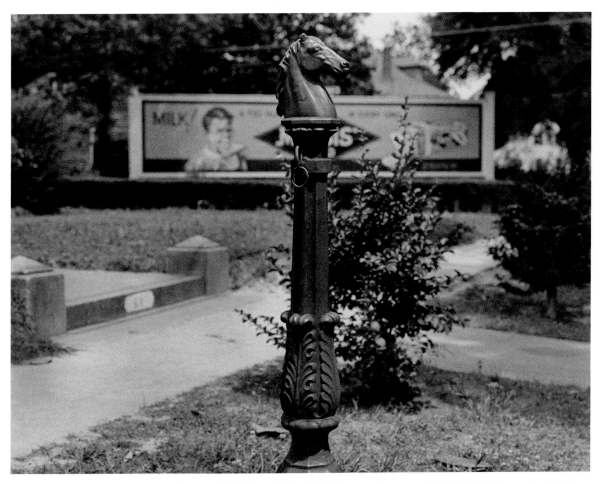

No architecture was too insignificant. E.W. Russell shot hitching posts around Mobile, Alabama, in 1935.

The Depression was easing and war was looming. In 1937, the first HABS regional office closed. "Today the plan has ceased to function in Indiana because there are no longer any unemployed architects and architectural draftsmen to carry on," the *Indianapolis Star* reported. "These men are too busy with their private practice due to a revival of the construction industry."

Many of the men who worked for HABS enlisted or were drafted at the start of World War II. Interestingly, newspapers made a connection between HABS work and the world situation. "Fourteen Episcopal Church buildings in and around New York City are among the 6,500 landmarks that have been photographed, measured or otherwise recorded so that restoration would be possible in the event of bombing or other war damage," the *Oklahoma City Star* reported in March 1942. The *Sheboygan (Wisconsin) Press* wrote: "While many of the world's ancient buildings are being destroyed in the war, many of the United States landmarks have been completely measured and recorded so that restoration would be possible in the event of enemy damage, the Department of Interior reports."

HABS had become part of the war effort.

THE HISTORIC AMERICAN Buildings Survey was inactive for most of the wartime 1940s. Then, Charles Peterson, whose memo set the survey in motion in 1933, revived the project. Peterson moved to Philadelphia after the war to work on a National Park Service plan to create a sprawling national historic park around Independence Square, where the Declaration of Independence and the Constitution were signed. The idea was to highlight Independence Hall in the midst of downtown by bulldozing structures built since 1820 that did not add to the story of early America. In order to do

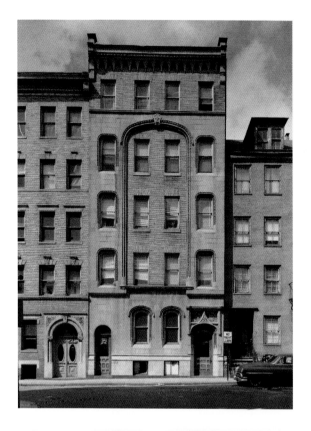
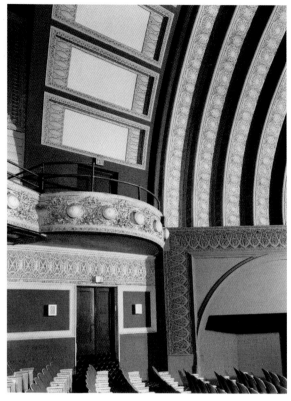

Top architectural photographers worked for HABS. Cervin Robinson shot the Gothic Apartment House (top left) in Boston in 1959. Richard Nickel photographed the interior of Chicago's Garrick Theater (top right) in 1960. Marvin Rand showed the Melville Klauber House in San Diego in 1971.

that, the Park Service razed hundreds of buildings not deemed "historic" in six square blocks.

Even though Peterson worked for the Park Service, he opposed such outright destruction. "Peterson seemed to be the voice in the wilderness," said James F. O'Gorman, who worked alongside him. "What he could do if he couldn't save the buildings was to record them as they went down." Peterson started by enlisting college students to measure buildings during their summer breaks. By the mid-1950s, Peterson sent the college teams out of Philadelphia to document National Park sites such as Harpers Ferry, West Virginia. Yet, until the mid-1950s, HABS was in hibernation. No federal money was spent to document buildings. It officially regained federal funding in 1957 through a program to enhance the National Park Service called Mission 66. New HABS offices were opened in Philadelphia

and San Francisco and teams were once again sent out to record buildings across the country.

Photography was to play a greater role in the reincarnated HABS.

"A searing reappraisal of the archives points up the need for upgrading the quality of photographs and historical coverage," a 1958 HABS advisory report pointed out. It would be impossible to prepare elaborate drawings for all historic buildings in the United States, the report continued. And photography was much quicker and more effective than measured drawings.

So HABS contracted professional photographers—some of the best in the business. Unlike the early HABS photographers who had little or no artistic training, these new hires were proficient shooters who had studied the art of photography. And they were not afraid to toss out HABS' guidelines in order to create more powerful photos. Each brought a sense of urgency to the job, alarmed by the growing number of buildings destroyed due to the rapid expansion of American cities. They understood they needed to work fast.

On the East Coast, Cervin Robinson took 1,500 photographs for the survey of classic architecture. "His contributions are essential," said James O'Gorman, who worked with Robinson in Philadelphia. His dedication to documenting buildings was unquestioned. "Robinson slept in cars and drafting rooms while on freelance assignments for HABS," wrote Elise Vider in her master's thesis on Independence National Park. "Peterson considered putting him on salary for one summer but ultimately decided against it, worrying that if it rained a lot, the photographer would spend his days with his feet propped on a desk in Philadelphia."

Not so. Robinson was far too dedicated. He created rich, melancholy views of buildings, often capturing the moody, decaying remains of the aging city around the structures to set them in context.

In the Midwest, Richard Nickel took only 150 photographs for HABS, but his work is among the survey's most stunning. "Photography deals with reality, and the transfer of a three-dimensional creation to a sheet of paper can never be spectacular," he wrote in the 1950s. Nickel, however, proved himself wrong. His personal photos and his work for HABS have far outlived their subjects. Nickel was a prolific documenter of doomed Chicago buildings, particularly the architecture of the famous firm of Adler & Sullivan. Nickel often stayed just a few steps in front of the wrecking ball but was killed in 1972 during the demolition of Adler & Sullivan's Chicago Stock Exchange Building. Nickel was alone inside the unsafe structure on the day he was crushed. His work continues to be an inspiration for those who devote their lives to historic buildings.

In the West, Marvin Rand took brilliant photographs of California's modern architecture. He, too, added an astounding appreciation of architecture. Rand never sought to create a signature style; he preferred to remain invisible. "The architectural photographer should never be set up as a critic," he wrote. "Our role is to enhance and state the content of the building in an aesthetic way."

Rand documented Los Angeles—sometimes with his three children in tow because he was a single father—from the 1940s through the new millennium. He took more than 500 photographs for the survey. Many seem simple on the surface, yet there were moments when he displayed his feelings, as with the last photo of this book showing the empty lot after the Dodge House was razed.

These new professionals brought an exciting dimension to HABS photography. Until then, HABS photographers stuck to the script.

Their influence was noted in HABS' 1970 book *Recording Historic Buildings*, compiled for the National Park Service by Harley J. McKee. In it, McKee recognized the powerful value of the new style and encouraged others to follow. He wrote:

> *Photographs of historic structures differ in character according to their purpose. Some are records, pure and simple: they are concerned chiefly with fidelity to form. Others establish a mood or make a pattern of light and shadow which appeals to the viewer primarily as a creative design—a work of art*
>
> *Architectural photography seeks to combine the best aspects of both. Fidelity to the subject is essential, of course, but it is a point of departure, not the entire objective. Architectural photography also makes use of a creative approach in order to add to the purely factual aspect of a picture, the intangible attributes which elevate*

"architecture" above "building." Some subjects are more responsive than others; it is not always possible to obtain more than a pure record but many times it is.

How different this was from the 1934 HABS Bulletin that urged photographers to be "clear and sharp," rather than take "artistically composed" photographs.

WHEN THE HISTORIC AMERICAN Buildings Survey restarted in the 1950s, there was talk about the need to "complete the survey," documenting all of the significant buildings missed in HABS' first decade. In 1952, the American Institute of Architects and the National Trust for Historic Preservation drew up an inventory of buildings worthy of documentation. The plan to record them all within ten years, along with other key buildings, was an overwhelming undertaking. HABS needed a focus. Once again, the survey's bullseye became endangered buildings. There were a lot of them, imperiled by the country's push toward urban renewal, the construction of the interstate highway system and the expansion of cities.

The primary idea behind urban renewal was to save central cities by clearing out decay. In 1954, the U.S. Supreme Court ruled that removing blight was a legal and legitimate prerogative of cities. "It is within the power of the legislature to determine that the community should be beautiful as well as healthy, spacious as well as clean," wrote Justice William O. Douglas in *Berman v. Parker.*

Old buildings—large and small—were the major target. This was an era when city planners, who demanded that cities be clean and sleek, presented themselves as savants or as visionaries. They thought big and came up with big plans. "We live in a motorized civilization, created by and for traffic. A city without traffic is a ghost town," declared New York's guru Robert Moses, before carving up the city with expressways. The influential French architect and planner Le Corbusier proclaimed that old buildings were "the detritus of dead epochs." His idea of a "Radiant City" was a metropolis of skyscrapers, open lawns and straight roads. "The great task incumbent on us is . . . clearing away from our cities the dead bones that putrefy in them," he wrote.

We can debate the pros and cons of urban renewal decades later, but there is no doubt of its effect on historic architecture. HABS teams were dispatched to cities like New York, Chicago, Philadelphia, Boston and Cincinnati to document neighborhoods before they were cleared, and to far-flung places like Anchorage, Alaska; Tucson, Arizona; Georgetown, Kentucky; and Burlington, Vermont, to record the last moments of entire neighborhoods.

"It was a pretty desperate time," said James C. Massey, who started with HABS in the 1950s and became chief in the 1960s. "Things were being torn down wholesale, blocks at a time and square miles at a time. We were running around trying to photograph and document buildings of some consequence."

IN 1958, THE NATIONAL Park Service hired Jack E. Boucher as its first full-time photographer since the early days of HABS. Boucher took as many as 55,000 photos during his 47-year career and "almost single-handedly elevated the importance of photography in HABS documentation," wrote HABS architectural historian William Lebovich.

Boucher grew up in Atlantic City in the 1930s and '40s. "The city was quiet and conservative with a lingering Victorian aura even into the war years," he wrote, "and many trappings of an earlier time remained to mold a mind and generate an understanding of the past." Young Boucher's photo career began at age ten, when he was given a plastic Brownie camera. His path was sealed in high school when he was the only male in the all-female photography club.

After two years as a photographer for the *Atlantic City Tribune,* Boucher was hired to work at a commercial photo studio, where he learned to use large-format cameras. Then he got a job with the State of New Jersey, photographing the construction of the Garden State Parkway and nearby historic structures. His credentials were ideal for HABS.

Boucher initially used a 5x7-inch wood Deardorff, a folding metal Linhof view camera or 4x5-inch Speed Graphic, the camera favored by early press photographers. The bigger the camera, the better. He went on field trips that lasted for months, carrying 900 pounds of equipment— cameras, filters, repair tools, spare batteries, cable releases, photo tape and flashbulbs. Boucher

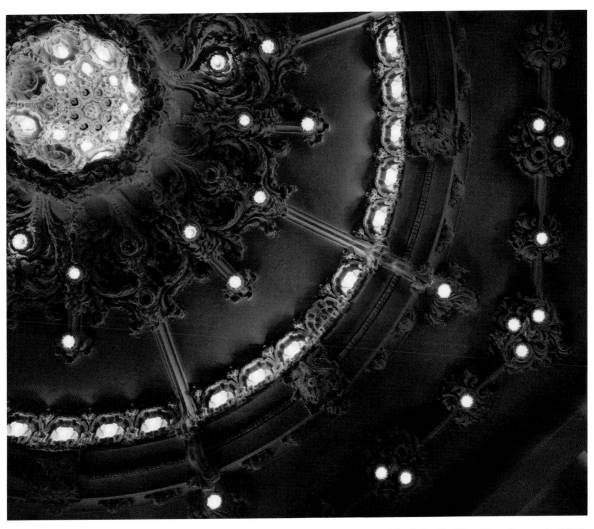

Photographer Jack Boucher painted with light inside the Blenheim Hotel in Atlantic City, New Jersey, in 1978.

refused to rush. He produced about 1,000 photographs a year for the archive. "My whole philosophy is I regard the building I'm doing as the most important one in my life, even if it's a single-seat log outhouse," he told a reporter in 1995.

Yet Boucher, a connoisseur of architecture, did measure the worth of a building. "A structure by a distinguished architect such as [Louis] Sullivan, [H.H.] Richardson, or [Frank Lloyd] Wright will get more attention than one by Joe Doe," he said. For a standard house, Boucher would take about six or eight exterior views and at least three interiors. "Regardless, I check the house from cellar to garret for original architectural details," he wrote. For major structures, he often took well more than 100 photos.

"If the weather is clear when I arrive at a site, I begin shooting exteriors, returning to houses as many times as is necessary to get the light right on the main facade," Boucher wrote. If overcast, he started inside.

Boucher was known for interior photography. He could not safely use flood lamps in most historic structures. Instead, he depended on ambient light as the base of his photographs and used the glow of large flashbulbs bounced off the walls or ceiling to lighten dark areas during a long exposure that could last several minutes. The technique was called "painting with light." And Boucher was a master. "The trick in such interior photography is to light adjacent rooms that open into the room being photographed so that these spaces do not appear

dark or black," he said. "Extension flashes can be rigged using long cords to the camera flash-control unit, but these take time to run and are usually difficult to conceal."

Like all serious architecture photographers, Boucher had to decide what to keep in the frame and what to reject. He wrote:

> *Generally, my policy is to include everything that is a part of the structure and eliminate anything that is not. In other words, I'll include additions and changes to a structure, even detailing them. I'll exclude people, vehicles, utility poles, trashcans, and even clean up the foreground of debris. There are thousands of my photographs in which pedestrians or even vehicles have moved just a millimeter or two out of the camera's range, behind a tree or a column.*
>
> *In other cases, I have moved the camera as little as—literally—a centimeter or two so as not to hide a roof detail behind a tree limb. This precise attention to camera positioning and composition is so important that after the camera tripod is positioned to the very centimeter the horizontal and vertical shifts of the view camera's back are then adjusted to the final millimeter.*

IN 1969, THE NATIONAL PARK Service launched the Historic American Engineering Record (HAER) to document notable sites and structures related to technology and engineering. Photographs from HABS and HAER along with the Historic American Landscapes Survey (HALS), which was started in 2000 to record significant landscapes, are all archived at the Library of Congress. Photo work for HAER and HALS are included in this book because photographers work interchangeably among the three agencies.

John "Jet" Lowe was hired in 1978 primarily for the Historic American Engineering Record. Born in 1946, Lowe earned a Master of Fine Arts degree in photography and had been doing large-format photography for nearly eight years before joining the federal agency. His 35-year career paralleled that of Jack Boucher.

Lowe admired Boucher, yet their approaches to photography were different.

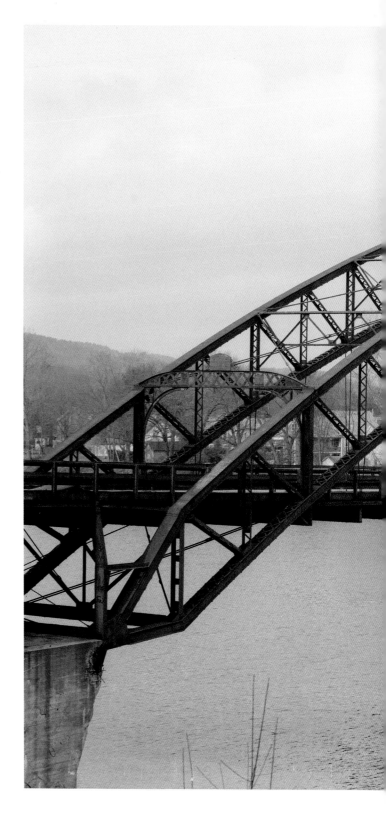

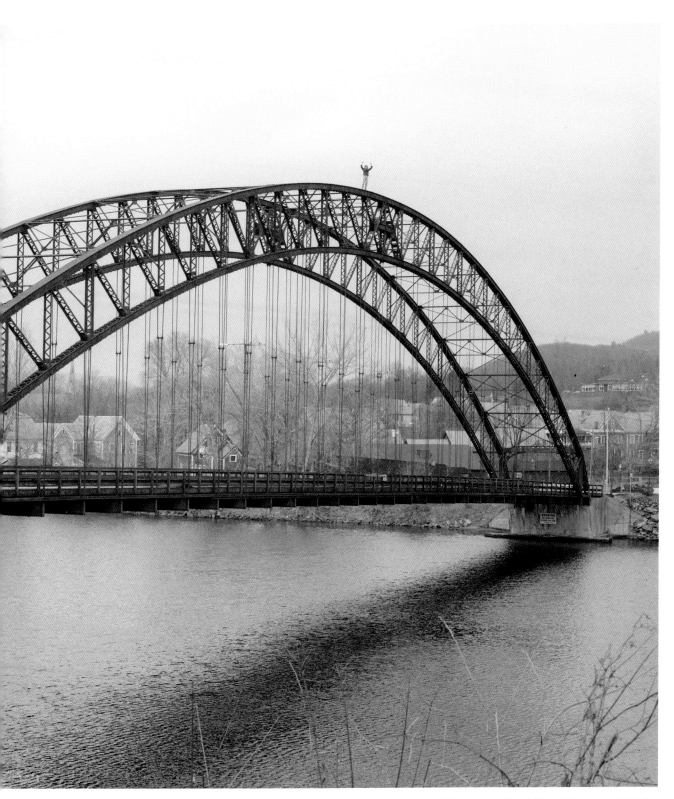

Jet Lowe's 1979 photo of the Bellows Falls Arch Bridge that spanned the Connecticut River. "I was just finishing up my shoot for the day and this young fellow offered to climb to the top of the bridge," Lowe recalled.

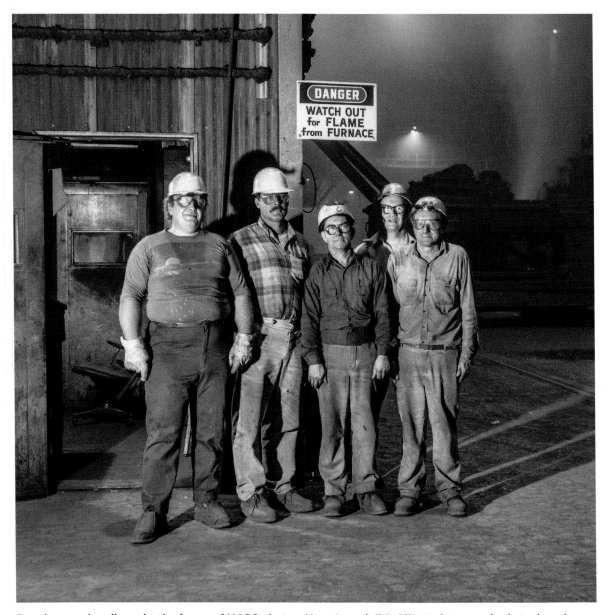

People occasionally make the frame of HABS photos. Here Joseph E.B. Elliott photographed steel workers in 1992 in Bethlehem, Pennsylvania. "I wanted to include people to give a sense of scale and life to the gigantic, foreboding spaces," Elliott wrote. "I wish I had made more images with people."

"Boucher came from a newspaper tradition," Lowe said. "He would jack up the contrast and make images snap. He liked contrastier images." Lowe approached his work in more of a fine art tradition, using the more nuanced "zone system," developed by virtuoso photographer Ansel Adams, to figure out the best exposure to capture as many black-and-white tones as possible. "Sometimes I sacrificed beauty for detail," Lowe said.

The Historic American Engineering Record had a slightly different mission. HABS showed how things looked; HAER showed how things worked.

Much of Lowe's photography was made in busy factories. "People were breathing down my neck in terms of safety," he said. Lowe had to work quickly. "I thought of myself as a guerrilla photographer. I was limited by the time I could get into industrial space." But he was unwilling to lower the photo standards

established by HABS.

"With a 35mm camera you can work fast but you tend to overlook things," said Lowe. "I stay with a subject a lot longer than most photographers. I have to analyze the situation carefully because it's so much work just setting up a shot." Placing the camera, measuring the light, loading the negative, twisting knobs so that photographs appeared level, most every frame took at least fifteen minutes. Some could take an hour.

Lowe's goal was to show the process: how machinery was organized in factories and how production flowed through industrial plants. He was looking for idiosyncrasies. "What makes this factory or mill or bridge different from all the rest?"

Lowe understood that he was documenting the remnants of the industrial revolution. He knew his subjects—blast furnaces, iron works, water towers, powerhouses, grain elevators, tugboats and drive pulleys—would not be around for long. "Sometimes I feel like an undertaker," he told a reporter in 1985. "One-third of what we've documented has been destroyed. This is a melancholy business."

In addition to his detailed imagery, Lowe developed a reputation as a daredevil. He was willing to climb rusting ladders and walk precarious cables, including on the Brooklyn Bridge, carrying and setting up his bulky view camera. "I thought of it as fun at the time." Yet years later, he said: "I've developed a healthy respect for height." Lowe retired in 2013. The work was strenuous and exhausting. "Even today," he said in 2022, "I'm often on HABS/HAER assignments in my dreams."

MARTIN STUPICH, WHO worked for two years as a steel worker after graduating from college with a degree in art, followed in Lowe's footsteps. "I was born in the Midwest Rust Belt during its last good years, to the din of blast furnaces and thundering forges," he wrote. Photographing factories was particularly challenging and dangerous. As a HABS contract photographer, he climbed craneways and catwalks to photograph the sad end of the steel mills of the Monongahela Valley near Pittsburgh. He wrote:

> *Many of the cavernous halls, especially the blast furnace buildings, were not illuminated by natural light but instead existed in surreal darkness. Grit-encrusted steel columns, rafters, trusses, 12-foot-tall ladles and dormant blast vessels were all covered by a dusting of cakey, talc-like grime, the color exactly between coal and rust.*
>
> *Any faint daylight reaching the interiors of these implausibly huge rooms was overwhelmed by the darkness and completely absorbed. Making it worse, Pittsburgh mornings often never brightened beyond low overcast. During those gray days, I hoped for a break in the gloom, but in three months, I never saw one of those dramatic, piercing shafts of sunlight so common in saccharine atmospheric postcard views of cathedral interiors and vaulted industrial spaces.*
>
> *It was Pennsylvania, so days were hot and brutally humid, and, where I had to work, it was dirty and dark.*

THE HISTORIC AMERICAN Buildings Survey holds a noble role as the longest operating Depression-era government agency. Yet only five people work full-time at HABS today. Another five National Park Service employees work for the Historic American Engineering Record and two for the Historic American Landscapes Survey. In addition, a collections manager oversees the work of all three agencies and two photographers in the field.

For years, the collection has been supplemented by outside contributors hired to record buildings that are threatened. The National Historic Preservation Act in 1966 mandates that historic structures that are owned, funded, permitted or licensed by the federal government must be documented to HABS photo guidelines if they are to be altered or razed. The negatives of all of these photographs are supposed to be sent to the National Park Service for cataloging. Federal departments and state historic preservation agencies across the country hire administrators to oversee this work, which is called "mitigation photography."

However, many agencies do not comply with the law. They allow structures to be torn down or altered without documentation.

"The developers that hire us to take mitigation photographs just want it done quickly so as not to slow down their project," said photographer Tavo

Olmos, who has worked for HABS since the early 1990s. "We take our time in showing the buildings in the best light possible."

There is drama in laying bare buildings just before they are demolished.

"Mitigation documentation photography is beautiful in counter-intuitive ways," wrote Martin Stupich. "Its aesthetic depends little on the photographer's interpretation; instead, it relies heavily on straight objectivity. A stunning HAER photograph of a blast furnace works because the camera, its operator, and the process honor the subject. A 4-by-5 view of a rolling lift bridge counterweight does not need my swooning 'interpretation' to ensure a good picture. By simply faithfully recording the artifact (+focus+tilt+shift+level+plumb+focus again), a good picture is likely."

Digitization of photographs taken by HABS and HAER and later HALS started in the late 1990s through the Library of Congress. Measured drawings, photo negatives and historic reports of every structure were scanned and put online. Yet over the years, the scanning has fallen behind due to budget constraints that created a backlog of more than 35,000 photographs.

"That's okay," says Stephen D. Schafer, who has close to 1,100 photographs still waiting to be digitized. "This is all about the future." John A. Burns, who served as deputy chief of HABS for more than three decades, disagrees. "I think it's appalling," he said. "HABS photographs need to be accessible. A project is not completed until anyone in America can click on a photo and download it for free."

Despite huge changes in photography over the decades, HABS guidelines have remained remarkably the same. Guidelines updated in 2015 still call for all photographs be taken with large-format cameras using black-and-white film. No digital cameras yet. "Film continues to be the best way to store visual information about architecture and engineering for the long term," the newest guide instructs.

And HABS still demands that film be processed by hand, as has been the rule since the 1930s. Film and prints developed and printed by machines are not adequately washed of photo chemicals, the guide states. "Thus they are not archivally stable and will not be accepted for inclusion in the collection at the Library of Congress." But changes might come soon. HABS is field-testing digital photo equipment and developing new guidelines. It plans to include digital images in the archive in the near future.

For the present, the basic look of HABS photographs has hardly changed—even though there is a more artistic style to survey photos now. "There is something about HABS work that has an old-fashioned feel about it," said photographer Olmos. "Everything about it seems old. And I like that."

THE PHOTOGRAPHS IN this book chronicle the disappearance of 100 buildings. Their final days pushed people like Cervin Robinson, Richard Nickel, Marvin Rand, Jack Boucher and Jet Lowe to create a lasting record of what has been lost. The photographers saw, when few others could, what was happening to cities and towns and rural landscapes. They understood that where they saw destruction, others saw progress. They couldn't stop it, but they could document it.

Their assignment was to photograph structures. Yet they knew they were also capturing the environment and mood of many eras. They were mourning what they saw. As you will see, they took beautiful, soulful pictures that were both literal and symbolic.

Photographs, of course, can never replace buildings. However, they can tell crucial stories.

"You can't put architecture in a museum," said photographer Stephen Schafer, who has worked for HABS for more than two decades. "This is the closest we can save it, enjoy it, and compare it with what comes next."

"I had a sense of how important HABS was," said James O'Gorman, the architectural historian who started with HABS in the 1950s. "We were preserving and documenting the history of architecture." Buildings are like books, he said. "They speak a different language. They imprint information we need."

Why do old buildings matter?

"In the same way that history matters," O'Gorman said. It is the setting in which things happened. "You can't save everything," he said. "But you can make people aware of what we had."

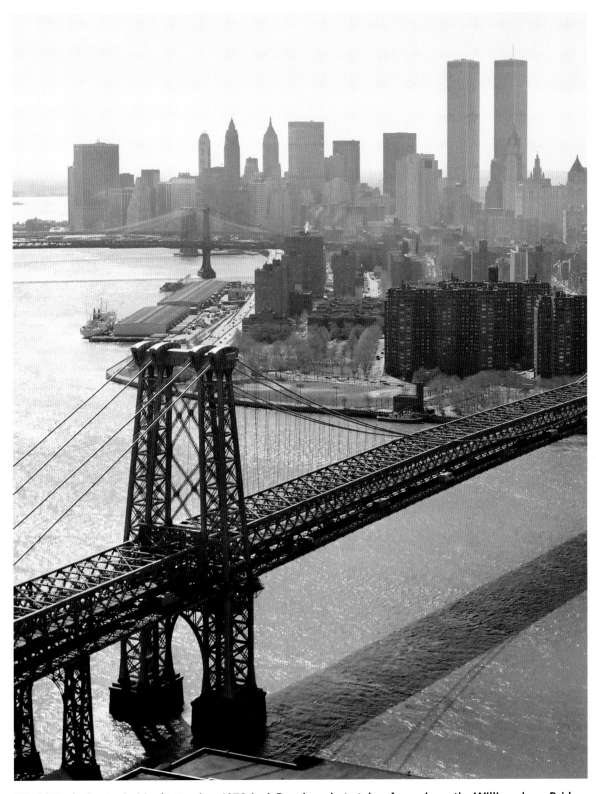
World Trade Center in Manhattan in a 1978 Jack Boucher photo taken from above the Williamsburg Bridge.

PART 1

TIMELESS

I hope to help people appreciate the architecture of the past and how the present is always changing. Everything I photograph is ultimately about time.

—Jet Lowe
HABS photographer

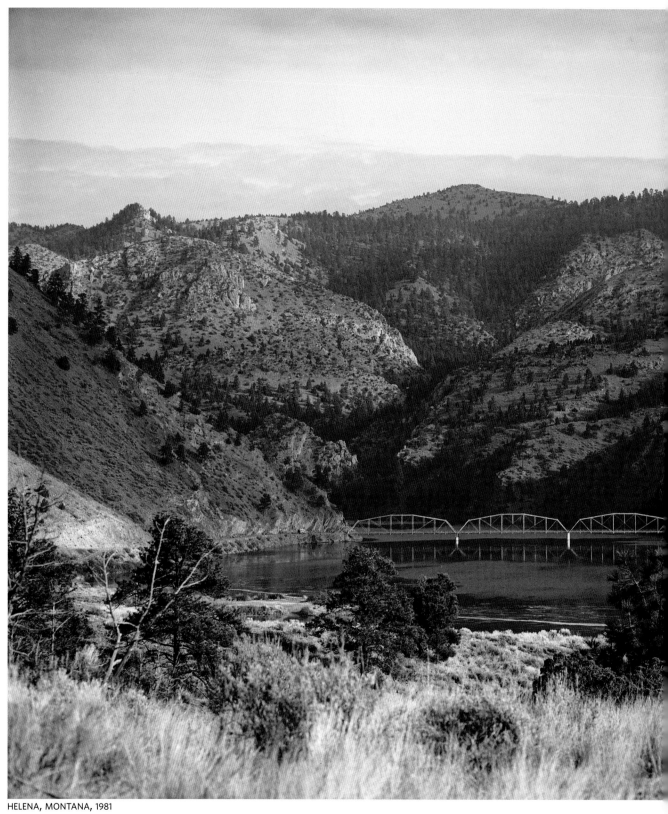

HELENA, MONTANA, 1981

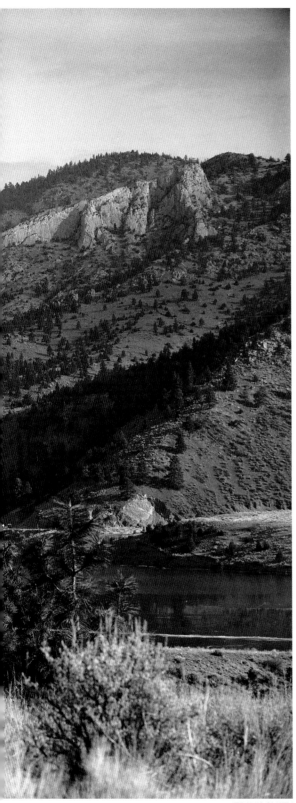

TRAVIS SMITH

Like an undulating ribbon, the three spans of the York Bridge arched above the Missouri River for much of the twentieth century, a graceful landmark on the rugged Montana landscape. Built in 1906, the steel truss bridge crossed the river about ten miles outside the capital of Helena, then reconnected with a road that led up into the Rocky Mountains.

"The bridge is not particularly significant for structural or engineering reasons," wrote the Historic American Engineering Record. But it did change lives.

The new bridge helped Helena grow. People no longer had to wait for a ferry to cross the river. The bridge also provided access to a dam that brought electricity to residents and to a new copper factory.

Yet two years after the York Bridge was built, Hauser Dam collapsed upriver, sending wicked waves down the Missouri. The bridge was severely damaged. When it was repaired with steel brackets, the bridge was strong enough for ranchers to steer their herds over the river on their way to the Montana stockyards.

By the late 1970s, the bridge was starting to show its age. Engineers, fearful that the center support pier was about to collapse, condemned the timber-decked bridge. "No one knows whether the old bridge can stand the weight of a single cow," wrote the *Helena Independent-Record.* After years of public hearings, state highway officials decided to tear down the bridge rather than repair it.

Photographer Travis Smith was dispatched to document the old bridge. He took fourteen photos, mostly technical shots of its superstructure, detailing both sides of the ironwork from top to bottom. Then he moved back to take this distant view as light played on the bridge's delicate spider-like structure.

The once beloved bridge was replaced by a plain, concrete two-lane overpass that more efficiently spans the river. It's hardly noticeable. It sports no fanciful elements or artistic flair. It's simply a continuation of the highway.

The graceful old York Bridge is gone. This is its record.

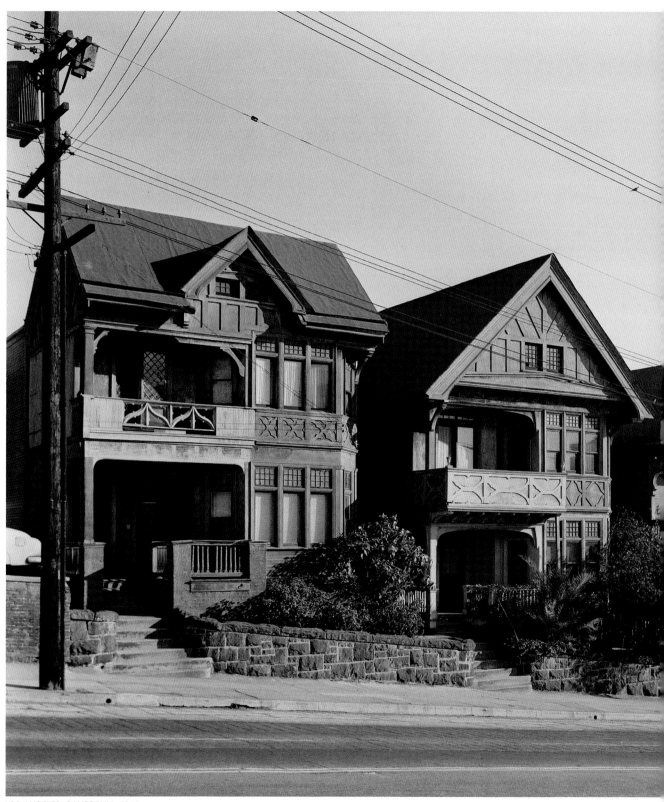

LOS ANGELES, CALIFORNIA, 1960

JACK E. BOUCHER

L.A. noir. Even in daylight.

Los Angeles' Bunker Hill neighborhood was once the setting of dozens of films: *Kiss Me Deadly, Criss Cross, Cry Danger.* The films were stylish and seductive. Not unlike this part of town.

High on a slope overlooking downtown Los Angeles, Bunker Hill was one of the city's wealthiest neighborhoods, created by self-made entrepreneurs who escaped Midwestern winters and created what they saw as a new utopia. They built flamboyant Victorian mansions, elegant hotels and decorative duplexes, like these Tudor Revival style apartments that marched down South Olive Street.

Yet it wasn't long before the newcomers looked for new neighborhoods. The wealthy abandoned Bunker Hill in the early part of the twentieth century, lured to oases like West Adams, Beverly Hills and Pasadena. The homes they left behind were converted to rooming houses and large apartments.

"Bunker Hill is old town, lost town, shabby town, crook town," wrote Raymond Chandler in his 1942 novel *The High Window.* "Once, very long ago, it was the choice residential district of the city, and there are still standing a few of the jigsaw Gothic mansions. . . . They are all rooming houses now, their parquetry floors are scratched and worn through the once glossy finish and the wide sweeping staircases are dark with time and with cheap varnish laid on over generations of dirt."

Chandler's view, brusque and crass as it was, was shared by city officials. By the 1950s, the neighborhood was declared blighted. Over the next decade or so, old Bunker Hill was erased in the name of urban renewal. Thirty-four city blocks were wiped away, 400 buildings torn down, and more than 6,000 people, mostly poor and old, were moved out. Photographers from the Historic American Buildings Survey showed up in its final days.

Bunker Hill is now a neighborhood of residential mega towers, malls, concert halls, museums and schools. Revitalized—but without a past.

PASADENA, CALIFORNIA, 1972

MARVIN RAND

SAN FRANCISCO, CALIFORNIA, 2001 — JOHN STAMETS

Above: The Jewish Community Center of San Francisco was the heart of the city's Jewish life. Designed by Arthur Brown Jr., who built Coit Tower and the San Francisco City Hall, the JCC's purpose changed with the times. It offered classes for the unemployed in the 1930s and childcare for war workers in the 1940s. However by the 1990s, the center was on the verge of bankruptcy. Board members proposed a new building with a larger fitness and aquatic center to attract new members. Preservationists countered, arguing the two-story Mediterranean style structure, with this patio for holiday festivals, should be remodeled and updated instead. Their plan was rejected. The building was razed in 2002, replaced by a $66 million facility described as "state-of-the-art."

Left: Pasadena's Neighborhood Church was torn down for a highway that was never built. California transportation officials announced plans in the early 1950s to extend the Long Beach Freeway through the church's property and other parts of South Pasadena. "Ministers and members of the congregation served in countless planning committees, attended innumerable highway department hearings, wrote letters," recalled church member Clara Link in 1972. "The highway department always wins." The Craftsman-style church, built in 1887, was purchased through eminent domain and razed that same year. Sixty years of protests eventually stopped the extension of the planned Interstate 710 freeway and saved other historic structures. But the church was gone.

The Dodge House was one of the world's first homes in what is now known as the modernist style. It was a massing of five rectangular spaces—some one story, some two story—that intersected to create a Cubist sixteen-room masterpiece.

"We should build our house simple, plain and substantial as a boulder," wrote architect Irving J. Gill, "then leave the ornamentation of it to Nature, who will tone it with lichens, chisel it with storms, make it gracious and friendly with vines and flower shadows as she does the stone in the meadow."

Here was something new.

The house was a collaboration between Gill and owner Walter Luther Dodge.

"They are agreed that the time has come to glorify the twentieth century, and to quit digging around in the past and in foreign lands for something to copy more or less badly," the *Los Angeles Times* reported in 1916 as the house in West Hollywood was completed.

Yet the modern home had a short life. Dodge sold it in 1924 when he and his wife separated. The Los Angeles Board of Education acquired the property in 1939 to build a new high school. Plans fell through. The district hired a caretaker and maintained the house for decades but announced in 1963 that it was "surplus property."

The fate of the Dodge House was sealed the following year when the Los Angeles County Board of Supervisors changed the zoning of the property from single family to high-density apartments. The three-acre parcel was now ripe for real estate speculators. The land was auctioned off in 1966 to Bart Lytton, a flamboyant financier who held an $800,000 check in his teeth and promised to save the Dodge House by making it the centerpiece of a new apartment complex on the site. Yet soon after, Lytton lost his fortune and the house was acquired by Equitable Savings and Loan, which had investors to consider.

After a group of Los Angeles residents sued to prevent the demolition of the Dodge House and lost, Equitable sold the building to a real estate management firm that had no interest in saving the building.

It was torn down in early 1970. Wrote Ada Louise Huxtable in the *New York Times,* the destruction of the Dodge House was a "tragic commentary on how we throw our national heritage away."

WEST HOLLYWOOD, CALIFORNIA, 1968

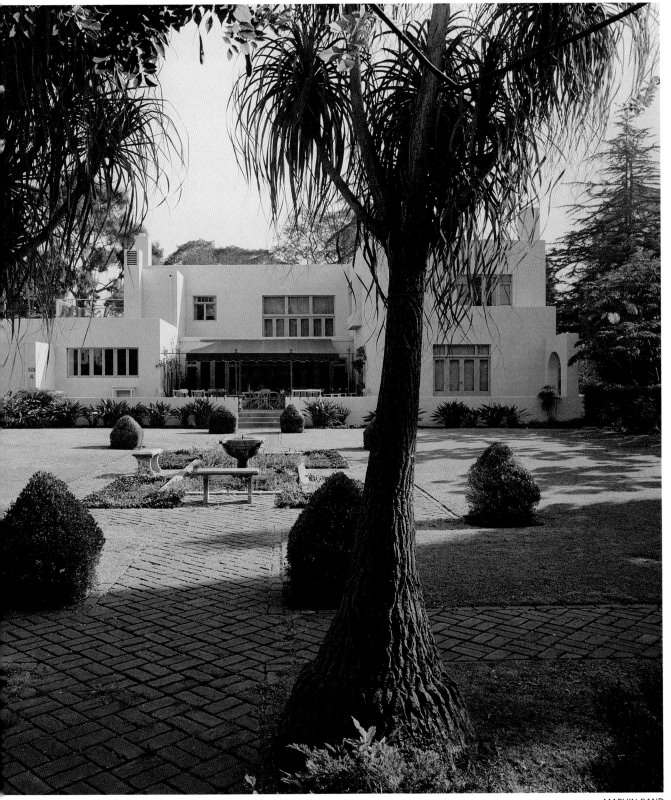

MARVIN RAND

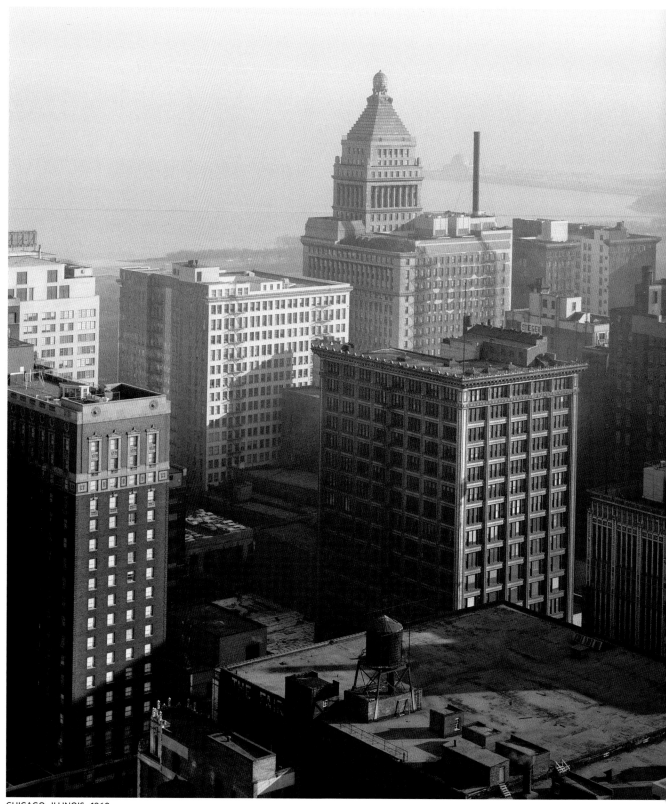

CHICAGO, ILLINOIS, 1960

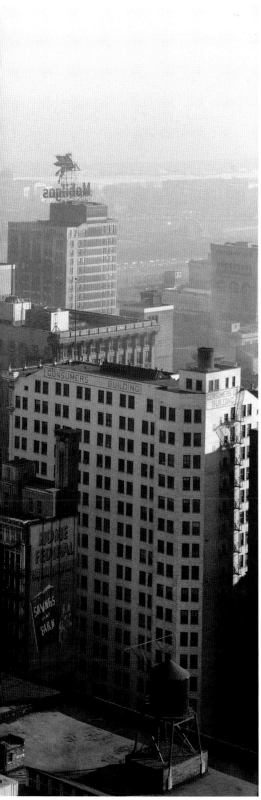

RICHARD NICKEL

The twentieth-century American city was invented in Chicago. Or at least that's the view of Chicagoans. It was there that architects built tall, steel-framed structures with enormous windows and speedy elevators.

Sheathed in white-glazed terra cotta that had turned sooty over the years, the Republic Building (in the dead center of this photo) was the epitome of this new Chicago School style. Built in 1905 by the firm of Holabird and Roche, the building was sold in 1958 to the Home Federal Savings and Loan Association, whose owners planned to remodel the nineteen-story skyscraper for banking. Instead, the Chicago architecture firm of Skidmore, Owings & Merrill persuaded the bankers to tear down the perfectly sturdy Republic for a modern fifteen-story aluminum and glass tower. The Republic was one of the first significant structures lost in Chicago in the 1960s.

Richard Nickel took 86 photographs of the Republic Building for HABS during its last days. He roamed the building, photographing the machinery in the basement, the street-level arcade (a forerunner of shopping centers), the winding staircase and wrought-iron elevator cages. He climbed all the way to the upper-level offices with skylights and the building's massive cornice. "This building sings of the steel-skeleton construction," he wrote.

Nickel also stepped back, photographing the building from another, taller skyscraper. He depicted the Republic in the middle of the Loop to show the building in context. It was his love poem to the building and to Chicago.

Later, Nickel thought back on the Republic Building, which was torn down in 1961. "I had a good look recently at the Home Federal Savings and Loan Building, which replaced the Republic several years ago. That looms in my mind now as one of the great tragedies . . . or rather as one of the most willful, unnecessary destructive acts to Chicago School heritage." He concluded: "The Republic was a work of art, and the new building is nothing, maybe some tinsel."

An architectural style guide in one photograph.

Detroit's Old City Hall is ringed by buildings of contrasting eras. On the left is the modernist National Bank of Detroit Building, from 1959 by the Detroit firm of Albert Kahn Associates. Rising behind it is the 47-story Art Deco Penobscot Building, from 1928 by Detroit's Wirt C. Rowland. The white towers are the Neo-Classical Chrysler House, from 1926 by Chicago's Daniel Burnham. And peeking out on the right is the Classical Revival First State Bank, from 1925 by Albert Kahn.

The surrounding buildings stand. City Hall was demolished.

Detroit Mayor Louis Miriani detested the Old City Hall. He wanted Detroit to look more modern. "When supporters of Old City Hall argue that European cities maintain their historic buildings, they are forgetting something," Miriani said. "Those buildings are made of marble and are works of beauty. Old City Hall is made of poor grade sandstone and certainly no beauty."

Beauty or not, the building designed by Detroit architect James Anderson and constructed in 1871 could have lasted for centuries. It was built in an Empire Revival style. Think Paris Opera House or the Louvre. Or the Philadelphia City Hall, which still towers above the city.

Miriani strong-armed the Detroit Common Council in 1961 to demolish the City Hall. Following the 5-4 vote, the council president asked for a referendum to let Detroit voters decide the fate of the building. A poll indicated a firm majority favored preservation. But the referendum was never held.

Wreckers reported on a Monday night in August 1961. The clock tower, described as the pride of the city, was the last section to fall.

DETROIT, MICHIGAN, CIRCA 1960

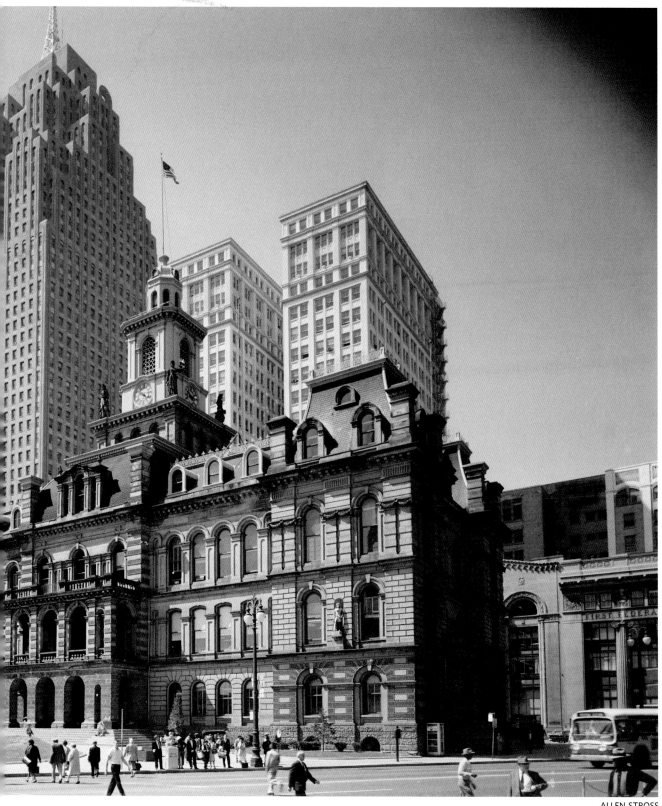

ALLEN STROSS

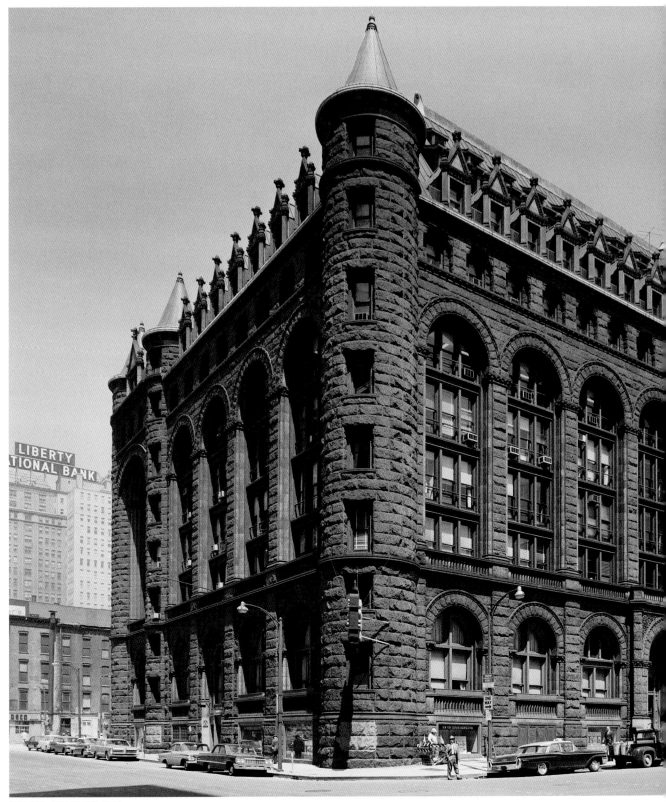

BUFFALO, NEW YORK, 1965

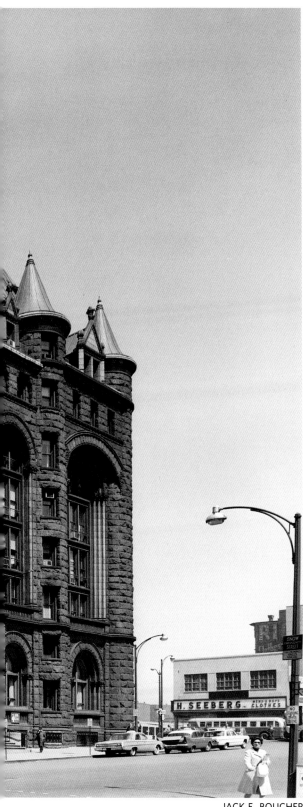

JACK E. BOUCHER

The Erie County Savings Bank was Buffalo.

The ten-story building that dominated downtown Buffalo since 1893 was constructed to look like a medieval castle or fortress, with turrets and gargoyles to connote timelessness. The bank's thick, pink granite walls, which turned black over time, emoted power. This is where Mr. Potter would have maintained an office if *It's a Wonderful Life* was based in Buffalo.

It was solid and seemed to be permanent. But it's gone.

For three months in 1968, two gargantuan wrecking cranes did battle with the building. "A crowd of variable size would gather to see the kill," wrote *Buffalo Evening News* reporter Ellen Taussig. "It was the show of the town. Whole families arrived in station wagons from the suburbs. A middle-aged couple might bring chairs. A friend would explain to a blind man what was happening."

As with any old building, there were many arguments to justify the need to raze the bank. The Richardson Romanesque masterwork designed by New York architect George B. Post was aging. The tile was crumbling. The plumbing substandard. By the 1960s, the building's electrical system needed to be updated and the elevators were becoming lazy.

The real reason the massive Big E was torn down and replaced by the Main Place Mall and the bank's 26-story concrete-and-glass Main Place Tower was a desire to modernize Buffalo.

"Renewal is a fresh, spring word that is echoing down the streets of most U.S. cities," wrote Taussig. "In its wake, some of the very structure and tradition of a city falls. Only time will tell if renewal justifies itself."

Decades later, reporter Todd Hariaczyi from that same newspaper answered Taussig's question. "When the Erie County Savings Bank was demolished in 1968 for the construction of Main Place Mall, downtown was forever altered and lost much of its heart."

CHICAGO, ILLINOIS, 1961　　　　　　　　　　　　　　　　　　　　　　　　　　　RICHARD NICKEL

Above: The 17-story Garrick Theater Building was the tallest structure built by architects Dankmar Adler and Louis Sullivan, who are credited as the originators of the modern skyscraper. Richard Nickel, who took this photo of the building's top floor, organized a spirited preservation campaign to save the 1892 building when demolition plans were announced in 1960. When the effort failed, Nickel led a team of three to remove and save irreplaceable terra cotta and plaster ornament. He also photographed the building in ruins. The Garrick was torn down in 1961. Developers put up a parking garage.

Right: The entrance arch of Adler & Sullivan's 1894 Chicago Stock Exchange. Another preservation battle failed to save the building in 1971. Tragically, photographer Richard Nickel died in an accident while inside the building salvaging ornament as it was being torn down in 1972. "Marvelous being in a work of art under rape," he wrote two months before. "How often do you experience the bones, veins, skin of a work of art, even if it be in dissection?" The disassembled arch was removed from the building and survives as a freestanding fragment outside the Art Institute of Chicago. Once the intergral part of a massive facade, it now sits alone.

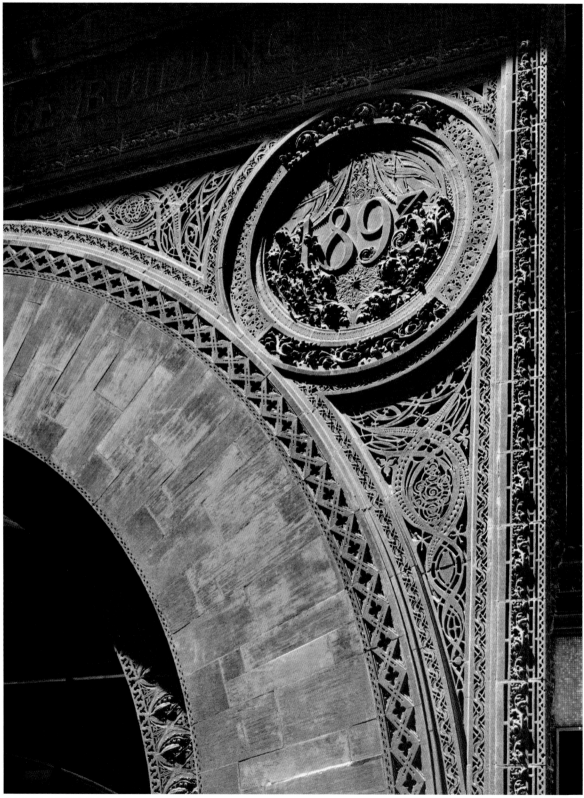

CHICAGO, ILLINOIS 1963 — CERVIN ROBINSON

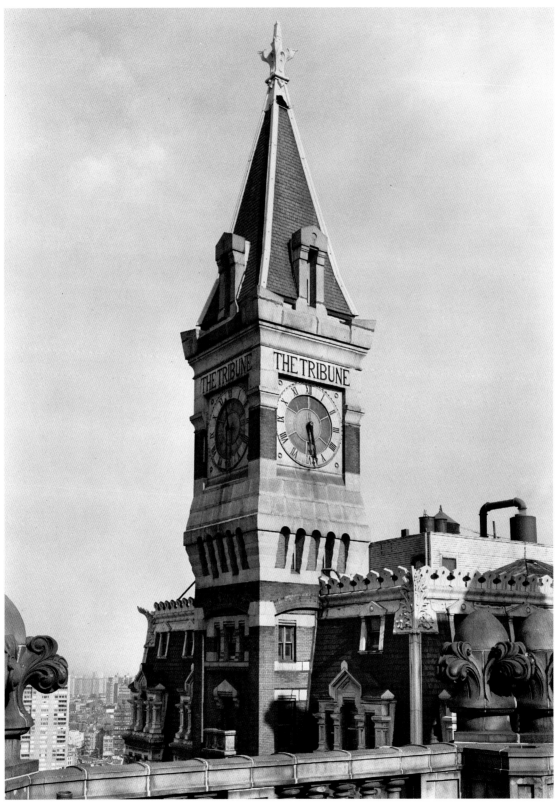

NEW YORK, NEW YORK, 1966 — JOHN FEULNER

NEW YORK, NEW YORK, 1966 — JOHN FEULNER

The clocktower of the 19-story New York Tribune Building, one of the city's pioneering skyscrapers. Opened in 1875, the building by Richard Morris Hunt was part of "Newspaper Row" near the Brooklyn Bridge in Manhattan. Before the wide use of wristwatches, clocktowers served as timekeepers in many American cities. The Tribune Building "vanished almost without a trace, and barely a whimper," according to the *New York Times,* when it was razed in 1966 for a new building for Pace University.

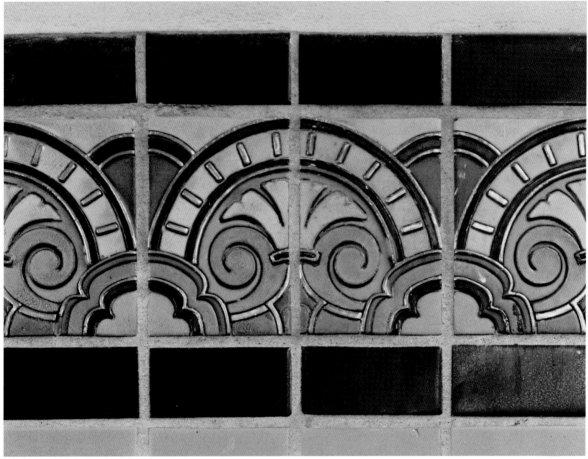

CAMDEN, NEW JERSEY, 1983 GEORGE EISENMAN

Above: Underground to soaring heights. Art Deco ceramic tiles in the 1936 Broadway Subway Station in Camden, New Jersey. This section of the station was abandoned in the mid-1980s when the Camden Transportation Center was built. The rapid-transit PATCO Speedline, which operates underground in Camden, still runs between Lindenwold, New Jersey, and Philadelphia.

Right: The Singer Tower, by architect Ernest Flagg, was the world's tallest building when it opened in 1908. Almost sixty years later, it was the world's tallest building ever to be razed. Here photographer Jack Boucher gives the building a heroic feel as he shoots from below just as demolition of the Singer begins.

 The tower, which rose 612 feet, was built atop the existing fourteen-story Singer headquarters completed in 1898. A "breathless crowd" watched nearly a decade later as a steeplejack placed a golden ball on the flagpole of the new tower. The following year, the building's observation deck, highest in the world, opened. One woman said it was as good as going up in an airship.

 "The demolition of the 47-story Singer Building, at Broadway and Liberty Street, is still viewed as one of the great tragedies of New York architecture," wrote the *New York Times'* Christopher Gray. "Its bulbous Beaux-Arts top was one of the landmarks of the New York skyline from the moment it opened in 1908 until it fell for One Liberty Plaza in 1967."

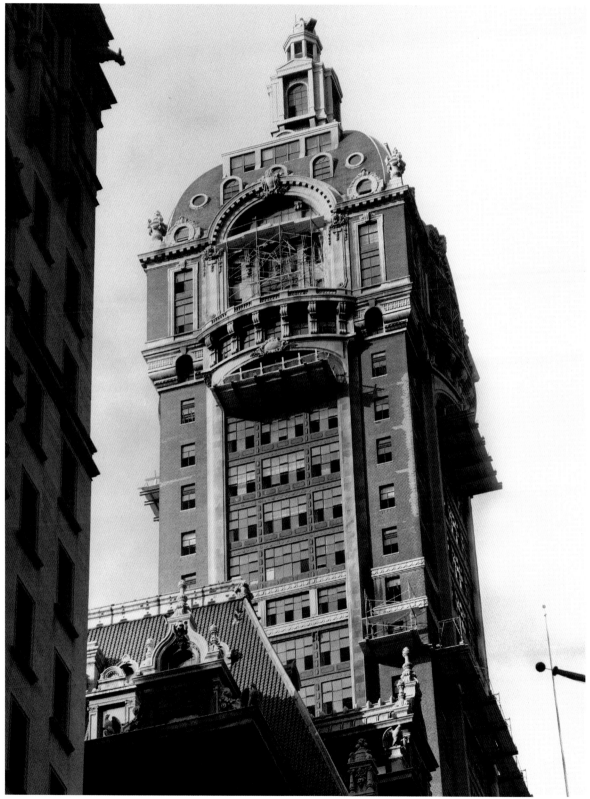

NEW YORK, NEW YORK, 1967

JACK E. BOUCHER

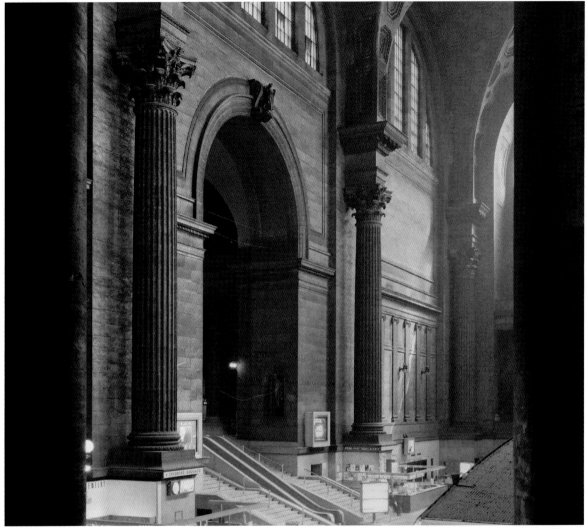

NEW YORK, NEW YORK, 1962 CERVIN ROBINSON

There was no greater loss than New York's Pennsylvania Station.

The station, designed by McKim, Mead & White and built in 1910, took up two New York City blocks between Seventh and Eighth Avenues and Thirty-First and Thirty-Third Streets.

Traveling through Penn Station was like a journey through time. From the main entrance, passengers would stroll through a long arcade modeled after the nineteenth-century shopping galleries of Italy to the ten-story general waiting room based on the ancient Roman baths of Caracalla. Next, they would cross the iron-and-glass main concourse reminiscent of London's Crystal Palace on their way to trains below.

One hundred million people passed through Penn Station's portals during its peak year of 1945. But as the railroad age waned, Penn Central announced plans to sell its air rights above the station's below-level tracks for a new Madison Square Garden sports arena and skyscraper.

A respectful protest of 100 "sharply dressed" marchers gathered with signs in front of Penn Station in 1962. The edifice was demolished in 1963 and replaced by a humdrum underground transit hub. Wrote architectural critic Vincent Scully Jr. of the contrast: "One entered the city like a god; one scuttles in now like a rat."

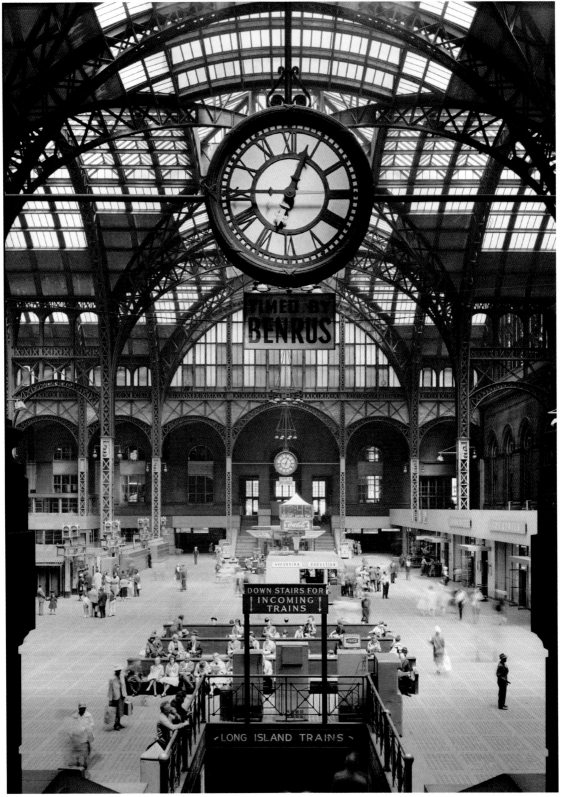

NEW YORK, NEW YORK, 1962 CERVIN ROBINSON

ATLANTA, GEORGIA, 1970　　　　　　　　　　　　　　　　　　　　　　　　　　　　　P. ALAN GUNBY

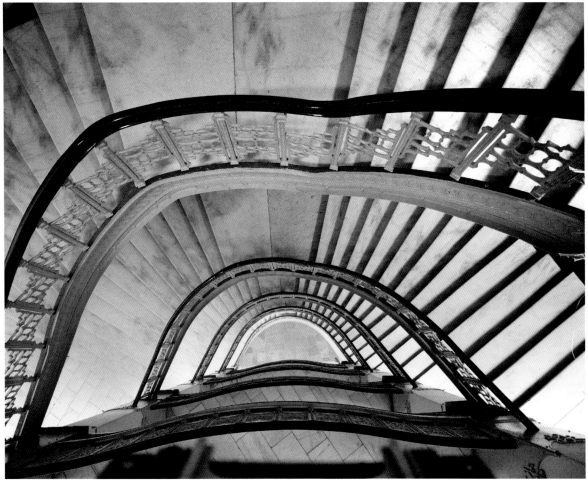

ATLANTA, GEORGIA, 1970 — P. ALAN GUNBY

Most photographers working for HABS specialize in straight-on, large-format documentation. P. Alan Gunby couldn't resist looking up and looking down as he photographed the 1892 Equitable Building, considered the first skyscraper in the South even though it was only eight stories tall.

The Equitable, known for decades as the Trust Company of Georgia Building, was a steel-frame structure built in the Chicago School style by the Chicago architectural firm of Burnham and Root. (Partner John Wellborn Root was a Georgia native.) Those who made it to the top floor via the eight-story staircase or elevator felt they were reaching "almost to the skies."

The building was razed along with railroad stations, hotels, shopping arcades, theaters and other commercial buildings in Atlanta to make way for a "new downtown" as metro Atlanta's population boomed.

The Equitable was torn down just before Atlanta's preservation movement took root. "It's the only building in Atlanta that an architect would stop to see," said Georgia Tech history professor James Grady, who led a group of seventy students carrying a petition to stop the demolition in 1970. They were met by a building representative, who expressed sympathy. The Equitable Building was demolished the following year.

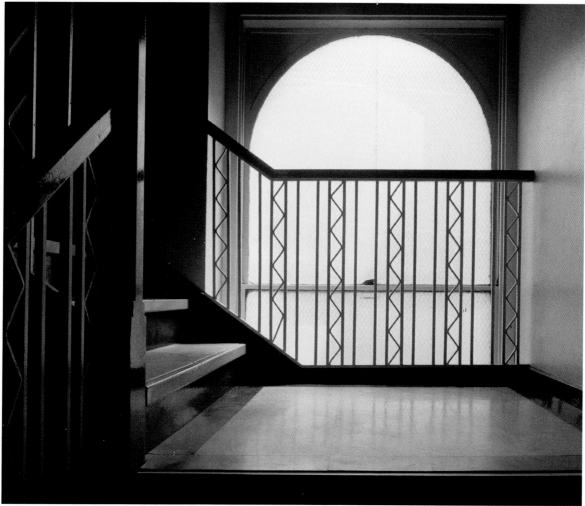

LOS ANGELES, CALIFORNIA, 1968　　　　　　　　　　　　　　　　　　　　　　　　　　　　　　　　　　　　MARVIN RAND

Few stood up for the Richfield Tower when its owners announced plans in the late 1960s to tear it down.
　　The thirteen-story building, designed by Los Angeles architect Stiles Clements and opened in 1929, was the city's Art Deco gem—as sleek and beautiful as New York's Chrysler Building. It was perhaps best remembered for its beacon, which illuminated downtown L.A. for four decades.
　　One of the few who campaigned to save the building was young University of California, Los Angeles professor Denise Scott Brown, who along with husband Robert Venturi became two of the most influential architects and planners of the twentieth century. The Richfield was as important as the California work of architects Irving J. Gill, Greene and Greene, and Frank Lloyd Wright, she argued. "I cannot claim that every architect will agree that the Richfield Building, with its black and gold, its virtuoso decorations, its great arch at the back and its very particular silhouette is one of only two outstanding buildings of its kind [in Los Angeles]."
　　Scott Brown knew she was entangled in an intractable fight. The idea of saving a commercial building was almost unheard of in Los Angeles.
　　She persevered in her effort to save the Richfield Tower—but lost.
　　"Most architects have a distinct preference for a cleared site," Scott Brown said. "But this is a modern prejudice which, had it been shared by builders of the past, would have left us few examples of Medieval, Renaissance or Baroque architecture."

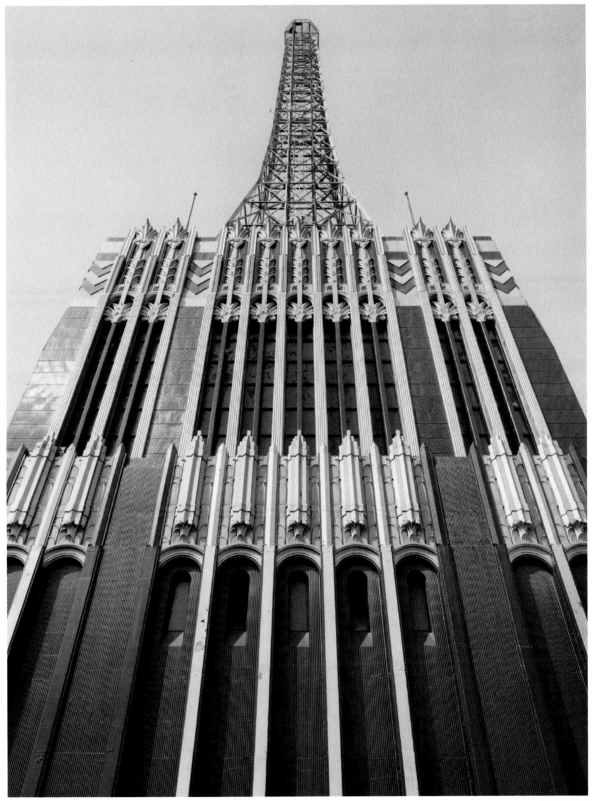

LOS ANGELES, CALIFORNIA, 1968 — MARVIN RAND

Atlanta's classic Carnegie Library—where Margaret Mitchell researched *Gone with the Wind*—was razed in 1977 for a new main library.

Officials justified the demolition by promising that the replacement would become another landmark. They were wrong.

The library board hired internationally known architect Marcel Breuer, but his Brutalist style Central Library that opened in 1980 was so unpopular that it has undergone two major renovations. The library board even considered tearing down Breuer's colorless building. Instead, exterior windows were carved into the concrete walls and a skylight was added above in an attempt to make the new library more appealing.

Albert Randolph Ross, who designed the 1900 Carnegie Library in downtown Atlanta, went on to build at least five other Carnegies. Between the 1890s and 1919, industrialist Andrew Carnegie funded the construction of more than 1,600 libraries across the United States and hundreds more around the world. Almost half of the U.S. Carnegie libraries, including about fifty in New York City, are still in use. Carnegie spent $100,000 on the Atlanta library.

David J. Kaminsky, who photographed the columns and entablature of the Beaux-Arts library, said artificial lights were key to showing specific architectural elements in HABS photographs. He was instructed to use lighting even for outside work to show minute details. "We were taking this for history."

ATLANTA, GEORGIA, 1976

58

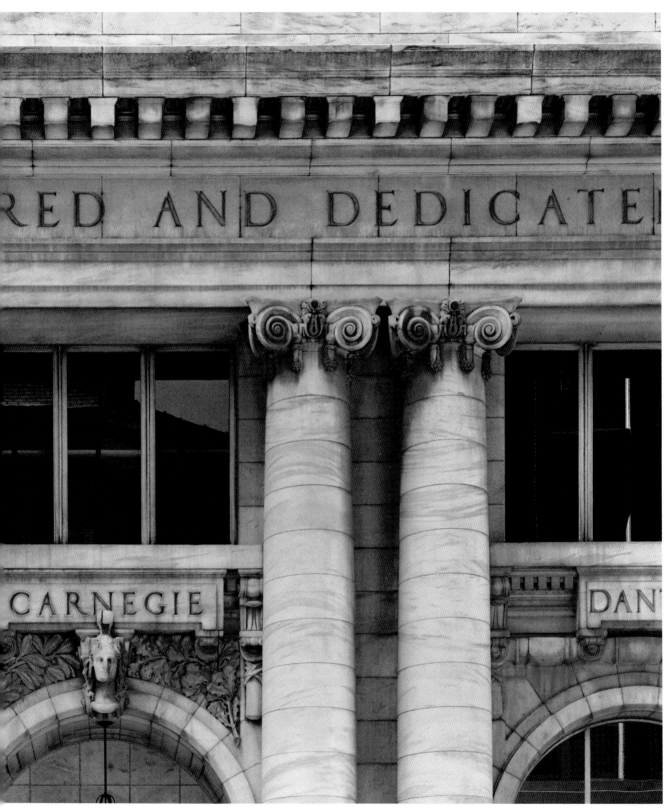

DAVID J. KAMINSKY

Two blocks north of the White House, the John R. McLean House was one of the most monumental mansions ever built in the District of Columbia.

Designed in 1907 by John Russell Pope, architect of the Jefferson Memorial and National Archives Building, the residence was built for McLean, owner and publisher of the *Washington Post.* The mansion also housed McLean's art and sculpture collection.

McLean's son Edward inherited the house and made it into the "social salon of the Harding era" during the 1920s. Edward is best known as the last private owner of the Hope Diamond, which he purchased for wife Evalyn Walsh McLean to help her solidify her role in Washington society. Evalyn, called "one of the most charming hostesses ever in Washington society," wore the diamond frequently and bodaciously. She also reportedly placed it in the collar of her Great Dane.

The mansion stayed in the family through the late 1930s but became overwhelming to maintain. It was leased to the federal government and used as New Deal offices. Sold in 1939, it was demolished for the government's Lafayette Building, itself now a landmark.

Many of the early photographers working for HABS were trained architects. Frederick D. Nichols, who roamed the mansion during its last days, went on to teach architecture at the University of Virginia and supervised the restoration of Thomas Jefferson's Rotunda on the university's campus.

WASHINGTON, D.C., 1938 — FREDERICK D. NICHOLS

WASHINGTON, D.C., 1938 FREDERICK D. NICHOLS

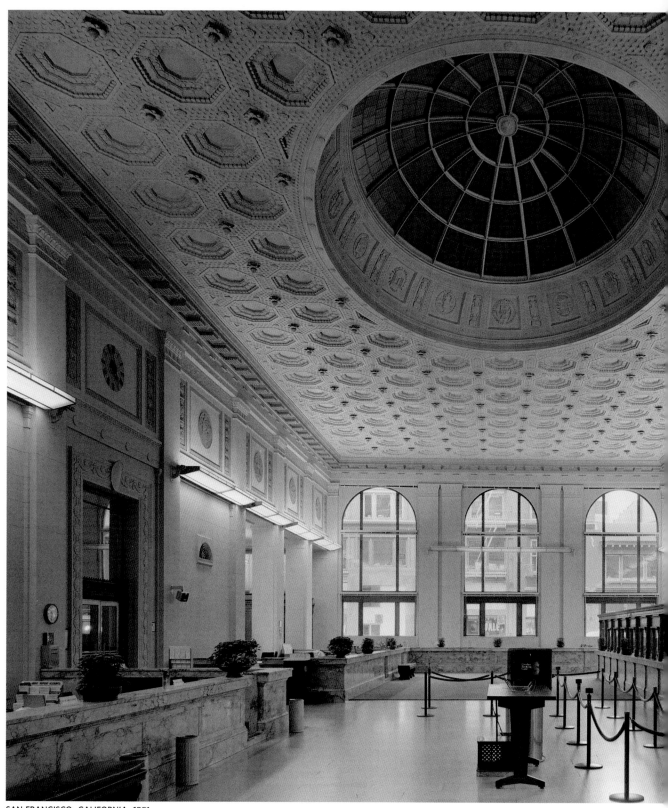

SAN FRANCISCO, CALIFORNIA, 1981

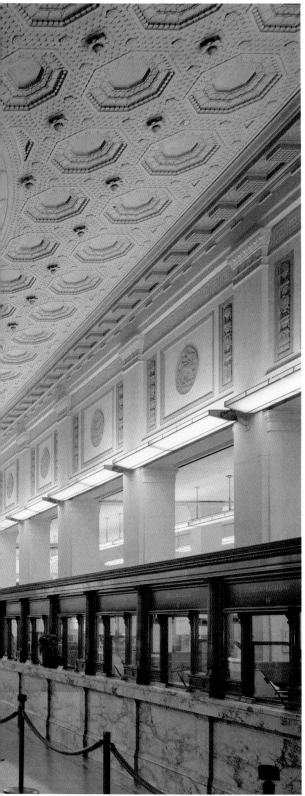

JACK SHAFER

Not all lost buildings have disappeared.

The two-story Anglo & London Paris National Bank was gutted in 1984 to serve as the entrance of a new 41-story skyscraper in San Francisco. Gone are the first-floor teller cages, marble counters, coffered ceiling and skylight, as well as the building's entire second floor, its cornice and parapet.

The monumental 36-foot-tall main hall, called a "magnificent banking house," was turned into a glasshouse in 1984 just off the Montgomery public transit stop in the heart of downtown.

Ironically, that is exactly how the room was described by the *San Francisco Examiner* in 1910, the year the bank opened. "The bank looked like a conservatory when the doors were thrown open for inspection," the newspaper reported. "As one spectator remarked, 'It looked as if the park conservatory had been brought bodily to this corner.'"

Seven decades later, architect William L. Pereira promised the San Francisco Planning Commission to repurpose the historic bank building in order to get approval for his proposed skyscraper. Pereira, known for his Transamerica Pyramid a half mile north, retained most of the bank building's exterior walls, but then lathered the interior walls with austere Carrara white marble. He may have overdone it. Preservationists called the new room "a marble mausoleum" and the "world's largest latrine."

The architect topped the new room with a glass ceiling and filled it with loads of vegetation. "Blank marble panels and perfectly groomed (and perfectly boring) ficus trees conjure up the tightly controlled world of an architectural rendering," wrote John Chase in the *Examiner* in 1985. "The 8-month-old Citicorp Center at Sansome and Sutter Streets is an uneasy marriage of an old bank building and a new skyscraper."

Over the years, the ficus trees have been removed and replaced by tall palms. It is an oasis of green in a busy urban district. However, for those who know the history of the room, it is also known as the "tomb of the unknown bank officer."

Some residents of the Detroit neighborhood of Poletown used a church to try to save their community.

In 1980, General Motors and the City of Detroit agreed to a deal. The city would acquire more than 400 acres of land in the historically Polish community of Poletown, about three miles north of downtown Detroit, and give it to the automaker so it could build a huge assembly plant.

To purchase the land quickly, state legislators expanded the state's eminent domain law, making it possible for Detroit to acquire property "in order to encourage commercial development." The city promptly paid homeowners the market value of their land (an average of $13,000) plus relocation costs. In order to get the mighty Catholic Church on its side, the city offered to buy two churches for $1.3 million.

The archdiocese took the deal and gave the GM factory its blessing, despite the fact it meant the end of Immaculate Conception Catholic Church, a neighborhood beacon since 1928.

Members of the church and the local priest defied the archbishop. "This is a criminal act," said Father Joseph Karasiewicz. "The basic definition of stealing is simply taking somebody's property against their will. That's all it is."

Opponents of the planned GM factory saw the church as their last hope to keep the factory from taking over the neighborhood. They picketed the company with signs that read: "GM Desecrates Churches" and organized a sit-in at the church that lasted 29 days. It ended when they were arrested and forcibly evicted. The City of Detroit transferred 465 acres to GM.

The new factory displaced 3,400 residents, 1,500 homes, 144 businesses, 16 churches, 2 schools and a hospital.

The Detroit-Hamtramck Assembly Center opened in 1985. Despite the best efforts of the company, it was most often called the "Poletown Plant." GM promised 6,000 new jobs but only 3,000 worked in the factory at its peak. The plant closed in 2019. It was retooled in 2021 as Factory Zero, GM's first dedicated electric vehicle assembly plant. Poletown and its Immaculate Conception Church are a memory.

DETROIT, MICHIGAN, 1981

MARIE MASON

If there were a Xanadu, "a stately pleasure-dome" as Samuel Taylor Coleridge imagined, it must have been at the swooping Pan Pacific Auditorium in Los Angeles. That's what the producers of the film *Xanadu* thought when they used the Streamline Moderne building as the basis of their movie.

The 1980 film, Gene Kelly's last, was a flop, but it drew attention to a landmark that had been nearly abandoned. For decades, the phrase "going to the Pan" in Los Angeles meant hearing Elvis Presley perform, watching Dwight Eisenhower and Richard Nixon campaign, or showing up for an auto show, sporting event or the circus.

That all ended in the early 1970s when the Los Angeles Convention Center (seven times as large) and the Forum (capacity 17,000) became the major venues for indoor L.A. events. That's when Marvin Rand, chronicler of modernist California, photographed the Pan Pacific's main entrance with pylons that looked like the smokestacks of an ocean liner. His picture, an asymmetrical view of symmetrical architecture, adds dynamism.

Los Angeles County officials considered restoring the building as a hotel in the mid-1980s. However, solid plans were never completed. The Pan Pacific, which had been constructed out of wood over the course of two months, burned to the ground in 1989.

At least one Los Angeles resident blamed the end of the dreamy, wooden structure on neglect. "The loss of the Pan Pacific Auditorium was just a matter of time," wrote Richard Laurent Katz a week after the fire. "It allows us to continue to avoid the sticky issue of how to care for cultural and architectural landmarks."

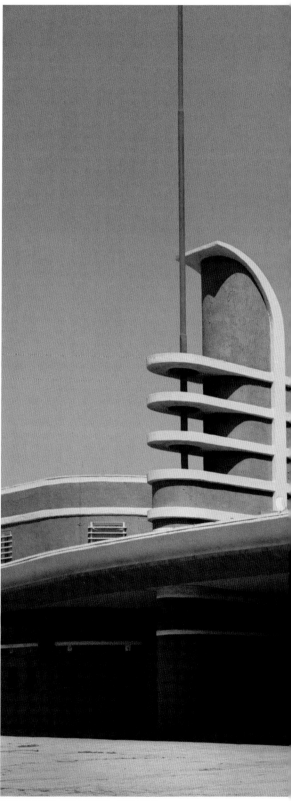

LOS ANGELES, CALIFORNIA, MID-1970s

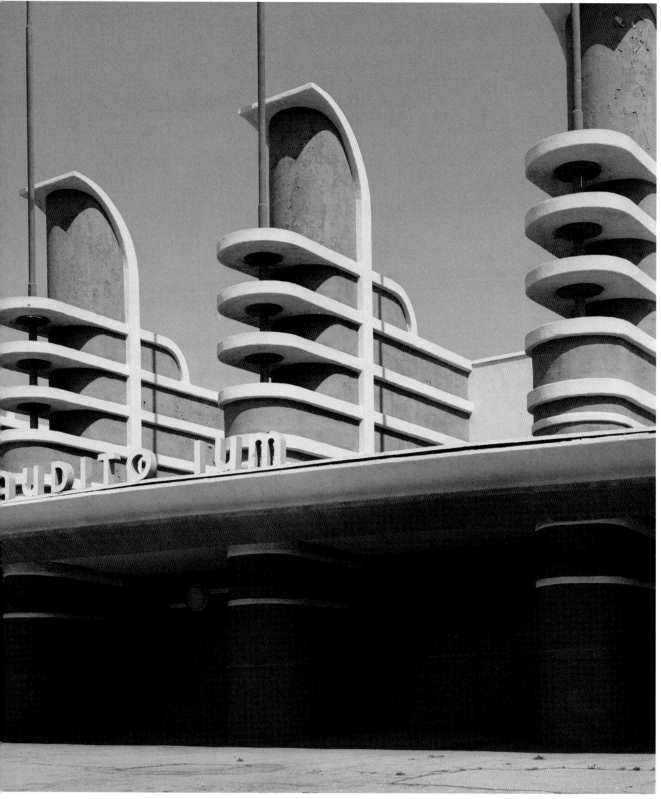

MARVIN RAND

PORTLAND, OREGON, 2004 — JET LOWE

SAN JUAN, PUERTO RICO, 1967 — JACK E. BOUCHER

Above: The Prairie School comes to Puerto Rico. Architect Antonin Nechodoma, who grew up in Europe and Chicago, introduced Frank Lloyd Wright's Prairie style to the Caribbean. He designed an enormous mansion (13,500 square feet) for Aúrea and Eduardo Giorgetti in the Santurce district of San Juan in 1923. Decades later, preservationists tried to save the mansion but could not interest the Puerto Rican government.

"Since the late 1950s through the 1960s there was an urge to restore and preserve colonial buildings of the Spanish rule in Old San Juan and around the islands," wrote architectural conservator Héctor J. Berdecía-Hernández. "Everything that was built before the invasion of the United States in 1898 was in the preservation agenda by the principal cultural institutions in Puerto Rico of the time. Unlike the community, the Giorgetti Mansion was not considered worthy of preservation by the government."

The house had been neglected by the time photographer Jack Boucher traveled to San Juan. He took overall views and then looked for details that showed its unique Hispanic Prairie style. The house was demolished in 1971.

Left: "Factories can be beautiful," declared New York architect Walter Monroe Cory, who designed this 1947 Canada Dry ginger ale bottling plant in Portland, Oregon. Cory created thirteen distinctive Streamline Moderne warehouses across the country and in Vancouver and Montreal, Canada, as well as in Havana, Cuba. This is a view of the office entryway.

Photographer Jet Lowe documented the Portland building and another Cory-designed Canada Dry plant in Silver Spring, Maryland. "Architectural historians were very interested in the idea of these streamlined factories," Lowe said. The Oregon factory has been replaced by an office building. The Maryland factory has been turned into condominiums.

In the beginning, the Parker Center seemed ahead of its time.

The eight-story building, designed by L.A.'s own Welton Becket and opened in 1955, was the headquarters of the Los Angeles Police Department. During the 1950s, the building stood for modernism—with its glassy International look and up-to-date police facilities. Inside was not just the crime lab. It was a futuristic scientific investigation center equipped with a heliport.

But during the 1960s, the building also stood for a department known for its use of excessive force. Police Chief William H. Parker, for whom the building was named after his death in 1966, had directed the brutal response to the Watts Rebellion, also known as the Watts Riots. And in 1991, the building was linked with LAPD's savage beating of Rodney King.

On the Good Friday after the King video was released, Reverend Al Sharpton carried a six-foot wooden cross to the Parker Center as he led hundreds of demonstrators chanting "Free L.A. Free L.A."

By the new century, police officials claimed that their headquarters was outdated. The department moved out in 2009 and the building closed in 2013. While vacant, the city's Cultural Heritage Commission voted 5-0 to designate the building a cultural monument. "By preserving Parker Center, we hold on to a part of L.A.'s story that needs to be remembered," wrote commission member Gail Kennard. "There is a reason 'White's Only' drinking fountains are preserved in the South, and the Japanese internment camp at Manzanar is a national historic site on the east side of the Sierra. These places are lessons from our past."

The City Council disagreed. It voted unanimously to reject monument status for the Parker Center. When a Los Angeles organization argued that the building would be better used as a homeless center, wreckers moved in and dismantled the building floor by floor. By 2019, the Parker Center was gone.

LOS ANGELES, CALIFORNIA, 2018

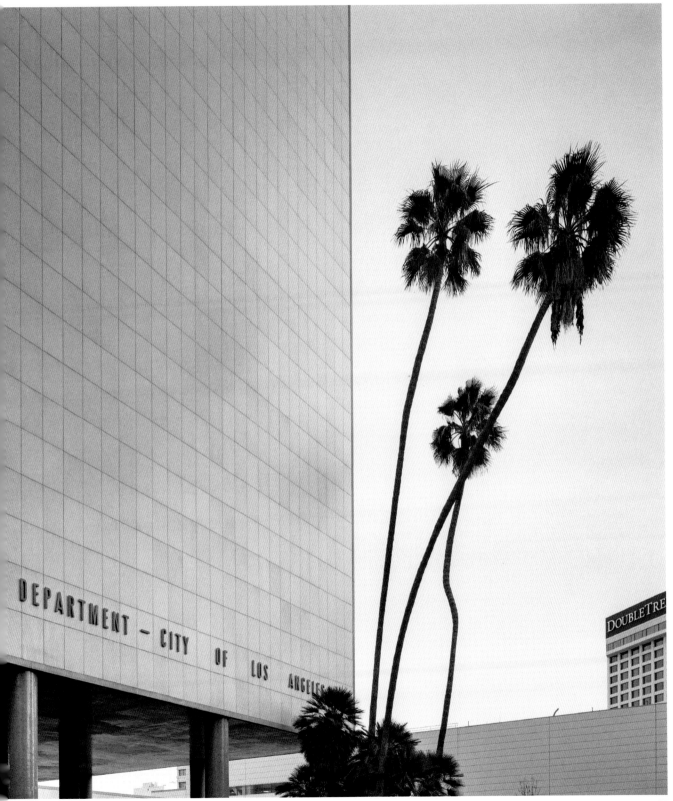

STEPHEN D. SCHAFER

CINCINNATI, OHIO, 1934 — EDGAR D. TYLER

Above: Cincinnati's National Theater had been converted into a tobacco warehouse by the time Edgar D. Tyler photographed it nearly a century after its construction.

The theater, built in 1837, had an outstanding reputation for hosting stage drama. It was a venue for stars of the era, including the Booths (Junius and sons Edwin and John Wilkes). But it also was known for its third tier, the balcony that was a front for prostitution where "the girls of the pave," according to the 1845 *Cincinnati Enquirer,* "made their assignations and took their clients off to a nearby hotel or brothel."

The National couldn't stay legit. It became a burlesque house in the 1880s and was later retrofitted as a tobacco warehouse. The building, near what is now the Great American Ballpark, was razed in 1940.

Right: The Metropolitan Opera House was one of the most opulent concert halls—from 1883 until it closed.

Here is the oval stairway that led to the auditorium. About a block west of Bryant Park in Midtown Manhattan, it "made the world a better place to live in," the *New York Times* noted. "Virtually every great singer appeared there, and no career was considered complete until a singer stepped on the big stage."

The Metropolitan Opera Company fought efforts to name the opera house a landmark when it moved to Lincoln Center because it feared a rival company would purchase the building. It was demolished in 1967 and replaced by a skyscraper.

NEW YORK, NEW YORK, 1967

JACK E. BOUCHER

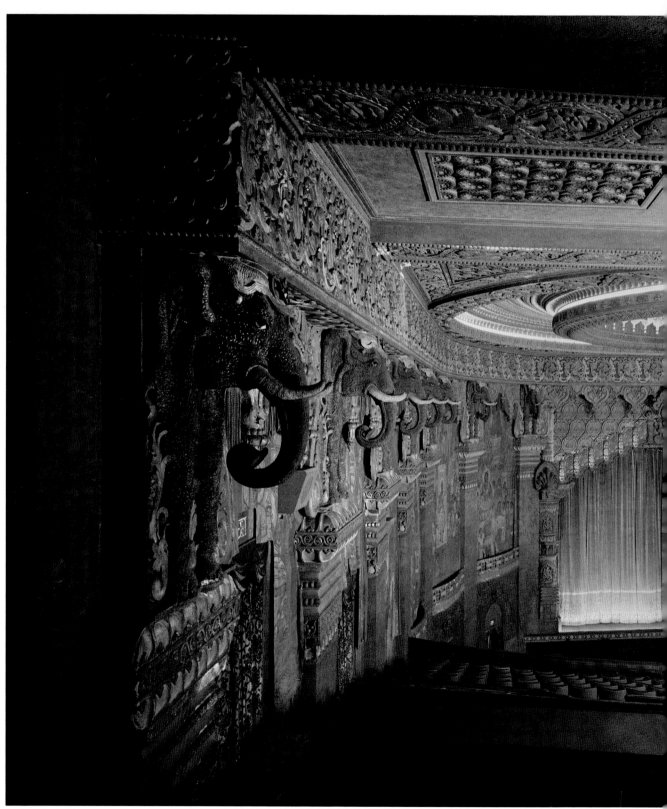

PORTLAND, OREGON, 1969

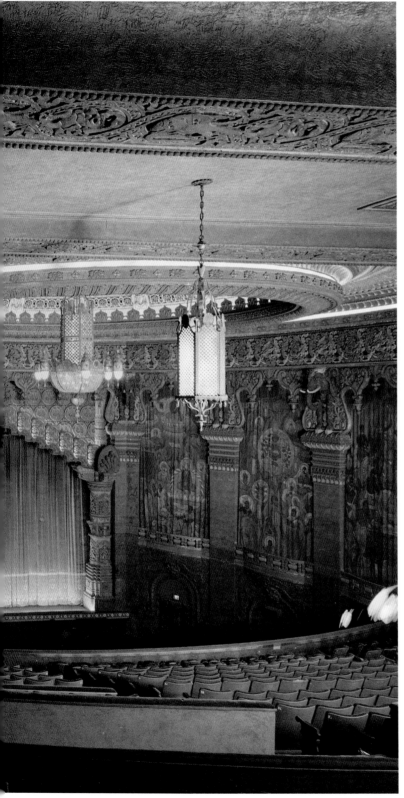

LYLE E. WINKLE

The Oriental Theatre in Portland was built to dazzle. Its wildly exotic interior was fashioned to look like a Buddhist temple. Columns on each side of the screen were said to be modeled after Cambodia's Angkor Wat. Life-sized "sacred elephants" peered down from the auditorium, accompanied by a menagerie of plaster monkeys, fish, dragons and deities who lived in the lobby and mezzanine.

Like many movie palaces built in the 1920s, the Oriental was an "atmospheric playhouse" designed to transport patrons from the everyday into a world of fantasy. It was designed by the Oregon firm of Thomas and Mercier and opened in 1927 with a capacity of more than 2,000. The theater's indispensable interior designer was Adrien Voisin, who created the magical zoo. (He also created sculpture for Hearst Castle.)

The theater presented stage shows and silent films during its first years. By 1930, the Oriental had installed a sound system for talkies. To attract families, theater owners offered free babysitting in a "Kiddie Circus Nursery." When the allure of the big screen waned in the 1950s and '60s, the Oriental returned to its live-theater roots by hosting a local opera company and concerts as Portland's temporary civic auditorium. In 1966, violinist Isaac Stern, who helped save Carnegie Hall, took the stage as one of the theater's final performers.

Because the huge Oriental could not maintain a profit, it was sold. Much of its incredible interior was disposed of at auction in 1969. Just before the sale, photographer Lyle E. Winkle carefully recorded the building. He took this photo from the back row of the balcony, using a long exposure to record this remarkable view.

The theater was razed in 1970, replaced by a parking lot.

75

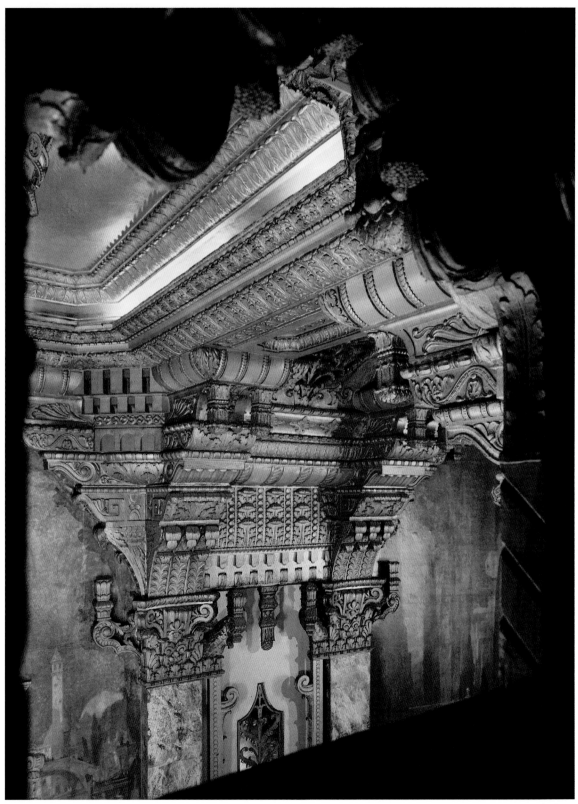

BROOKLYN, NEW YORK, 1970 — JACK E. BOUCHER

BROOKLYN, NEW YORK, 1970 JACK E. BOUCHER

There was hardly an inch of the Fox Theatre in Brooklyn that was not swathed in lavish decoration.

The Brooklyn Fox, on Flatbush Avenue just south of downtown, was one of the largest and most ornate of the giant Fox movie palaces. It was designed by C. Howard Crane, who built 250 other movie theaters across America. The Brooklyn Fox, which cost $8 million and could seat 4,000, was one of his jewels. On a busy Saturday in the 1940s and '50s as many as 12,000 people filled the Fox for multiple shows. By the 1960s, the theater was lucky to attract more than a hundred.

Fox Theatres opened dozens of theaters across the United States before going bankrupt in 1932. Several are still around, repurposed as performing arts centers, churches, a city hall, bank, drug store and even a beauty salon. The Brooklyn Fox played its last movie in 1966. It hosted rock concerts and a grand opera before being torn down in 1971.

GETTYSBURG, PENNSYLVANIA, 2004

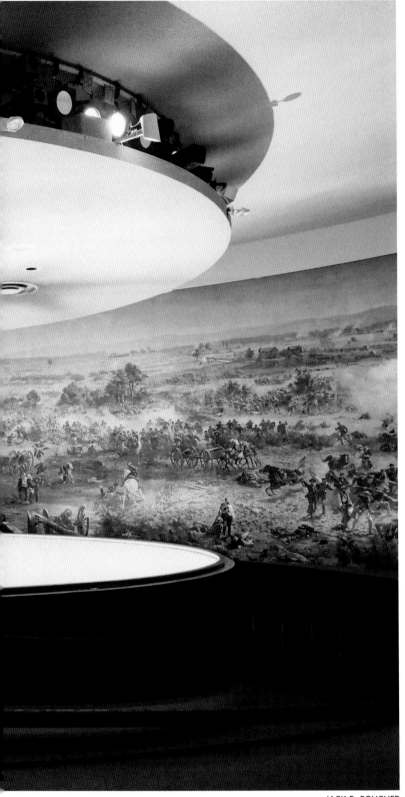

JACK E. BOUCHER

It was the second battle of Gettysburg.

In the late 1950s, renowned modernist architect Richard Neutra was hired by the National Park Service to design a new visitor center at the Gettysburg National Military Park. He and partner Robert Alexander created a sleek, futuristic structure situated in an area of the battleground known as Ziegler's Grove. Neutra was pleased; he felt the innovative building would link the past and the future.

"The building will last forever," he declared.

Opened in 1962, the visitor center housed an epic 377-foot painting created in the 1880s that depicted Pickett's Charge, the Confederates' last-ditch assault. The painting was actually a 365-degree cyclorama, displayed in a circular building that Neutra called the concrete drum.

Less than fifty years later, officials of the Park Service decided to demolish the building. Civil War historians considered the Cyclorama Building—sneered at as "Starship Enterprise"—a blot on the historic landscape. The Park Service agreed. Funds to restore the structure were withheld and the painting was removed for conservation. Plans were made to raze the building.

Neutra died in 1970. His defenders fought to protect the Cyclorama Building. They filed a federal lawsuit arguing the building was historic. They also maintained the Park Service had not studied alternatives to demolition. The court battle lasted longer than the Civil War. Nuestra's building was razed in 2013.

Photographer Jack Boucher positioned himself in the Cyclorama's gallery so he could show the nineteenth-century painting lit by twentieth-century technology. Here was Neutra's vision: the juxtaposition of past and future.

79

The two-story post office on a quiet section of Saint Joseph Street was one of the most elegant buildings in Mobile.

Its long, graceful loggia entrance and red tile roof resembled an Italian Renaissance villa that could have been built on the Grand Canal of Venice. A marble stairway with bronze balustrade and brass handrail led to the public lobby. There, patrons were met by marble wainscotting, postal boxes in solid bronze, arched plaster walls and this elaborately coffered ceiling. It was a perfect example of early twentieth-century civic architecture.

The building was designed in 1914 by Oscar Wenderoth, a government architect who drew plans for post offices across the country. This was perhaps his most beautiful.

Even so, its grace belied the building's difficult past.

The first Black postal clerks were hired at the Mobile Post Office in 1948. Four years later, the *Chicago Defender* reported that Black letter carriers in Mobile were barred from eating with white clerks and were required to use separate restrooms. Through the next several years, postal workers were assigned jobs based on their race.

By the 1960s, the old post office was overcrowded. A larger post office opened in 1967. "This behemoth of brick and concrete was spacious, but cold," wrote Mobile resident Tom McGehee about the new post office. "There was no Alabama marble, no loggias, no coffered ceiling."

MOBILE, ALABAMA, 1966

ROY THIGPEN

CHICAGO, ILLINOIS, 1964

HAROLD ALLEN

The monumental dome that rose fourteen stories within the Federal Building in Chicago was ethereal. Built atop the U.S. District Court and Court of Appeals, the dome—200 feet high and 100 feet in diameter—was larger than the dome of the U.S. Capitol. It was created to convey the idea of eternal justice. This was where gangster Al Capone was finally sent to federal prison.

The easy shot of the dome, of course, was from the lobby floor. Nevertheless, photographer Harold Allen, who documented all parts of Chicago for HABS, climbed high to the base of the dome to take this shot.

The courthouse, which also contained a large post office, was created in the Beaux-Arts style that was the rage in Chicago and across the nation following the 1893 World's Columbian Exposition. Architect Henry Ives Cobb, who designed seven buildings at the fair, brought the Neo-Classical spirit to this enormous building, which took seven years to build and opened in 1905.

By 1960, the structure was deemed inefficient and structurally unsound. It was also considered unsightly, covered by decades of city grime.

The once-majestic courthouse and post office had become lost in the canyons of skyscrapers that crowded the south end of Chicago's famous Loop. But during the early 1960s, when neighboring structures were also razed to make way for the neighboring Federal Center, the towering round roof of the Federal Building reappeared in the skyline—one final time.

"The old courthouse looks better than ever now that a new view of its dome can be seen from the glass-enclosed lobby across the street," wrote Chicagoan Miriam Arnette in early 1965.

A few months later, the building was razed, replaced by a complex of glass-and-steel federal buildings designed by Ludwig Mies van der Rohe.

PART 2

FORGOTTEN

Great architecture has only
two natural enemies:
water and stupid men.

—Richard Nickel
HABS photographer

Mayhew Primary is long gone, as is the intersection of Poplar and Chambers Streets and much of the West End neighborhood that the public school once served. West End was razed to create a "New Boston."

The school was designed by once-prominent, later-notorious New York architect Stanford White and built in 1897. Photographer Cervin Robinson, who documented the school for the Historic American Buildings Survey, also took pictures of houses, stores and apartments throughout West End after the area was deemed blighted by the Boston Redevelopment Authority. Officials argued that the streets were too narrow and that the structures in West End were not up to code. It was a death knell for the dense, winding neighborhood of Italian Americans, Jews and African Americans just north of Beacon Hill.

Sociologist Herbert J. Gans moved into West End in 1958 to watch it die. He was surprised by what he learned: crime and drug addiction were low, and the neighborhood's old buildings were in working condition. He found vitality where he had expected to find depression. "The West End was not really a slum," he concluded. In fact, he found it was "by and large, a good place to live."

Still, the Boston Redevelopment Authority—flush with federal money—tore down about thirty city blocks (nearly half the neighborhood) in the 1950s and '60s, including the Mayhew School in 1959 and the idiosyncratic streets it faced. Fixated on the new, city officials insisted West End was showing its age. New residential towers, government offices, commercial buildings and a highway replaced apartment buildings and family-owned stores. Only a few historic buildings and the massive Massachusetts General Hospital were spared.

About 2,700 families were displaced by the destruction of West End, forced out to other parts of the city or to the suburbs.

BOSTON, MASSACHUSETTS, 1959

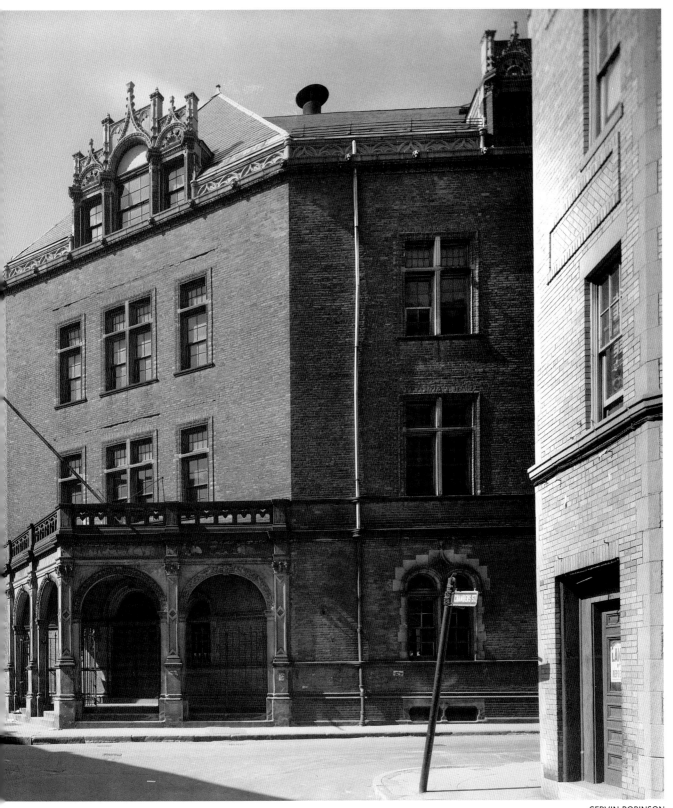

CERVIN ROBINSON

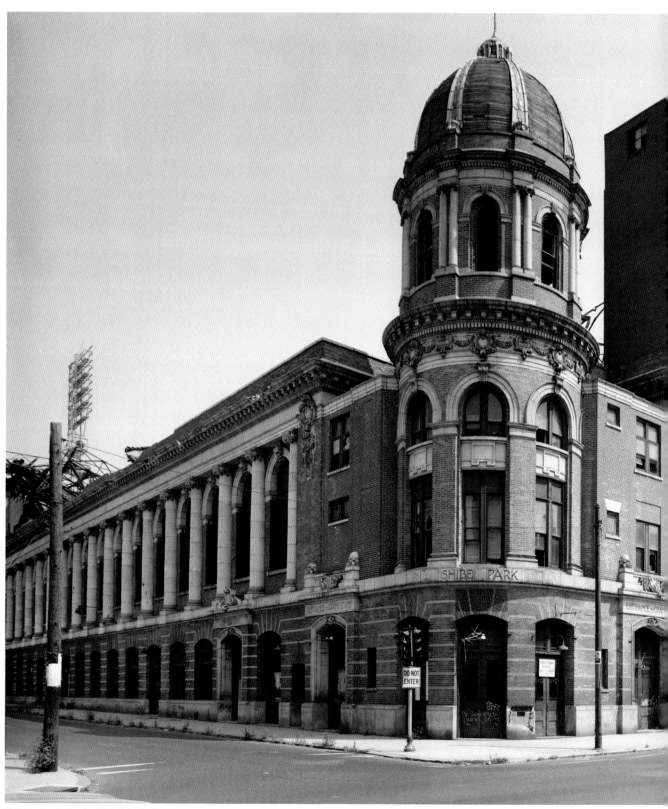

PHILADELPHIA, PENNSYLVANIA, 1973

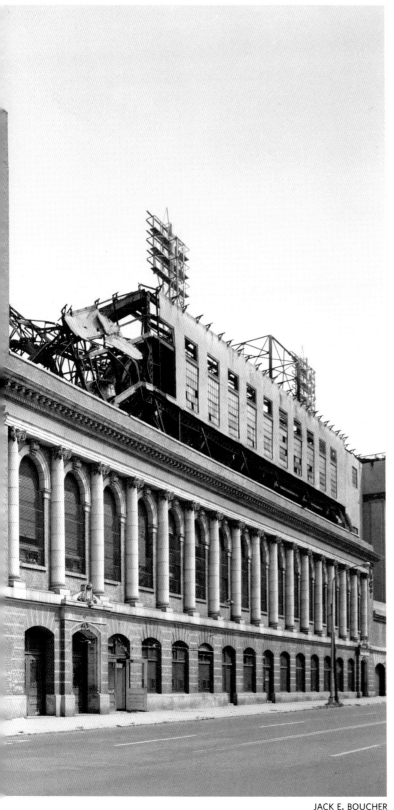

JACK E. BOUCHER

Imagine a baseball stadium built in the Beaux-Arts style with graceful arches, bas-reliefs and cartouches jutting out of its brick and terra cotta walls. That's Shibe Park, described as the "baseball showplace of the country" by Philadelphia's *Evening Bulletin* when it opened in 1909 in the Swampoodle neighborhood, about three miles north of downtown.

Early baseball stadiums—Sportsman's Park and Forbes Field (1909); Comiskey Park (1910); Griffith Stadium and the Polo Grounds (1911); Crosley Field, Tiger Stadium and Fenway Park (1912); Ebbets Field (1913); and Wrigley Field (1914)—were built in city neighborhoods and designed to fit in during and after the baseball season.

Shibe Park was one of the nation's first concrete and steel stadiums. Built for baseball, Shibe (later known as Connie Mack Stadium after the owner-manager of the Philadelphia Athletics) was the A's home until 1954, when the team moved to Kansas City. It was also the home of the Philadelphia Phillies starting in 1938 and Philadelphia Eagles football team from 1940 to 1958. And it hosted three Negro League World Series.

The final game at the stadium was played in October 1970, when the Phillies hosted the Montreal Expos. Fans knew this was Shibe Park's last hurrah. "The game was only an afterthought," recalled Phillies fan Bob Wolff. By the fourth inning, he and others started dismantling the stadium. "People were taking anything that could be detached from the stadium," he said. "Chairs, railings, signage, urinals." Phillies faithful flooded the field at the end of the game, ransacking the dugouts and tearing apart the rain tarp. "It was time to go," said Wolff, who took a couple of seats home.

The next year, the Phillies moved to new Veterans Stadium, about seven miles straight south on the other end of town. Shibe Park was torn down six years later.

89

The Bronx Third Avenue Elevated Line once ran more than five miles north-south from 143rd Street in the South Bronx past Bronx Park to the top of the borough. The line, part of the city's earliest transit systems, dated back to the 1880s, when steam trains journeyed along the tracks. As originally built, the line was a vital link between the Bronx and Manhattan. But as automobiles took over New York's streets, the Bronx line started to lose money. Whole sections were decommissioned.

By the 1970s, New York political leaders were eager to get rid of elevated lines. Rusty old train cars were noisy and disruptive, city officials argued, and the superstructure of the tracks cut off light in the streets, making it hard to run a business or live nearby. El lines often served as a barrier between neighborhoods, they said, and contributed to the relentless downfall of the Bronx.

Mayor John Lindsay declared that elevated lines were "one of the cancers of the city." His first target was the Bronx El. The city closed the line in 1973 and tore down the tracks four years later. Sixty new air-conditioned express buses replaced the trains. Buses made more stops but took twice as long to make it through the borough.

HABS photographer Jack Boucher documented the length of the Third Avenue Elevated Line through the Bronx over two months in 1973 and 1974. This photo is south of the 169th Street Station in the middle of the Bronx.

Just a few days after the last run of a Third Avenue Elevated train, the *New York Times* questioned the decision. "Will we or our successors cry when this happens? Who knows?"

BRONX, NEW YORK, 1974

JACK E. BOUCHER

Nearly two centuries of U.S. history played out behind this stone wall at Peltz Street and Gray's Ferry Avenue, a mile southwest of downtown Philadelphia.

Built around 1800 on the eastern shore of the Schuylkill River, the arsenal was first used as a storage depot. Lewis and Clark were outfitted here before their expedition out West. This was where the U.S. government stored tribute money that was shipped by frigates to Barbary Coast pirates in North Africa in return for the safe passage of U.S. ships on the Mediterranean. Firearms and ammunition were stored at the arsenal before being given to Native American tribes in return for land and peace.

After the War of 1812, the building took on other uses. Starting in the Mexican-American War, workers (mostly women) manufactured coats, shirts, trousers, pantaloons, stockings and shoes for U.S. soldiers as well as blankets, bedding, tents and flags. They worked at the arsenal or at home making the goods on a per-piece basis. During the Civil War, a legion of 10,000 seamstresses and tailors produced Union Army uniforms.

After the Korean War, the eight-acre arsenal once again became a storage facility. It was declared excess property by the federal government in the late 1950s. Few mourned its loss, although the *Philadelphia Inquirer* editorialized in 1958: "In the light of the considerable history associated with the site, some consideration should be given to the possibility of preserving it at least in part as a national landmark. Battlefields and the sites of great encampments are not the only areas that should be set aside."

The depot closed in 1961. All 23 buildings were demolished two years later when the property was bought by the Philadelphia Electric Company. But several blocks of its stone perimeter wall, including this corner, remain.

PHILADELPHIA, PENNSYLVANIA, 1958

THEODORE F. DILLON

CUMBERLAND, MARYLAND, 1970　　　　　　　WILLIAM EDMUND BARRETT

PHILADELPHIA, PENNSYLVANIA, 1965 — JACK E. BOUCHER

Above: One of the earliest U.S. buildings modeled after ancient Egyptian architecture was constructed in 1836 as part of a Philadelphia prison. It was a special wing of the Moyamensing Prison that was built strictly to jail debtors. The cruel practice of jailing people who would not make payments ended a few years later, but the wing remained.

The foreboding Debtors' Wing was designed by Thomas U. Walter, who went on to build the U.S. Capitol dome. During a time when Americans were becoming intrigued by Egyptian architecture, Walter based his design on an ancient temple.

The interior of the wing was converted and used to house female prisoners. H.H. Holmes, America's first known serial killer whose life was chronicled in Erik Larson's book *The Devil in the White City*, was jailed down the hall in "Old Moya" and executed there in 1886. The Smithsonian Institution acquired fragments of the Debtors' Wing when it was torn down in 1968.

Left: The Queen City Hotel, designed by railroad architect Thomas N. Heskett, was built in 1872 by the Baltimore and Ohio Railroad for passengers in Cumberland, Maryland, who needed overnight accommodations as they switched trains. In its heyday, the Queen City was a showplace with 174 rooms, a huge dining room and banquet hall as well as formal gardens. It was one of the nation's last great railroad hotels. The Queen City closed in 1964 as train travel decreased. It was severely damaged by fire five years later. Wrote author Dianne Newell: "It was, for everyone who knew it, a landmark."

QUEENS, NEW YORK, 1966

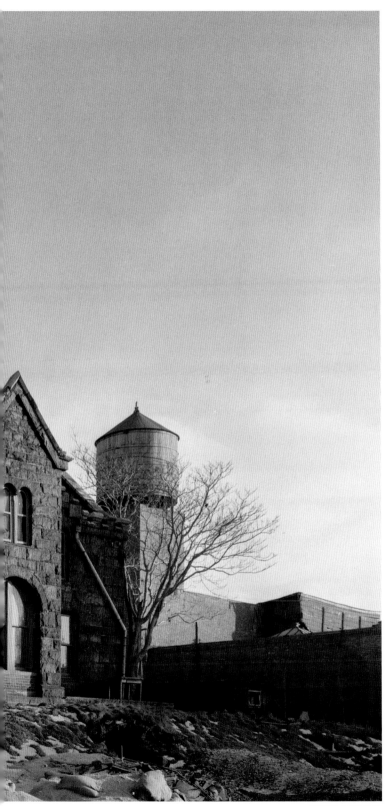

JACK E. BOUCHER

The Bodine Castle sat atop a hill in Queens, facing the East River and Manhattan. It was the last of the East River mansions in the once-fashionable neighborhood of Ravenswood.

Like any castle built in America, the Bodine place was replete with tales. The *New York Times* reported in 1894 that the Gothic Revival mansion was rumored to have been the headquarters of a French secret society, with covert panels that led to underground tunnels. The 1936 *Long Island Sunday Press* and 1940 *Brooklyn Eagle* detailed legends of an underground dungeon. According to stories, owner John Bodine kept his daughter locked up because she was flirting with workers on the property. Other tales had it that Bodine kept his wife in the castle tower for the same infraction.

What is documented is that Bodine was a prosperous wholesale grocer who bought the castle in the mid-1800s, a few years after it was built. Building castles was a fad among the super-rich during those years. It imbued kingship and suggested security.

Bodine later served on the board of a local bank, ran for mayor of Long Island City in Queens, and died in 1887. Public records indicate that Bodine was married and had one son. (No mention of a daughter.)

By the twentieth century, the house found itself in the shadows of the Queensboro Bridge, which connects Queens to Midtown Manhattan. The waterfront neighborhood became more and more industrialized. By 1965, Consolidated Edison, which had purchased the mansion, opened its Ravenswood Generating Station near the Bodine property.

That same year, the castle was nominated for city landmark status. Con Edison opposed the designation. The electrical company's attorney called the castle "a freak of architecture . . . better forgotten."

And that's just what happened. The house was razed in 1966.

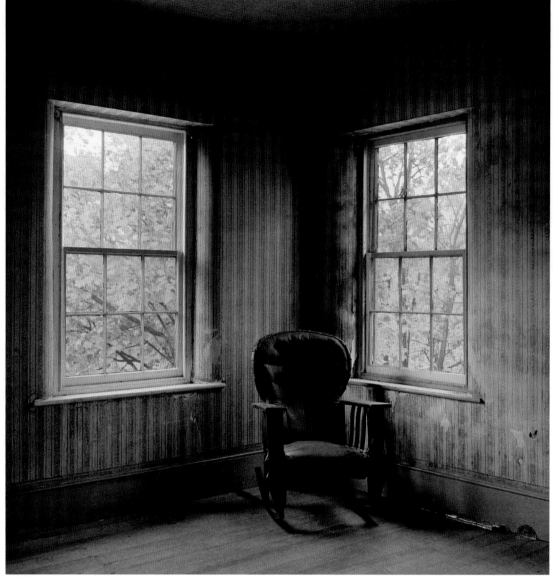

BERNVILLE, PENNSYLVANIA, 1975 — ANTHONY BLEY

Above: The 1850s South Bernville Hotel was a reminder of the days when coal and lumber were shipped on barges along the 80-mile Union Canal through southeastern Pennsylvania on the way to Philadelphia. The photo shows a second-floor bedroom of the longstanding hotel. The Bernville became a rooming house. It was razed in 1977 to make way for a flood control project by the U.S. Army Corps of Engineers.

Right: It's not a mirror but a view of two front rooms taken from the entrance hall of a home built by a man named Moses Yale Beach. He made his money as an inventor and went on to create the Associated Press news service. The 1850 house, by New Haven architect Henry Austin, was demolished more than a century later. Its front porch columns were saved and are displayed in a bank on Main Street in Wallingford.

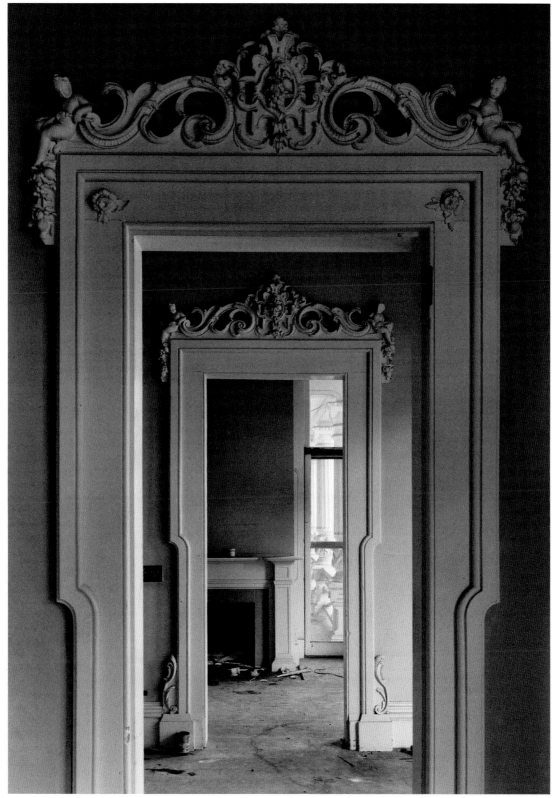

WALLINGFORD, CONNECTICUT, 1960 CERVIN ROBINSON

This Japanese language school in Tacoma was shut down soon after Japan's 1941 attack on Pearl Harbor.

It was one of fifty schools built before World War II in the western states to help keep alive the Japanese language and culture. All the schools in Washington, Oregon and California were closed because whites feared teachers at the institutions were inculcating allegiance to the Japanese Empire.

The *Nihon Go Gakko* was designed by prominent local architect Frederick Heath and built in 1922 by Japanese immigrants and their descendants who were born in the United States as U.S. citizens. Children attended the school just southwest of downtown Tacoma following their regular public-school days. The language school also served as a community center, offering arts and crafts as well as English language classes for adults.

President Franklin D. Roosevelt's Executive Order 9066 in early 1942 forced about 1,000 Tacoma residents of Japanese descent (and more than 120,000 in West Coast states) from their homes. This language school was used as a registration center before men, women and children were sent by train to incarceration camps, many for the duration of the war. Some used the school basement to store belongings.

Only about 150 Japanese Americans returned to Tacoma after the war. A few lived in the school building as a temporary hostel. The school never reopened.

By the 1990s, when John Stamets photographed this classroom and its lesson plan, the building was in disrepair. It was purchased by University of Washington Tacoma in 1997. After the school building was labeled a safety hazard, the Tacoma Landmarks Preservation Commission approved its demolition despite a letter-writing campaign. The three-story, wood frame building was torn down in 2004. A sculpture marks the site.

TACOMA, WASHINGTON, 1994

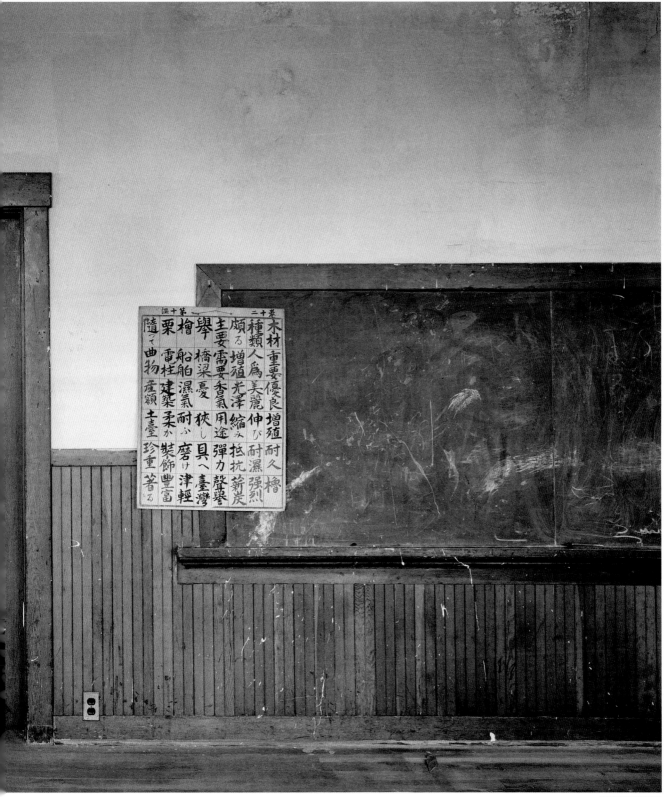

JOHN STAMETS

CAHABA, ALABAMA, 1934

W.N. MANNING

The Methodist Church in Cahaba was built in 1848 by enslaved African Americans for a white congregation. Its steeple rose 45 feet above a once-vibrant town of 2,000.

Cahaba was the first state capital of Alabama. It was also the county seat. For many white people, life was comfortable before the Civil War. In the center of the state, the town was a cotton-loading stop on the Alabama River and could be reached by a new railroad line. But the war changed the city's fortune. The line was rerouted and a flood swamped the city in 1865. The following year, the county seat was moved to Selma. The town's population, which once reached 2,000, dropped precipitously. By 1870, only about 300 Black people and 100 white people lived in town.

The Black residents who stayed transformed much of downtown Cahaba into farmland and established their own churches and schools. They purchased this Methodist church in 1868 and converted it to the Colored Methodist Church, according to the HABS report. At the same time, a group of freed African Americans took over the abandoned county courthouse for political rallies and created what was called the "Mecca of the Radical Republican Party" by a Selma newspaper.

"These were people on the front line of the civil rights movement," said Linda Derry, director of a state-run archaeological park in Cahaba. "They were getting their first taste of freedom, seeking out a chance to vote." Their fight for equality ended when Reconstruction Era reforms were reversed in the mid-1870s.

By the 1930s, the city was nearly deserted. "Now Cahaba is one of Alabama's dead towns," wrote E. Walter Burkhardt, HABS district director, in 1936. Only a few old houses and this one church remain." HABS photographer W.N. Manning placed an identifying number on the back wall of the church, common in the project's early photos.

The church burned to the ground in 1954. "Whites say it was lost in a controlled burn," said Derry. "There are Blacks who question this. They wonder if it was done on purpose."

A remnant of southern Arizona's frontier years.

This structure was near Arivaca, about sixty miles southwest of Tucson and ten miles north of the Mexican border. It's classified by architects as a "Sonoran rowhouse," a type of home built in the Sonoran Desert during the last half of the nineteenth century. These one-story rowhouses were made of exposed mud adobe block or brick.

"All the houses were constructed by Mexicans or Mexican Americans," said local historian Mary Kasulaitis. The homes were built when Arizona was a territory of the United States, but they were based on the building traditions of Mexico.

They were rudimentary and rectangular with shared walls. And they were inexpensive to build because making mud bricks was straightforward. Needed clay and straw were free and easily available. Yet the adobe would melt in the rain if not coated correctly or if the flat wood-framed roofs were not properly finished.

These rowhouses were likely built in the 1870s or 1880s, said Kasulaitis, when gold and silver mines were operating in the area. Men of Mexican descent worked in the mines or on nearby ranches. When the mines played out, some of the miners stayed, she said.

At least five Sonoran style rowhouses remain in the tiny town of Arivaca, although most have been modernized. The walls of each are thick enough to provide protection from the heat and the cold. Most units have a chimney.

HABS photographer Frederick D. Nichols roamed the Southwest for three years in the late 1930s documenting churches, missions, houses, military installations, police stations, mills and the remains of Native American buildings. He was a trained architect who showed a special interest in the influence of Mexican architecture.

ARIVACA, ARIZONA, 1938

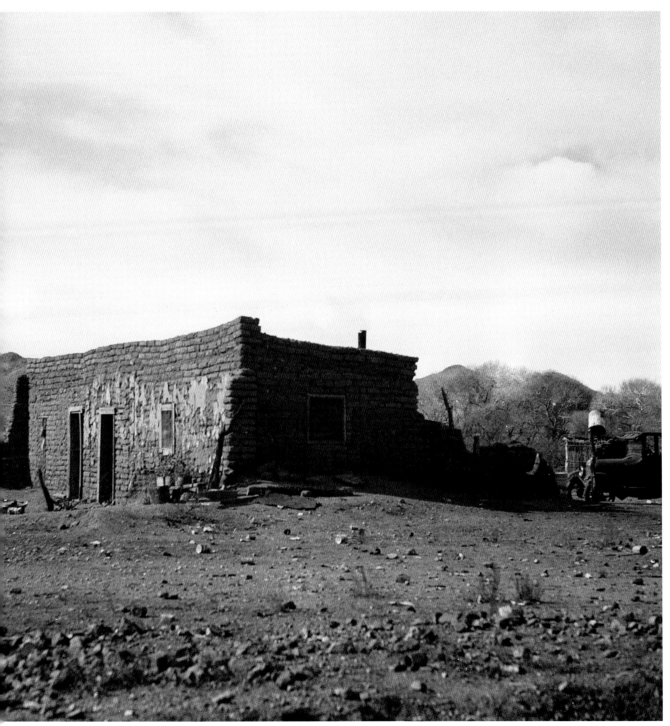

FREDERICK D. NICHOLS

WHITE SHIELD, NORTH DAKOTA, 1952

JOHN A. BRYAN

The Army Corps of Engineers flooded this Native American dance lodge and submerged it in an artificial lake on the Fort Berthold Indian Reservation in western North Dakota during the 1950s. "It's in the bottomlands," said Gary Dickens, a member of the Mandan, Hidatsa and Arikara Nation. He was a boy when the lodge was submerged. In 2022, Dickens drove around Fort Berthold Indian Reservation to ask elders for confirmation of what had happened.

The old Round Hall lodge was one of the last Indigenous-made dance halls in the United States when it was destroyed to create Lake Sakakawea, a huge, man-made reservoir.

The thirteen-sided lodge made of cottonwood logs was built in 1921. "It was round because Indians tend to dance clockwise in a circle," said Dickens. "In that way we can see our whole community." Its roof was sagging when it was photographed by HABS.

The reservoir was part of the government's Pick-Sloan Missouri Basin Program to tame the upper Missouri for flood control, irrigation and hydroelectric power. The project wiped out the best farmland on five Indian reservations. "The Pick-Sloan Plan was, without doubt, the single most destructive act ever perpetrated on any tribe by the United States," wrote historian Vine Deloria Jr., a Standing Rock Sioux.

At the time, tribal members protested. Fort Berthold Indian Tribal Business Council Chairman George Gillette, who was forced to consent to the plan, was shown weeping in a famous photograph as his tribe was forced to sell 155,000 acres to the U.S. government.

"We will sign this contract with a heavy heart," he said in 1948. "With a few scratches of the pen, we will sell the best part of our reservation. Right now, the future does not look too good for us. We are worried and we wonder whether everything will come out all right in the end."

Indians lost their homes, their towns and their ancestral burial grounds. "The lake divided our reservation," said Gary Dickens. Lake Sakakawea, which could not be crossed by bridge, disrupted traditional life. About 1,700 residents of the reservation, 80 percent of the population, were relocated, he said, including his family.

As for the lodge, Dickens said: "We really don't know what we lost until we've lost it."

HANNIBAL, MISSOURI, 1982 RICHARD CERRETTI

Above: The 1910 Robinson Mortuary Building was a vestige of a thriving Black business district in Hannibal. "If preservation efforts by local citizens are not successful," warned the Missouri Department of Natural Resources, "this extremely important building will be replaced with a supermarket." And it was.

Right: Stairs to the five-story tower of the 1899 U.S. Courthouse & Post Office in La Crosse, designed by government architect William A. Freret. "Let's admit it. The building has character," wrote Myer Katz, president of the La Crosse County Historical Society. Despite a late effort to save the building, it was demolished in 1977.

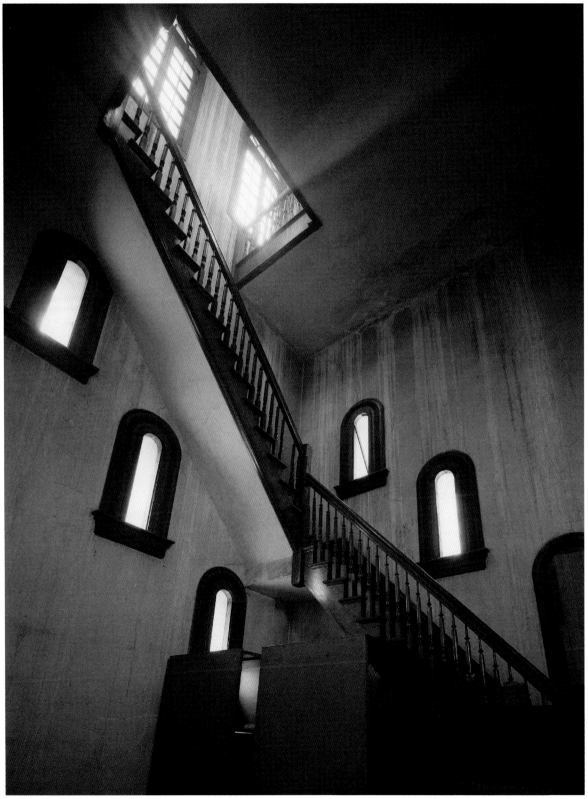

LA CROSSE, WISCONSIN, 1977 CHARLES AUERSON

Commuter train stations might not be large and grand, but they are essential to establishing the identity of suburban towns. Stations serve as "the symbolic entry or gateway to the adjacent city, town or village," wrote architecture professor Jeffrey Karl Ochsner. And they help keep suburbs alive. This picturesque two-story brick station, which opened for commuters in 1875, was a defining part of West Chester, Pennsylvania.

That's why West Chester residents put up a fight when Pennsylvania Railroad announced plans to tear down their Market Street Station in 1966.

Penn Railroad officials told a local newspaper reporter that the station was outmoded and deteriorated. The railroad offered to build a new station, yet the city resisted, saying that tearing down the historic building would damage the community's development plans.

The station was razed two years later, replaced by a small, frame building. The demolition was the beginning of the end for commuter rail travel to and from West Chester, about 35 miles west of Philadelphia. In 1986, the Southeastern Pennsylvania Transportation Authority ended train service to the town. The reason: the old tracks were too expensive to maintain for the few West Chester riders. After 154 years of continuous service, West Chester was left without a train.

Ned Goode, who took just one photo of the station's interior, was a commercial photographer who documented the borough since the late 1940s. He contributed more than 300 photographs to the HABS archive, photographing West Chester extensively and traveling throughout New England.

Ever since the 1980s, West Chester leaders have been trying to bring back commuter trains. But track reconstruction, a new signal system, the replacement of bridges and a new station with parking is now estimated to cost at least $300 million.

WEST CHESTER, PENNSYLVANIA, 1962

NED GOODE

SALISBURY, NORTH CAROLINA, 1979　　　　　　　　　　　　　　　　　　　　JOANN SIEBURG-BAKER

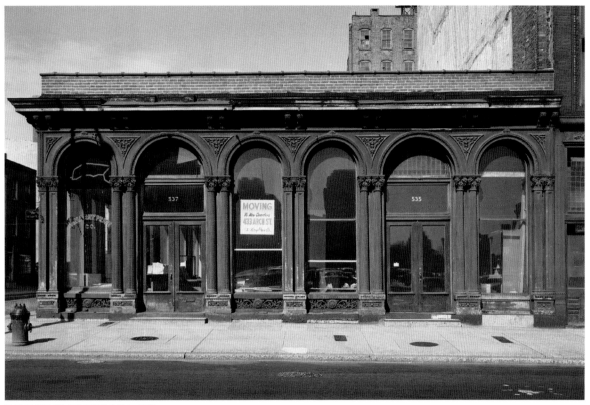

PHILADELPHIA, PENNSYLVANIA, 1958

Cast iron became a favorite building material in the mid-1800s. Formed in molds, the iron used for constructing exterior walls was light and strong, easy to shape, durable and fire resistant. The metal was less expensive than stone and could be painted to look remarkably like stone. With cast iron purchased from factories, builders could create ornate facades that gussied up their austere steel-framed buildings.

Above: Buildings decorated in cast iron filled the commercial district in Philadelphia near historic Independence Hall. The Schenck Building, constructed around 1870, was one of nearly 150 structures torn down to create an immaculate setting for Independence Hall. More than three blocks of nineteenth- and twentieth-century buildings—stationery shops, men's clothing stores, luncheonettes, offices, wholesalers and light manufacturers—were razed in the 1950s by the National Park Service to shape the Independence National Historical Park. The Schenck Building, originally six stories tall, was razed in 1959.

Left: Decorative cast iron adorned the entrance to the 1907 Swaringen Wholesale Grocery in downtown Salisbury, North Carolina. The lower left plate shows the building was a "Mesker," fronted by cast iron made by companies owned by the Mesker brothers. Their factories provided small-town builders in every state with architectural iron work. This store was converted into apartments by 1980. Ironically, it was torn down soon after the city created a historic preservation commission.

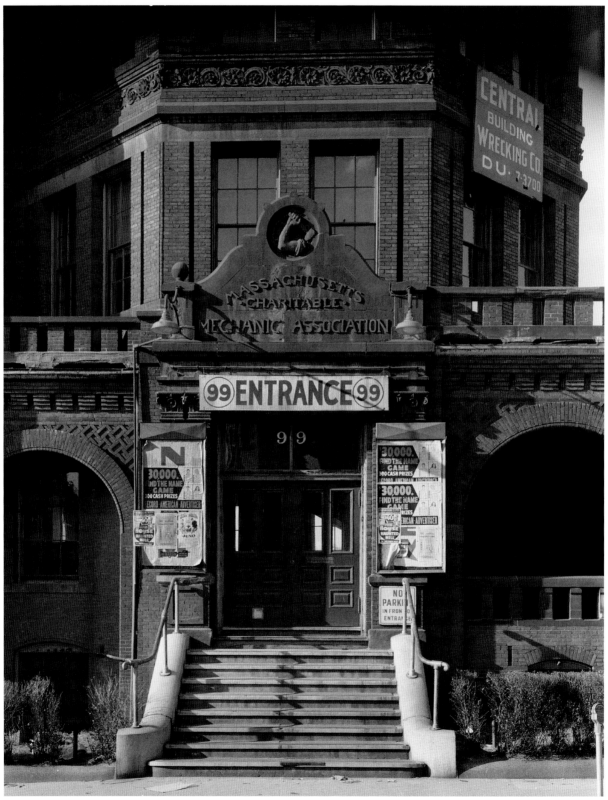

BOSTON, MASSACHUSETTS, 1959

CERVIN ROBINSON

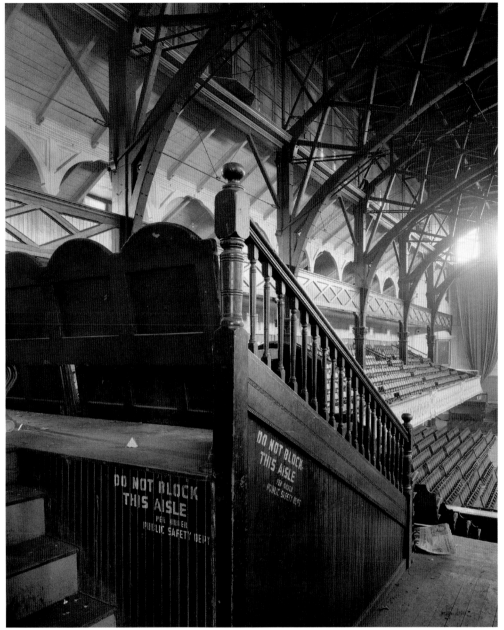

BOSTON, MASSACHUSETTS, 1957 — CERVIN ROBINSON

Boston's Mechanics Hall, once the nation's largest building, was demolished in 1959 to make way for the Prudential Center complex. Designed by William G. Preston and built in 1881 about a mile southwest of Boston Common, the Mechanics building's huge grand hall (at right) was used for boat and auto shows, indoor roller skating, wrestling matches, political rallies, track meets, flower shows and carnivals. This was where Ted Williams taught Bostonians the art of fly casting during the off season. "Ask anyone who lives in Metropolitan Boston about the Mechanics Building and you'll probably get an anecdote," wrote the *Boston Globe*.

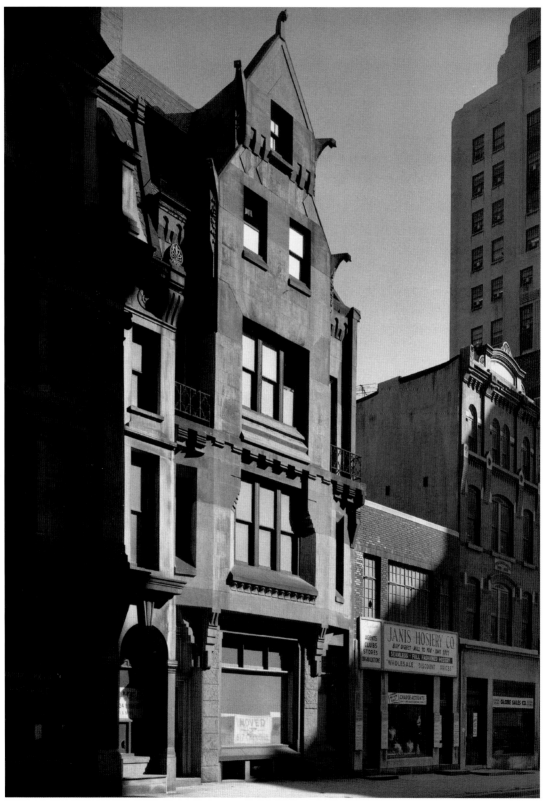

PHILADELPHIA, PENNSYLVANIA, 1959　　　　　　　　　　　　　　　　　　　　　　CERVIN ROBINSON

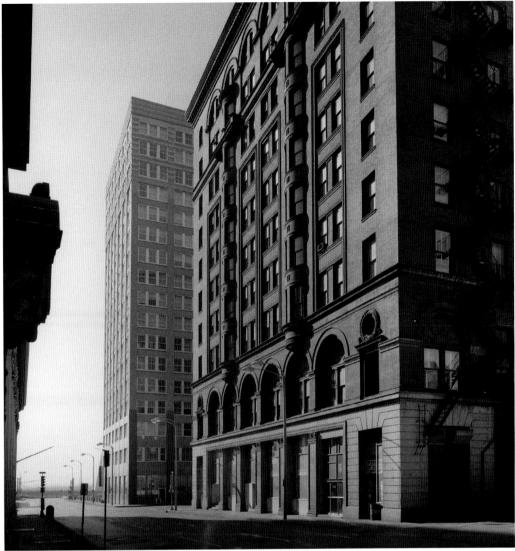

ST. LOUIS, MISSOURI, 1972 ROBERT PETTUS

Above: The imposing 1894 Planters House Hotel, once the largest and finest hotel in St. Louis, boasted 400 bedrooms and a staff of 300 in its heyday. But following World War I, it was converted into the Cotton Belt office building. It cast a long shadow on its streetscape until 1976, when the Planters House was torn down for an even taller high-rise. The structure to the north was the Pierce Building, which has been radically altered into what is now the Hyatt Regency Hotel just west of the St. Louis' Gateway Arch.

Left: This eccentric, updated Victorian building—the 1881 Reliance Insurance Company—was another victim of Independence National Historic Park in Philadelphia. New York architect Philip Johnson protested, declaring that Frank Furness, the building's designer, was the city's greatest all-time architect. "Furness was a giant among pygmies," Johnson wrote just before the Reliance was razed. "He lived at a time when architecture was not appreciated, and he had the strength to go against his entire generation."

BUFFALO, NEW YORK, 1965

JACK E. BOUCHER

The Kremlin Building was a beehive since the day it opened in 1855.

Busy stores and offices filled its four levels. They wrapped around a 1,000-seat Kremlin Hall auditorium that played a conspicuous role in the city's history. It was here that Frederick Douglass and William Lloyd Garrison delivered fiery speeches calling for the abolition of slavery and here that Buffalo residents gathered when news came that Fort Sumter was surrendered to Confederates in 1861.

"Crowds swarmed to a public meeting in the evening, overflowing first the Court House, then Kremlin Hall, and finally massing in the public street," wrote Buffalo historian Winfield Scott Downs. Rallied by former President Millard Fillmore, one of Buffalo's own, men volunteered at once to fight. The Civil War had begun.

A century later, the Kremlin Building—with its curious name—was fully occupied when it was marked for destruction. Hundreds of downtown buildings, mostly small shops and offices were razed during the 1960s to create a new downtown. Some were exuberant that the city's nineteenth-century past was being erased. "The wonderful sounds peculiarly identified with old buildings coming down and new buildings going up finally filled the air," wrote Bob Watson, a reporter for the *Buffalo Evening News*. "There will be more of this in 1964, still more in 1965 and 1966 when the rebuilding of downtown, particularly along Main Street, reaches its peak."

Yet old buildings like the Kremlin are essential to cities. Long ago paid off, these structures have less overhead than brand-new buildings and can charge lower rent and support businesses that help create thriving cities, wrote acclaimed urbanologist Jane Jacobs. "Chain stores, chain restaurants and banks go into new construction," she wrote. "But neighborhood bars, foreign restaurants and pawn shops go into older buildings." Cities, she asserted, need both.

The Kremlin was torn down in 1965 to make way for a shopping area named Main Place Mall. Like many downtown malls, it has been a long-term failure.

PHILADELPHIA, PENNSYLVANIA, 1958 CERVIN ROBINSON

Above: The Beck-Care Warehouse was the last of Philadelphia's eighteenth-century distribution centers on the city's Delaware River waterfront. Despite being fifty miles from the Atlantic Ocean, Philadelphia was the first major shipping port in America. The warehouse was razed in 1967 to make way for Interstate 95, which sweeps north-south on the eastern edge of Philadelphia.

Right: Pittsburgh was on its heels. Its downtown had become a red-light district of run-down bars, porn shops and massage parlors.

In the early 1980s, a small group of residents reclaimed the city. Armed with the resources of three major philanthropies, they created the Pittsburgh Cultural Trust that bought property (including two vintage theaters), built small urban parks, and cleared out buildings that were deemed nonessential. The effort revitalized fourteen blocks in the heart of Pittsburgh. It was art and architecture—with a heavy dose of real estate expertise—to the rescue.

Instead of leveling the area, they curated their buildings to create a cultural district that attracted people and development. The Loyal Order of Moose Building didn't make the cut. When it opened in 1915, the *Pittsburgh Gazette Times* declared it was the city's best Beaux-Arts building. Yet now it stood between the two vintage theaters that each needed more parking. "The demolition of the Moose Building was a major loss for downtown Pittsburgh and historic preservation," declared one preservationist. But overall, the rescue worked. The reborn downtown is the key to why Pittsburgh is called one of the "most livable cities" in America.

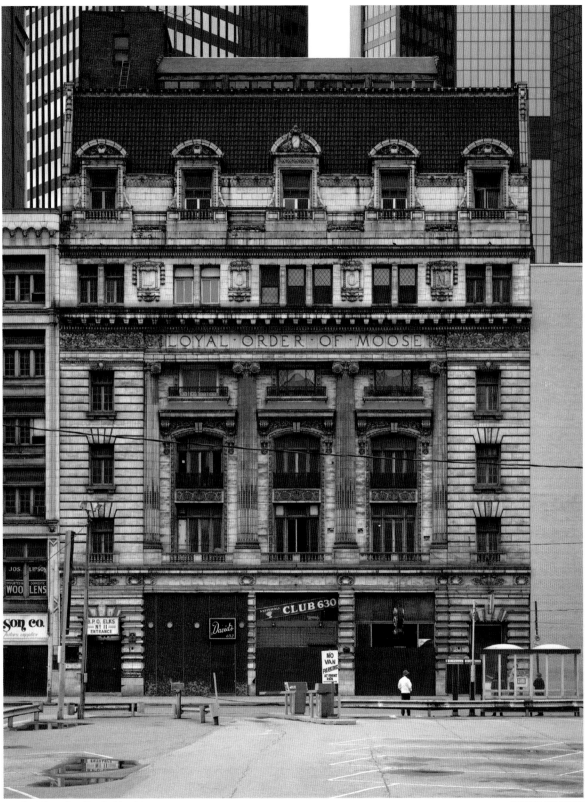

PITTSBURGH, PENNSYLVANIA, 1984 — DENNIS MARSICO

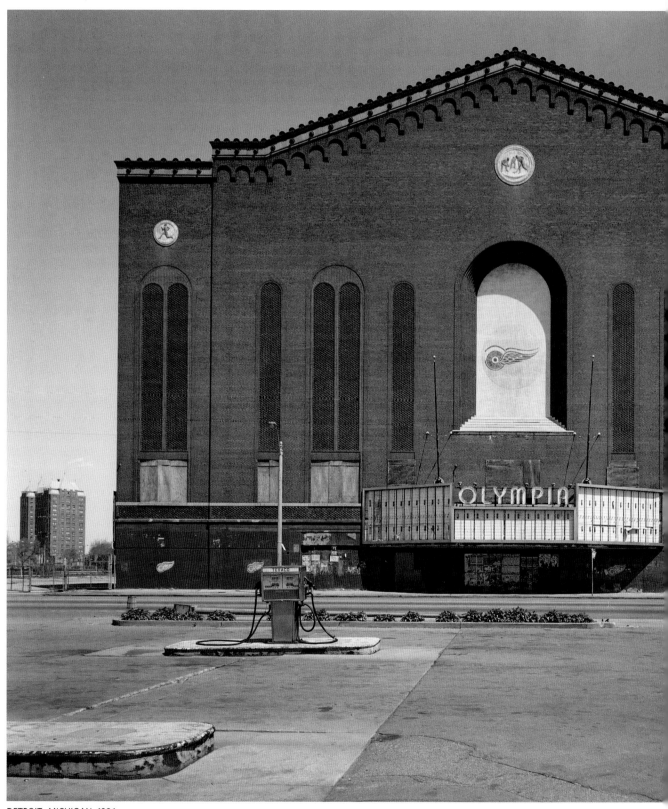

DETROIT, MICHIGAN, 1986

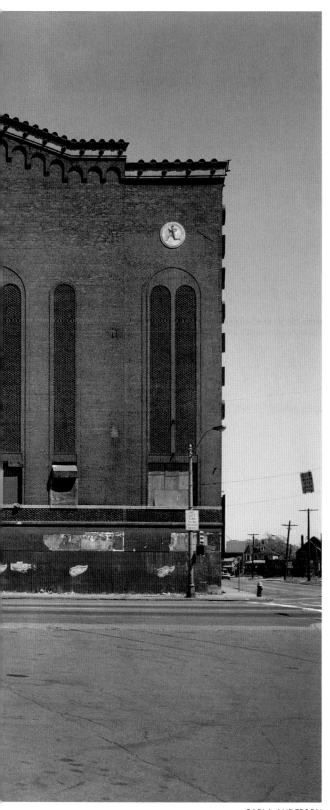

CARLA ANDERSON

When the wrecking cranes showed up at Detroit's Olympia Arena in 1986, several members of the Detroit Red Wings hockey team returned for one last look. The abandoned stadium, built in 1927, was almost pitch black when the long-retired players arrived and made their way through what was known to fans for decades as "The Old Red Barn."

The players found their old Red Wings bench and paused at what had once been center ice. Marcel Pronovost, who played for the team throughout the 1950s and some of the '60s, located the old locker room. "This was our spot," he said.

The arena was the first of the National Hockey League's Original Six stadiums to be demolished. The Olympia was more functional than elegant. It was a stack of bricks except for its lacy black cornice. The arena couldn't hold on because the neighborhood around it was deteriorating. The team moved downtown to the Joe Louis Arena in 1980.

Charles Howard Crane, the arena's architect, also designed the city's grand Fox Theatre, Orchestra Hall and the Opera House. Like most big-city venues, the Olympia hosted everything from rodeos to rock concerts. Elvis Presley played seven concerts there, the Beatles four. The Detroit Pistons basketball team called the Olympia home for four years, but the stadium was always known best for the Red Wings.

The Wings played their final regular-season game at the barn in 1979 yet returned for one last game the next year. The ticket read: "Olympia's Last Hurrah. The Old-Timers vs. the Detroit Red Wings." The result was almost predestined. The Great One, Gordie Howe, the team's right winger from 1946 to 1971, scored the final goal.

He was one of the players who returned to the dark stadium six years later. After he saw the stadium one last time, he told reporters: "It was rough."

PART 3

DISGRACED

America has lost and is continuing to lose its architectural wealth. Much of our heritage is crumbling away before our eyes—some falling prey to the wrecking ball, but more perhaps to wanton destruction.

—Jack Boucher,
HABS photographer

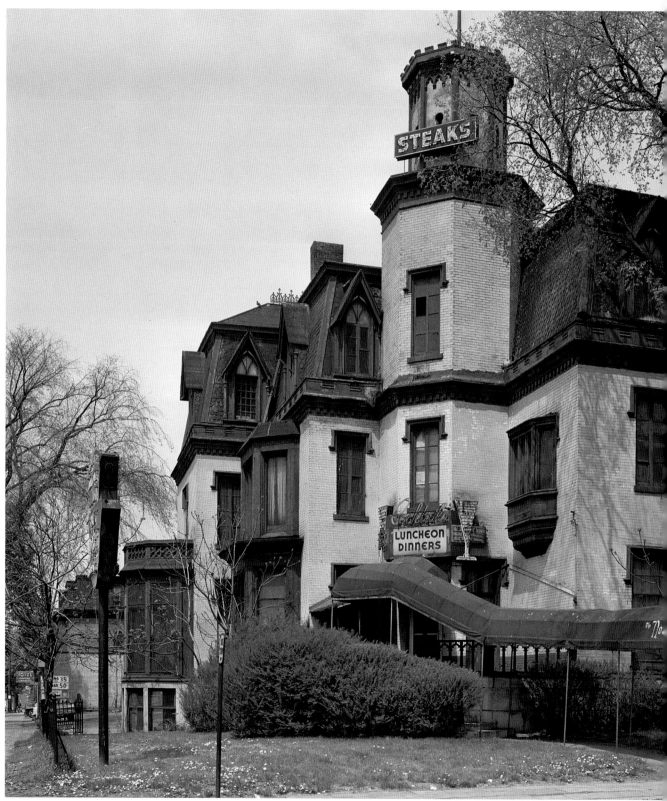

BUFFALO, NEW YORK, 1965

JACK E. BOUCHER

The sign at the turreted top of what was once one of Buffalo's most ornate mansions was an omen that the building's days were numbered. The advertisement was installed around 1955, when the Cary House was turned into the Normandy Restaurant.

Old buildings can have many lives. Homes are converted to commercial use, armories are reborn, buildings are rehabbed over and over again. They hang on, at least for a while.

The Normandy Restaurant had closed when Jack Boucher photographed the mansion, signs and all, for the Historic American Buildings Survey. Government photographers seldom had the opportunity to return to an individual building over time. However, their photos do show all stages of building life: from the prime years to the final days.

The changing city was the focus of many HABS photographers.

"A huge red 'Checks Cashed Open 24 Hours' billboard splashes across what once, clearly, was an elegant movie theater in the Art Deco style," wrote *Boston Globe* architectural critic Robert Campbell, describing work by HABS' Cervin Robinson—or any photographer working for the survey. "An auto body shop, with a phony castle-like facade, shoves itself rudely in front of a decayed object that appears once to have been a grand memorial arch. As we perceive such scenes, we visually peel back the present to reveal the past."

Buildings like the Cary Mansion were time capsules. The three-story Empire Revival style Cary house along with eleven neighboring homes in downtown Buffalo were tagged to be torn down the year this photograph was taken.

The Cary was built in 1851 along Millionaire's Row for the family of Walter Cary, a prominent physician, and wife Julia Love Cary. Their family filled the home until the 1930s, when the Cary heirs rented out the building for what turned out to be a series of restaurants. But the home's grandeur—its carved paneling, colossal chandeliers, parquet floors, leaded glass windows and fireplaces in almost every room—remained.

A concrete sixteen-story government office building replaced the home. The new Thaddeus J. Dulski Federal Building didn't last long. It was sold in 2005 to a developer who gutted the structure to its steel framework and remodeled it into the Avant, a combination hotel-office-condominium complex.

Once again, people are living at Delaware Avenue and Huron Street.

127

Take a look at the mismatched windows running along the first-floor gallery near the entrance of Frank Lloyd Wright's Geneva Inn. Times had changed since the hotel, originally known as the Hotel Geneva, opened in 1912. In the 1920s and '30s, the hotel was called the "Newport of the Midwest," complete with a marina, golf course and dance hall. But the block-long, 70-room resort passed through the hands of many owners. Each made changes. Not for the better.

The block-long hotel was designed with many of Wright's Prairie School touches. With a low-pitched roof and overhanging eaves, the hotel was noted for Wright's long rows of leaded-glass windows, terraces and porches as well as his trademark semi-circular brick fireplace.

In the 1940s, the hotel's Cavern Bar was raided several times. It was a horse-racing gambling operation and casino. A new swimming pool was built near the entrance in the 1950s and much of the lobby was turned into a bar. Over the years, Wright's interior was filled with Polynesian décor.

Once a popular destination for visitors from Chicago and Milwaukee, the Geneva Inn struggled through the 1960s. Its main dining room had transformed into "The Golden Orchid Cantonese American Cuisine." It became known for its cocktail lounge, the Inn Ferno and a discotheque called Snoopy's Lounge, which was frequently shut down by police because minors were being served there.

The Geneva closed for good in 1969. It was purchased by a businessman who removed the remaining Wright artifacts and razed the building. It was replaced—with hardly a whimper from townspeople—by a residential ten-story high-rise.

LAKE GENEVA, WISCONSIN, 1967

RICHARD NICKEL

PHILADELPHIA, PENNSYLVANIA, 1959

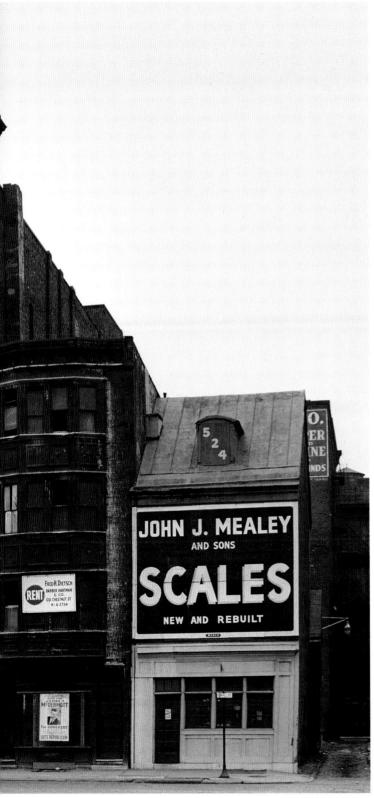

JACK E. BOUCHER

The Armory of the National Guards was yet another victim of the Independence National Historical Park in downtown Philadelphia.

The Historic American Buildings Survey, based in Philadelphia from 1950 to 1966, made a concerted effort to photograph what was being torn down for the expanding park. "HABS went around recording buildings as cultural documents, which the Park Service would then turn around and demolish," said James C. Massey, who worked in the Philadelphia office. "They [National Park Service administrators] weren't very happy about it, either. We were viewed rather awkwardly."

The armory, built in 1857 as the home of the Second Regiment, sat at the northern edge of the demolition district and was known for its second-floor "grand saloon," which was used for lectures, fairs, concerts—and drinking—during the nineteenth century.

The building was Philadelphia's focal point during the Civil War. This was the site of patriotic speeches and military parades, where enlisted troops departed or returned from battle. During the war, the National Guards building was used as a U.S. Army hospital.

The men of the Second Regiment fought for the Union as the Ninetieth Pennsylvania Volunteers Regiment. Recruitment began in September 1861. By December, 900 men had signed on. The Ninetieth took part in more than a dozen major battles including Second Battle of Bull Run, Antietam, Gettysburg and the Wilderness. Only a few hundred soldiers returned to the armory for dismissal when the company was mustered out in late 1864. Most had been killed.

After the war, the hall was rented out for functions until it was sold in 1897. It was purchased a few years later by a firm that used the old armory as a sheet metal shop. Jack Boucher started documenting the well-used structure just as wreckers were leveling the entire block.

The Illinois Regimental Armory was built to protect.

It was designed as a Gothic Revival style fortress in the 1890s to safeguard Chicago's affluent merchants and leaders who lived only blocks away on Prairie Avenue, also known as Millionaire's Row. The armory was constructed on land owned by Marshall Field, the retailer who founded the city's once-finest department store. Its cannons, Gatling guns, rifles and ammunition were reportedly supplied by railcar-maker George Pullman, meat-packer Philip Armour and their neighbors.

It was built only a few years after the Haymarket incident, in which Chicago police attempted to break up a labor rally. A bomb was thrown at officers, and ensuing gunfire killed police and rally attendees. The violence heightened fear among Chicago's moneyed elite that anarchists were plotting an uprising.

The response of the rich was to build a home for twelve companies of the Illinois National Guard in their neighborhood. Designed by the Chicago firm of Burnham and Root, the armory rose three stories above South Michigan Avenue. The only way inside was through a sally port, a secured door protected by chains and steel bars.

At the top were firing slits and battlements. "Four great bastions crown the angles of the fortress from which soldiers may deliver an enfilade fire on any side of the walls," wrote the *Inland Architect* in 1899. "The top of the walls is surmounted by a medieval cornice or parapet. Projecting as it does over the wall proper, and penetrated at the base with rifle slots, a handful of men could withstand an army."

Built to last centuries, the Illinois Regimental Armory lasted only decades. The rich pulled out of Prairie Avenue in the early 1900s and with them went support of the building. Abandoned by the National Guard in the 1940s, the building played host to auto shows, kennel club competitions, boxing matches, roller-skating marathons and roller derbies.

By the year it was torn down, the proud fort was primarily used as a giant billboard.

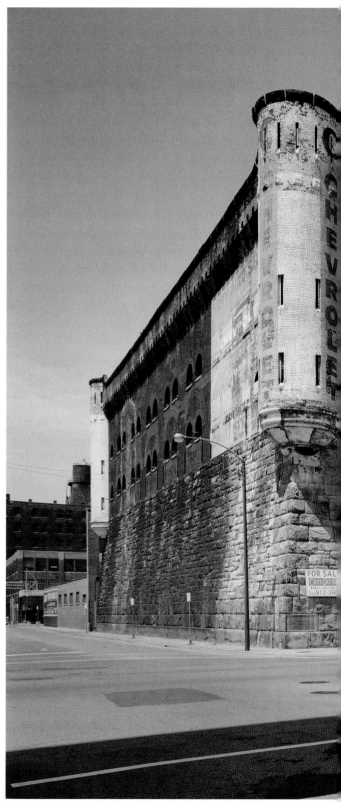

CHICAGO, ILLINOIS, 1967

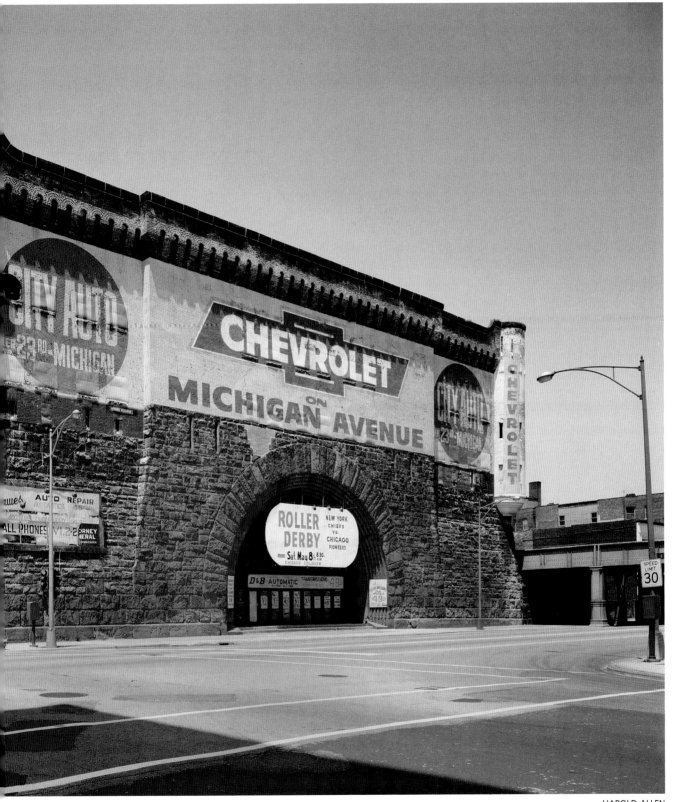

HAROLD ALLEN

These classic single-family homes were built along what was once Eighth Street, about two blocks west of Cincinnati's City Hall.

In its prime, the block was an encyclopedia of nineteenth-century residential architecture: homes that featured Queen Anne and Greek Revival styles with fanciful cornices and tall arched windows.

And yet, pigs used to run the streets of the West End on their way to Cincinnati's slaughterhouses. *Harper's Weekly* ran an illustration in 1860 showing hogs being driven past Victorian homes just like these. "A drove once started on its journey is bound, at all hazards and against obstacles, to go through," the magazine reported. There was no way to sidestep. "You may be splashed and run into, delayed and otherwise offended."

In those days, Cincinnati was known as "Porkopolis."

The running of the pigs was long over by the turn of the twentieth century. The obvious wealth that once marked the West End began to disappear as factories and warehouses packed the neighborhood. Its final blow came mid-century when Interstate 75 swept through the heart of the West End, creating a spaghetti tangle of roads that made living nearby downright dismal.

City planners marked the West End for renewal during the 1960s. These homes were designated as part of the Queensgate II Redevelopment Area. The city acquired the land between 1978 and 1983 and planned to tear down eighteen of these buildings for 298 new housing units and 120 renovated rental housing units. The historic homes were razed; the new homes were never built. Wrote the *Cincinnati Enquirer* in 1987: "The project has been marred by financial problems, bureaucratic holdups and criminal convictions."

West Eighth Street is gone. This block was removed from the map to create a parking lot for nearby office buildings. But Frisch's Big Boy restaurants remain.

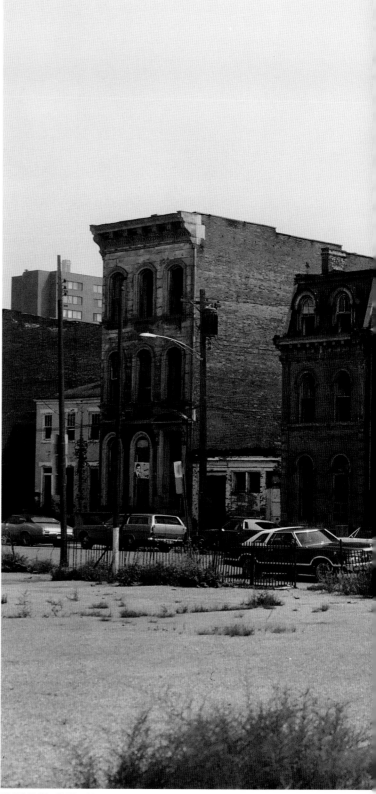

CINCINNATI, OHIO, 1994

134

ROBERT KELLER

DUBUQUE, IOWA, 1987 — CLAYTON B. FRASER

MANCHESTER, NEW HAMPSHIRE, 1981 — STEPHEN J. WHEELER

Above: The 1891 Manchester Hotel was built during an age when small cities boasted small hotels. The hotels were built mostly between 1880 and 1920 for traveling salesmen, considered the "lifeblood of the small-town hostelry." This hotel, later known as the Shea Block, was in the heart of Manchester, New Hampshire. It was cleared along with a neighboring building in 1982 to make way for a six-block redevelopment project.

Left: You can almost see the history of this building written across its front facade. Built in 1885 at the southern edge of downtown Dubuque, Iowa, as the home of a farm implement company, the four-story building later had a litany of uses: as a wholesale grocery, meat packing company, paper firm, candy manufacturer and toy factory. It became the Dubuque Seed Company in the 1930s and was a retail gift shop when photographed by Clayton B. Fraser, who documented hundreds of HABS projects. Its cast-iron first-floor storefront remained unaltered as the building changed hands, but it was razed for the expansion of a highway just as Dubuque was embracing preservation.

BALTIMORE, MARYLAND, 1981

Above: This Baltimore corner store transformed in every generation, changing its front facade to match new goods for sale. Built around 1890 and modernized in the 1950s, the store retained a bit of its original architecture: an interior timber floor, common bricks behind its dynamic exterior facing and a tin-bracketed cornice. The store was built across the street from the Lexington Market, the nation's longest running food bazaar, which dates back to 1782. The 400 block of West Lexington Street, including the Lexaco store, was razed to expand the market.

Right: Store owners often try to draw in customers with dramatic signs that beckon them to their first-floor entrance. This terra cotta high-rise, built in 1906 as the Economy Furniture Company in Scranton, Pennsylvania, was remodeled in 1949. The sign helped keep the store in business for decades, but the building was razed in 1992 along with four other stores for what is now known as the Marketplace at Steamtown.

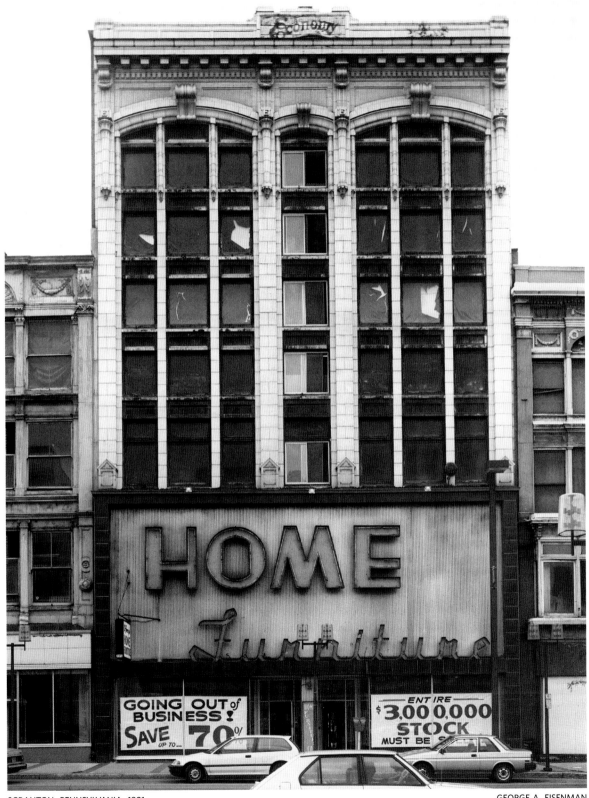

SCRANTON, PENNSYLVANIA, 1991 GEORGE A. EISENMAN

RAPID CITY, SOUTH DAKOTA, 1967 — WILLIAM C. ARTUS

A new shopping experience, the Rushmore Mall, opened in 1977, luring Rapid City's Sears, Woolworths and Penney stores to abandon the central business district for a more modern retail center three miles north.

By the 1970s, downtown Rapid City—particularly Main Street—was "a wild place." Twenty-five bars jammed the thoroughfare between Fifth and Ninth Streets. "There used to be a pole at the firehouse where we would cuff rabble-rousers, druggies and drunks until we had a car full to take to the jail," recalled former Police Chief Stanley Zakinski. "We sent multiple batches per night."

To clean up downtown, Rapid City approved an urban renewal plan that called for the demolition of five buildings on the north 600 block of Main Street, including these two structures. Both buildings, which date back to the 1920s, had been modernized with new signage, streamlined storefront windows and brick or stone facades. They were torn down for a bank building and parking lot.

The block has changed dramatically. Owners of the other buildings along Main Street have embraced the historical character of their facades. False fronts and glimmering signs have been removed. Instead of modernizing their architecture, owners have gone back to original storefront windows, installed period awnings, highlighted cast-iron columns, cleaned brick fronts and repaired metal cornices. The businesses that remain—a wine shop, jewelry store, souvenir outlet, brewery, art gallery, clothing mart, book and music store—are thriving because tourists and townies appreciate the authenticity of their "new" downtown.

RAPID CITY, SOUTH DAKOTA, 1967 — WILLIAM C. ARTUS

PITTSBURGH, PENNSYLVANIA, 1984

DENNIS MARSICO

KANSAS CITY, MISSOURI, CIRCA 1990 — CLIFF HALL

Above: The neon sign installed at the end of this innovative complex of buildings was all that was salvaged when Warner Plaza was torn down. Once advertised as "the most beautiful apartment development in Kansas City," the Warner was built in 1926 in the Midtown neighborhood as a combination of ten luxury apartment buildings and two commercial buildings with stores, offices and a hotel. By 1990, Warner Plaza was abandoned. Wrote one former resident, "The entire area was a living, breathing pulp detective novel." The site is now occupied by franchise stores. The sign headed to a downtown bar.

Left: The Deluxe Arcade and its South Liberty Avenue neighbors were replaced by skyscrapers in the revitalization program spearheaded by the Pittsburgh Cultural Trust. The Deluxe was a sex shop that presented 25-cent peep shows. The long, narrow loft was built in the 1890s for fruit and produce dealers who filled South Liberty. The area became a theater district in the early 1900s and then the hub of dry goods stores. Photographer Dennis Marsico was hired to document eight of the buildings before they were torn down.

DETROIT, MICHIGAN, 1989

The life of a city in one block.

These buildings, known as the Monroe Block, were the last remnants of what downtown Detroit looked like before the Civil War. Built in 1852, the block was acquired by the city in 1974 and demolished in the early 1990s.

Each building had a history. The Father & Son building (from left), at 70-72 Monroe Avenue, was Detroit's first nickelodeon movie house before it opened as a bar and shoe store. The Tip Top Book Store, 66-68 Monroe, once housed a pawnbroker and clothing shop. The Cinex adult theater, 62 Monroe, was once the Bijou Theater, Detroit's second movie house, and the Thom McAn shoe store, 52-54 Monroe, started as a saloon and later became clothing and music shops.

Residents mourned the loss of the Monroe Block. "The gradual decay and desolation of Detroit

CARLA ANDERSON

contribute to our civic inferiority complex and economic disinvestment," wrote Detroit resident William K. Steiner in 1990. He insisted that Detroit needed a preservation plan.

Detroit Free Press columnist Nickie McWhirter took a similar view. "So long, Monroe Block," she wrote when its fate was sealed. "Join your pals, Kern Block and Old City Hall, in Detroit architectural oblivion. Detroit is the only big city I know that measures progress by piles of rubble and acres of empty lots. It's embarrassing."

Carla Anderson, who took these photographs, understood the importance of the large-format camera in preserving the history of an architectural structure that would soon be wiped away. "There is magic with a 4x5 camera," she said. "Once you get under the dark focusing hood, everything is slowed down and you see details you would never notice."

WASHINGTON, D.C., 1941 — THOMAS T. WATERMAN

WILMINGTON, DELAWARE, 1984 — DAVID AMES

Above: Time stands still at 202 North King Street in Wilmington about two blocks north of what is now called the Joseph R. Biden Jr. Railroad Station. Thirteen commercial buildings, each of which had their nineteenth-century detailing removed during renovations, were condemned and torn down along the 200 block in downtown Wilmington in 1985.

Left: Salvagers work at a store in the Georgetown neighborhood of Washington, D.C. Constructed around 1800 as a home, the building and its two neighbors were razed for an F.W. Woolworth Company store. Photographer Thomas T. Waterman was one of the original architects hired to photograph for the Historic American Buildings Survey. He was also an administrator who decided which buildings would be documented. Nearly 900 of his photographs are in the archives.

WILMINGTON, DELAWARE, 1984

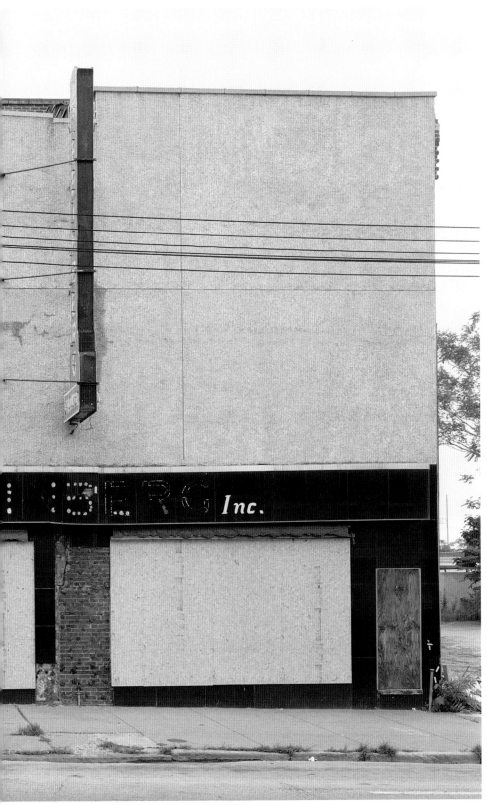

This is what happens to a building that has been modernized so many times its architecture disappears and it ends up looking like a box.

The Peter Feinberg Furniture Store was one of the thirteen buildings on the 200 block of North King Street in Wilmington to be condemned and razed. Built in the mid-1800s, the store had been used to sell women's hats, groceries and dry goods over the decades until it became a shop for furniture

"The *New* Peter Feinberg Furniture Store," as it was advertised, was modernized in 1938 and again in the 1940s. Because Feinberg sold contemporary furniture, it was important that it look up to date. A 1941 newspaper article stated the store was "modern to the last detail." And it kept getting fresher every decade until all of its original interior and exterior trim was removed.

By the 1980s, the building had been "slipcovered," enveloped so many times to keep up with the times that it was hardly recognizable. It was torn down in 1984.

DAVID AMES

DOOMED

> If the buildings documented by HABS
> were people, you'd take them straight
> to the hospital. Instead, we push
> them straight into the grave.
>
> —Stephen D. Schafer
> HABS photographer

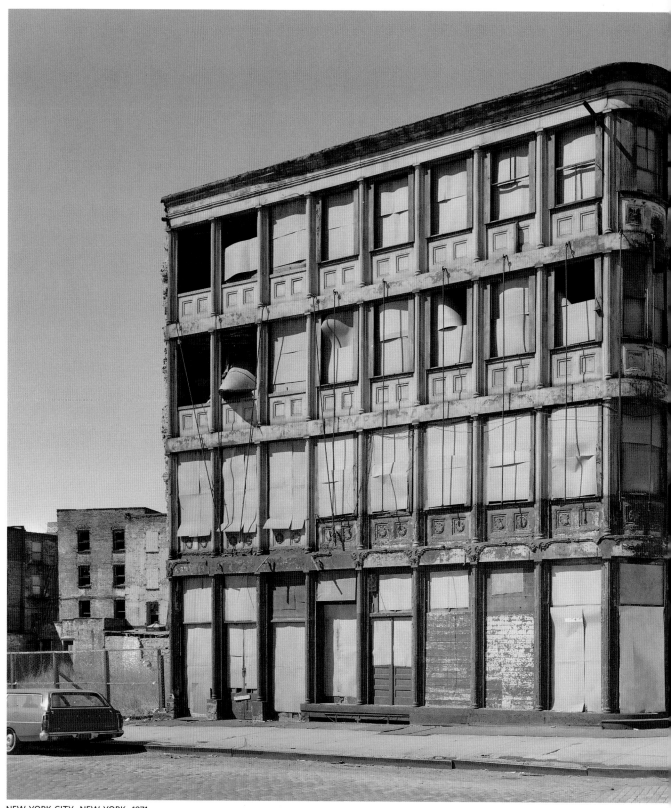

NEW YORK CITY, NEW YORK, 1971

JACK E. BOUCHER

There is a moment when time seems to stop. When a building set for destruction is left alone. Abandoned. Its front door is easy to jimmy. So many of its windows are shattered, there is no need to board them up.

Neighbors back away. The building waits.

That was the state of the Edgar Laing Stores in Lower Manhattan when photographer Jack Boucher of the Historic American Buildings Survey arrived. Built in 1849 by James Bogardus, the structure was one of the earliest cast-iron buildings in the United States and the oldest in New York. Also known as the Bogardus Building, it was remarkably modern, with a complete metal, prefabricated exterior and large windows. It was a forerunner of the skyscraper. A year after it was named a New York landmark in 1970, the Bogardus would become another victim of urban renewal, torn down to create a "superblock."

Wreckers worked gingerly to raze the Bogardus building because the New York Landmarks Commission planned to re-erect the building's facade at a community college. It took five weeks to take down the metal, scrape and weatherproof every piece with paint, and then label and stack each in a vacant downtown parking lot for storage.

But three years later, the head of the landmarks commission held a press conference to announce: "Someone has stolen one of my buildings." Thieves had removed two-thirds of the panels to sell as scrap. The criminals valued the iron more than the city.

The Bogardus was gone.

"Pious gestures are an empty substitute for preservation," wrote Ada Louise Huxtable in the *New York Times* of the plan to re-erect parts of the building. "No one needs architectural keepsakes. Better the scrapheap than sanctimonious games. Scrap was probably the best end for the Bogardus Building after so many ludicrous indignities."

ST. LOUIS, MISSOURI, 1938

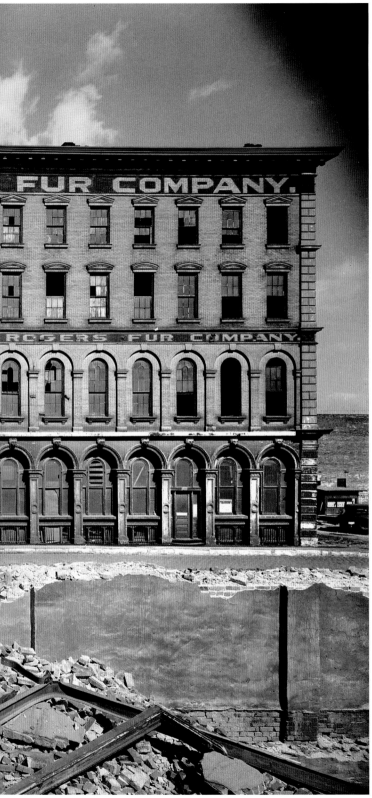

LESTER JONES

The Merchants' Bank Building, which later housed the Rogers Fur Company, was one of nearly 500 buildings in St. Louis' vast downtown district that were razed to make way for the city's signature Gateway Arch.

About 38 blocks were cleared by the National Park Service to build the arch and its surrounding park, initially known as the Jefferson National Expansion Memorial. The streets of St. Louis were covered with wrecking debris when Lester Jones photographed the last remaining buildings of old St. Louis. His photo of the Merchants' Bank just west of the Mississippi River shows the exposed basement of the building across Locust Street in the foreground.

The National Expansion Memorial predated the destruction of Philadelphia's downtown to create the Independence National Memorial Park. The Philadelphia project was built to highlight one of America's most essential buildings: Independence Hall. The St. Louis project was built to highlight an idea: America's push westward beyond the Mississippi. Both were created from the intentional destruction of downtowns and neighborhoods.

Chicago architect Thomas Tallmadge, who was on the HABS board of directors, visited downtown St. Louis in 1936 and declared that only five or six buildings were worth saving. The riverfront district, which dated back to the mid-1800s, rose after the city's Great Fire of 1849 when St. Louis leaders mandated that all new downtown construction be of brick, stone or cast iron.

The 1858 Merchants' Bank, designed by architect Thomas Walsh, almost made the cut. Tallmadge recommended the building be torn down but suggested its exterior cast-iron ornament be removed and displayed in a future architectural museum. "Architecture is an important part of life," he said. "This museum . . . ought to be as popular as a museum of paintings or a zoological museum."

The museum was never built. The building was razed soon after this photo was taken.

ST. LOUIS, MISSOURI, 1938

LESTER JONES

The destruction of Old St. Louis to create the Jefferson National Expansion Memorial was called the "Blitzkrieg on the Riverfront" by the *St. Louis Post-Dispatch*. In 1941, the paper ran a photo of the destruction, and described: "The memorial site, looking strangely like a scene from the European battlefields as wrecking nears completion."

Demolition, partly justified by the job opportunities it provided during the Depression, began in 1939 and lasted through 1942. Another casualty was the 1852 Old Post Office Building. By the time photographer Lester Jones showed up, wreckers had removed the roof of the three-story building and gutted its interior. The post office was in ruins.

St. Louis' downtown was unique; it contained the largest group of cast-iron buildings in the United States outside New York City's SoHo neighborhood. But only a few buildings were spared, including the 1818 Old Rock House, a warehouse restored by the National Park Service; the 1828 Old Courthouse, now part of the Gateway National Park; the 1834 Basilica of St. Louis, known as the Old Cathedral, which is still open as a church; and the 1884 U.S. Custom House and Post Office.

A tiny neighborhood known as Laclede's Landing, with seventeen historic buildings just north of the Arch, was also spared. The last intact section of St. Louis' eighteenth-century riverfront, it's one of the city's top tourist spots, which hints at what the downtown district could have been today.

The gleaming, stainless-steel Gateway Arch, designed by Eero Saarinen, took decades to plan and complete. Actual construction began in 1963 and lasted two years. It has become the city's most defining attraction.

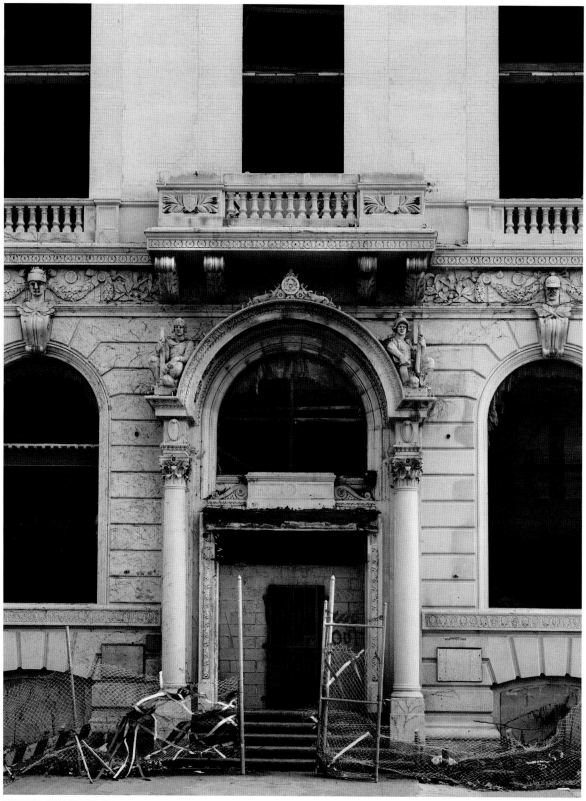

NEWARK, NEW JERSEY, 1992　　　　　TONY MASSO

SACRAMENTO, CALIFORNIA, 1992 — ED ANDERSON

Above: Defaced tile on the Coolot Building in Sacramento. The two-story store and apartment was remodeled in 1928 with a new facade faced in colorful terra cotta by master tilemaker Ernest Batchelder of Pasadena. It was torn down in 2003 for an apartment complex.

Left: The eleven-story Newark Athletic Club, built in the early 1920s, was described as "a playground" for Newark businessmen. But the club declared bankruptcy during World War II and was converted into the Military Park Hotel, beginning its reversal of fortune. The building declined until 1993 when about 6,000 people watched as it was demolished by explosives. It has since been replaced by the New Jersey Performing Arts Center.

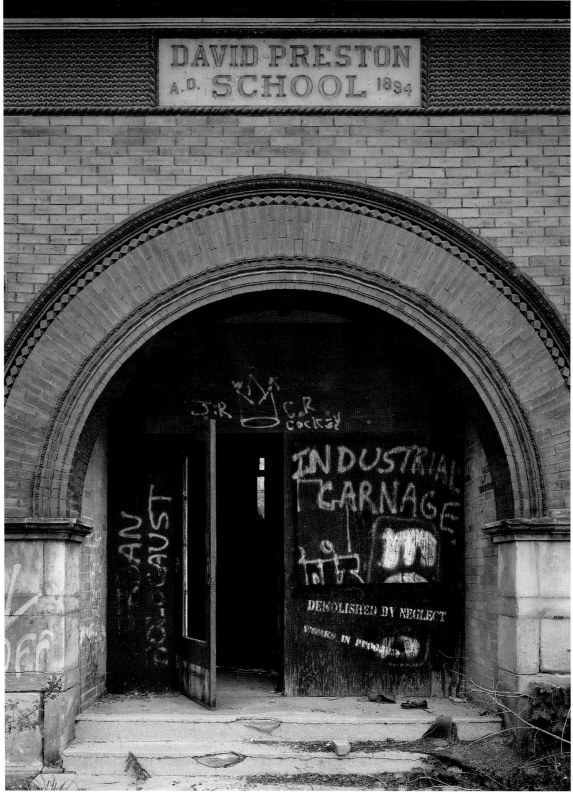

DETROIT, MICHIGAN, 1998 — ROBERT BENTON

DENVER, COLORADO, 1990 — ARNOLD THALLHEIMER

Above: And graffiti takes over. The front room of a farmhouse slated for destruction was defaced after it was abandoned to make way for the Denver International Airport. The homestead, known as the Altman farm, had been a livestock ranch since 1890. It was constructed at the end of Colorado's frontier-era when cattle ranges were built near the Denver cattle market. A century later, more than 50 square miles of land was acquired northeast of Denver for the new airport. "It was called 'Federico's Folly,'" said former Denver Mayor Federico Peña, "because how could you build this airport 25 miles outside the city?" But he and voters wanted to acquire enough land so that the airport could be expanded. The farmhouse was burned to the ground in 1992. DEN opened three years later.

Left: The Preston School in southeast Detroit was built in 1894 to relieve overcrowding in an area near the Ambassador Bridge to Canada. The two-story elementary school served changing neighborhoods during its nearly nine decades. It became one of Detroit's first to offer bilingual education in the 1970s and closed in 1981. Preston was old-school: no cafeteria or auditorium. "It was like a one-room schoolhouse because we had all of the grades together," recalled one teacher. "The younger kids for half day, then the older kids the other half day." It was torn down in 1998. The site is now a senior apartment building.

LOS ANGELES, CALIFORNIA, 2002

TAVO OLMOS

The Holiday Bowl was more than a neighborhood alley. It was the cultural hub of a Los Angeles community that changed over decades.

The bowling alley, about five miles southwest of downtown Los Angeles, was built in 1958 as a recreational haven for Japanese Americans who had returned in the mid-1940s from World War II incarceration camps. The bowling groups they formed—the Produce League, Floral League, Gardeners' League and even then 442nd League (based on the famous 442nd Regimental Combat Team)—reflected life in the community.

As the racial makeup of the area changed, so did the bowlers and the coffee shop menu. The alley, its pool hall, bar and restaurant were open twenty-four hours to accommodate aerospace workers, jazz musicians and others who worked uncommon schedules. Here you could get udon, chow mein, salmon patties, hot links and hamburgers.'

"It's like a United Nations in there," waitress Jacqueline Sowell told a reporter during the Holiday Bowl's last days. "Our employees are Hispanic, white, Black, Japanese, Thai, Filipino. I've served grits to as many Japanese customers as I do Black. We've learned from each other and given to each other."

When plans were announced to tear down the Holiday Bowl, preservationists argued that the alley's futuristic design was architecturally significant. They compromised with developers. The bowling alley was torn down in 2003 for a shopping mall, but part of its coffee shop was saved as a Starbucks.

Photographer Tavo Olmos recalls he had to work feverishly to document the building before the wrecking began. "This once had been a gem," Olmos said. He had to bring extra lights for the interior photographs because much of the power had been turned off. "Our ultimate goal was to please the historians that were writing narratives and doing drawings," he said. "I'm glad we were there."

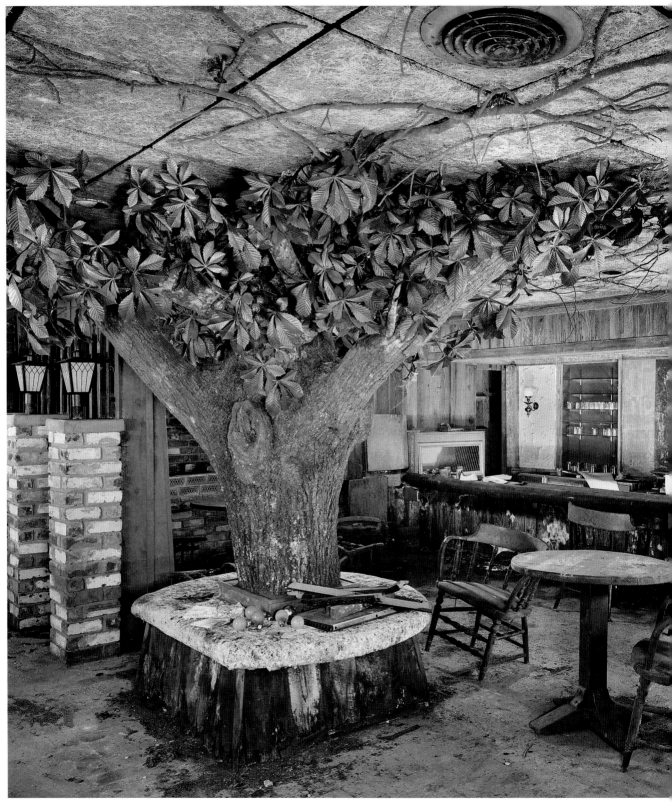

ATLANTA, GEORGIA, 1985

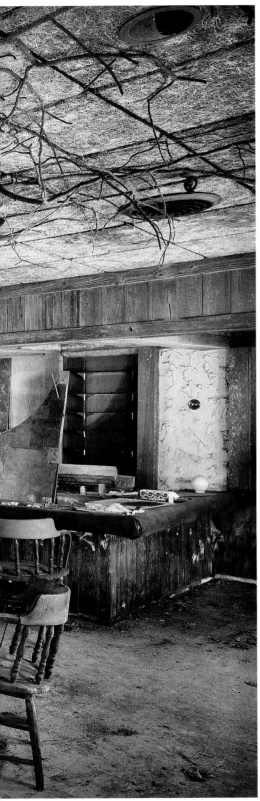

RICHARD T. BRYANT

The Old Carriage House Restaurant was once part of Underground Atlanta. The dining room was in the basement of one of the city's oldest commercial structures, the 1895 Atlanta Fixtures Building, which was torn down for a parking garage.

Underground Atlanta was the city's most popular tourist spot when it was opened in 1969. It was created inadvertently in the late 1920s when a series of viaducts were built along a five-block stretch that spanned a giant railroad yard known as The Gulch. The original downtown streets were covered by the elevated roadways to reduce traffic congestion. All at once, the first floors of dozens of Atlanta buildings became basements. New entrances were built on the second floor of each building in order to connect them to the new avenues.

Atlanta's below-ground landscape was largely forgotten, something like a Lost Atlantis. It was rediscovered in the 1960s by developers who saw the subterranean space as an ideal spot for piano bars, pubs, nightclubs and boutiques with a mystique. They created Underground Atlanta, a tourist mecca that attracted more than 3 million visitors a year during the early 1970s.

The four-story Atlanta Fixtures Building was one of the buildings that was transformed. Its basement and subbasement were turned into restaurants and a bar. What looks like a tree growing in the dining room of the Old Carriage House was part of this unexpected new world.

The allure of Underground Atlanta lasted only a few years. Alcohol laws were liberalized across the state, making it unnecessary to drive to Atlanta for a mixed drink. Tourists started heading to places like the nearby Peachtree Center by the mid-1970s. A new rapid-transit line tore up part of Underground Atlanta. By 1982, the destination was abandoned, only to be revived on a smaller scale several times over the years.

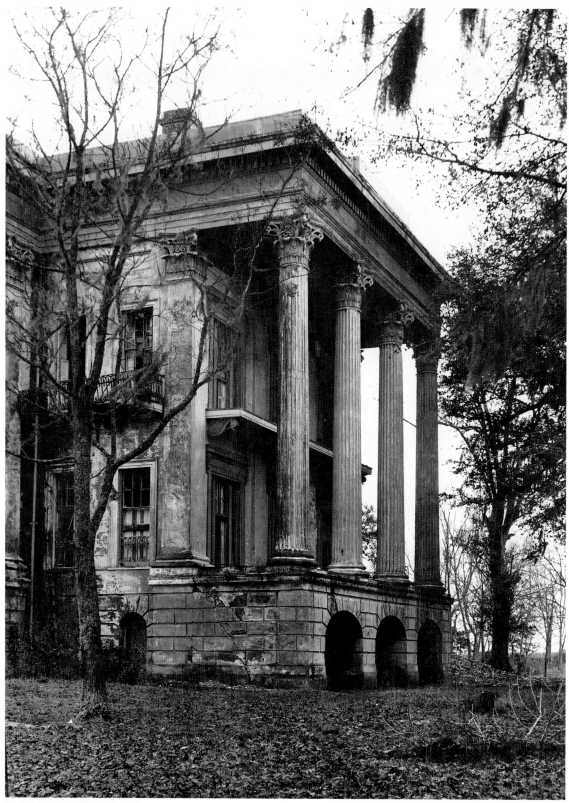

WHITE CASTLE, LOUISIANA, 1936 THOMAS T. WATERMAN

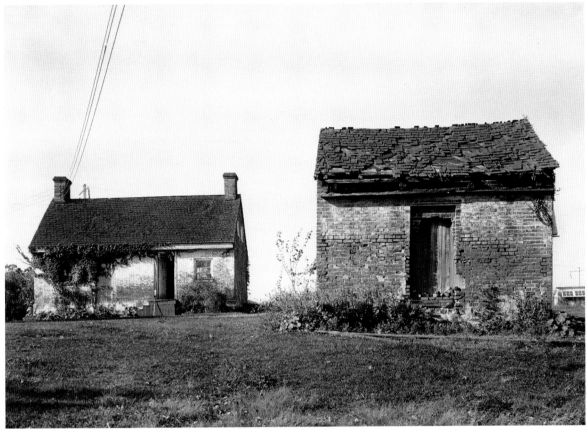

NORTH EAST, MARYLAND, 1990 E.H. PICKERING

Above: A 1830s slave quarters (left) and woodhouse on what was once a 428-acre plantation known as Russell's Union. The tiny house for enslaved men and women has been razed and the woodhouse substantially altered. It is one of few slave quarters photographed by HABS that has since been torn down. The property was owned by the prominent Russell-Thomas family from 1773 to 1900, according to the Maryland Historical Trust. It is now known as Greenhill Farm, in the small town of North East, Maryland, at the top of Chesapeake Bay.

Left: The Belle Grove Plantation, one of the largest country homes built in the South prior to the Civil War. The mansion, constructed in 1857 with 75 rooms, was the base of a large plantation labor camp about 25 miles south of Baton Rouge on the Mississippi River. Sugar planter John Andrews held 148 enslaved men and women in 1860 before moving his sugar operation to Texas in anticipation of the Civil War. His family lost the Louisiana property after the war and the house was abandoned in the 1920s.

By the time HABS documented the plantation in the 1930s it was in "ruinous condition." Windows and ironwork were missing. The mantels and furnishings had been sold at auction and the rear wing had collapsed.

"Each time that I have visited Belle Grove in recent years, the sight has come as a shock," wrote Harnett T. Kane, author of *Plantation Parade* in 1945. "In this air, decay advances at least as rapidly as growth; and man has done his part to prod apart this carcass of what had been a handsome thing."

The house caught fire in 1952, and nearby residents gathered to watch it burn. In an hour, it was gone.

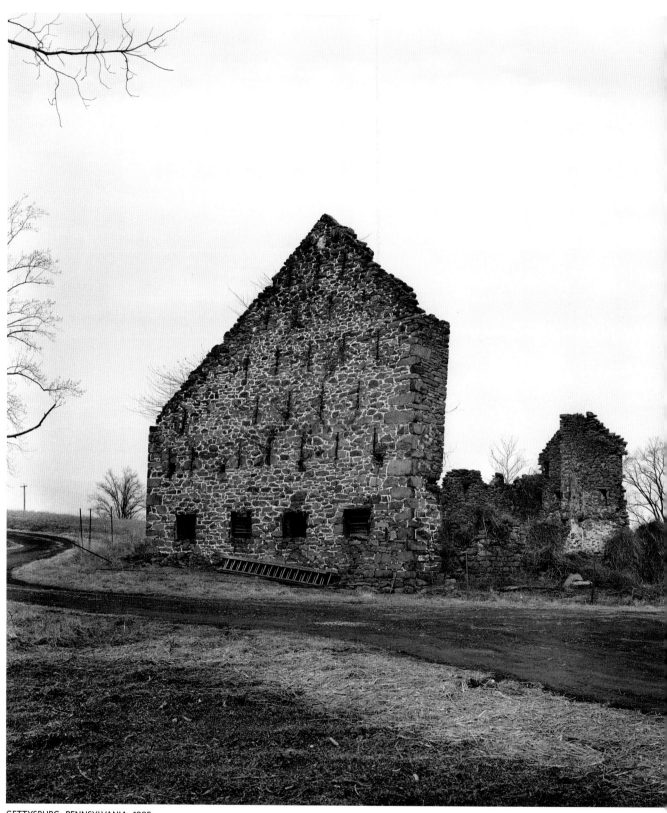

GETTYSBURG, PENNSYLVANIA, 1985

JACK E. BOUCHER

Most of the massive stone walls of the Rose Barn have fallen since the Civil War. The walls once towered nearly 40 feet above the fiercest fighting of the Battle of Gettysburg, in which Union troops turned back the advancing Confederate Army in the turning point of the war. More than 6,000 soldiers on both sides were killed, wounded or captured around this barn on July 2, 1863.

"No pen can paint the awful picture of desolation, devastation and death that was presented here to the shuddering beholders," wrote a local farmer the day after the clash. Two days later, photographer Alexander Gardner arrived at the Rose property and took iconic photographs of dead soldiers lying on the surrounding field. The images were among the first that showed the ravages of the war.

The Rose farm was a horror scene following the battle. The bodies of Union soldiers were removed to the National Cemetery later that summer, but the dead Confederates were left on the property in shallow graves for years, making the farm inoperable.

George Rose, who had moved from Philadelphia to Gettysburg in search of the "simple joys of farming," wanted to rid himself of the property after the battle. His livestock and furniture were gone, his farmstead in shambles. It took him fifteen years to sell the farm.

Not much remains except the barn's foundation, small sections of the four exterior walls and rubble. The structure, about one mile south of the town of Gettysburg, started to crumble in 1910 when it was struck by lightning. A 1934 windstorm caused more damage, yet the barn's south elevation was still standing when HABS documented the wall in 1985. That was the year the National Park Service announced it would dismantle the higher portions of the standing walls for safety and store the pieces for future reconstruction. The marked stones are piled near the barn's foundation. The barn has never been put back together.

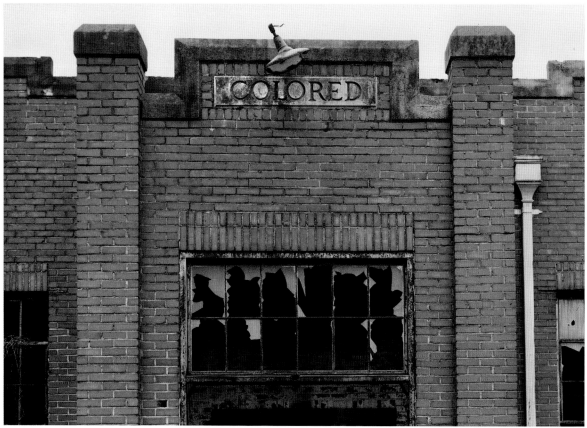

BESSEMER, ALABAMA, 1993 JET LOWE

Above: Signs of segregation. "Colored" and "White" entrances at the bathhouse of the TCI-U.S. Steel Surface Plant on the southeast side of Bessemer, Alabama. Maintaining segregation made it difficult but not impossible for Black and white workers to unite, including for union organizing. Separate housing was built in the Muscoda Red Ore mining community and mixed-race union meetings were often banned. The Muscoda mines supplied iron ore and limestone to nearby steel furnaces. The mines closed in the mid-1950s as steel producers looked overseas. When civil rights laws later made separate bathhouses illegal, "some whites initially responded by leaving work without showering," wrote historian Max Krochmal. "Black workers fondly remember that this strategy failed because the white workers' wives protested their husbands' smell in the car on the way home from their shifts." The Muscoda bathhouse building was abandoned for almost seventy years and torn down in 2020.

Right: The Lawrence Courthouse in Moulton, Alabama, was built around 1860 and used as a hospital during the Civil War. The two-story brick building was photographed after voters approved a plan to raze the building for a new courthouse. Lawrence County, like many in the South, charged residents a fee to cast a ballot in order to raise revenue and disenfranchise poor people. Wrote the *Tuscaloosa News* in 1940: "This newspaper believes in white supremacy, and it believes that the poll tax is one of the essentials for the preservation of white supremacy."

MOULTON, ALABAMA, 1935 — ALEX BUSH

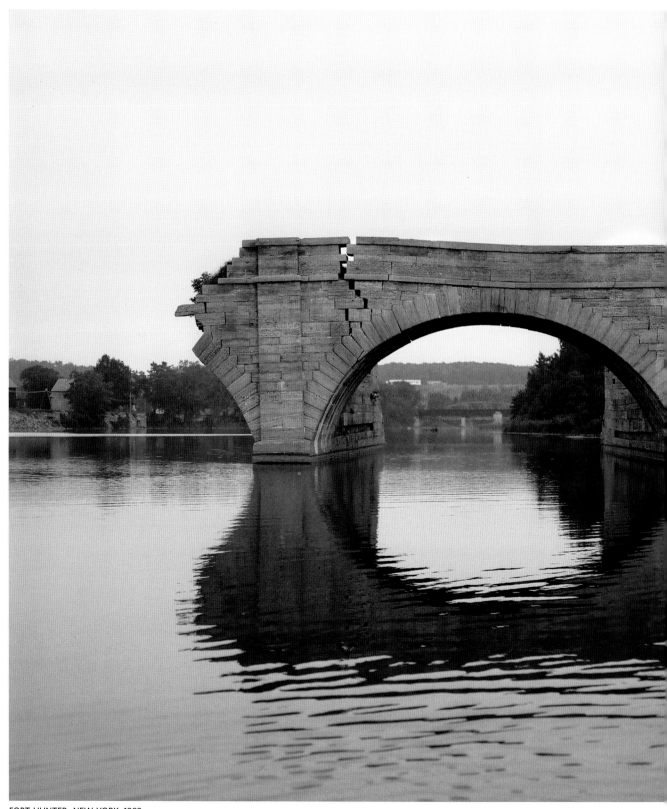

FORT HUNTER, NEW YORK, 1983

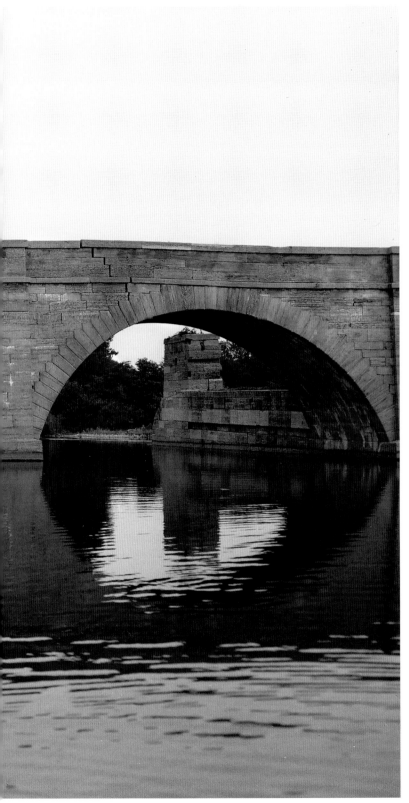

JACK E. BOUCHER

The 1840s limestone aqueduct that once spanned Schoharie Creek in eastern New York has been crumbling for decades. Fourteen Roman style arches originally held a 624-foot-long boat canal and towpath that made it possible for the Erie Canal to pass over the creek. The canal and towpath were rerouted around 1915. Only six of the arches remain.

The monumental aqueduct, even in its present state of ruin, helps tell the story of the Erie Canal, a 363-mile man-made waterway connecting the Hudson River and New York City to the Great Lakes. At Fort Hunter, freight barges were tugged by horses and mules along the wood-framed waterway that was supported by the arches. The narrow canal, enlarged in the 1840s to a width of seventy feet so boats could pass each other, opened trade across the North and spurred westward expansion, said David Books of the Schoharie Crossing State Historic Park. "In addition, ideas and culture, such as the beginnings of the women's rights movement and the abolitionist movement, moved along this waterway," he said.

The aqueduct's arches remained intact until about 1940, when one on the east end collapsed into the creek. Soon after, the Army Corps of Engineers removed four connecting arches to relieve ice jams on the Schoharie. Nine arches were standing in 1969 when the Historic American Engineering Record photographed the viaduct. Since then, the two arches in this photograph and one more in 1998 have collapsed.

Private and government efforts started in the 1970s to stabilize the remaining arches, but it is a tricky engineering challenge to balance what remains. Without the engineering, the remaining arches are expected to fall one by one.

JERSEY CITY, NEW JERSEY, 1984 ROB TUCHER

Above: Jackie Robinson made his professional debut and history at Roosevelt Stadium. This is where Robinson broke the baseball color barrier in his first minor league game. (He went 4-for-5 for the Montreal Royals on Opening Day in 1946.) The stadium, a Works Progress Administration project, was home to minor league teams for decades and to the Brooklyn Dodgers for part of two seasons. Due west of Lower Manhattan, the stadium hosted rock concerts, auto races, boxing matches, high school football games and Independence Day celebrations. "It was our stadium," wrote journalist Frank Borsky, "a center of the socio-economic-political fabric of Jersey City." In the end, though, the city could not afford to keep it up.

Right: Memorial Stadium was expanded to provide a home for the Baltimore Colts and Baltimore Orioles after baseball's St. Louis Browns moved to Baltimore in 1953. The Colts played in the stadium for forty years, winning four championships. Their fans were so loud that one sportswriter called the stadium "the World's Largest Outdoor Insane Asylum." The Orioles won three World Series before moving in 1992 to Camden Yards in the city's downtown. Memorial Stadium was torn down ten years after the cheering stopped.

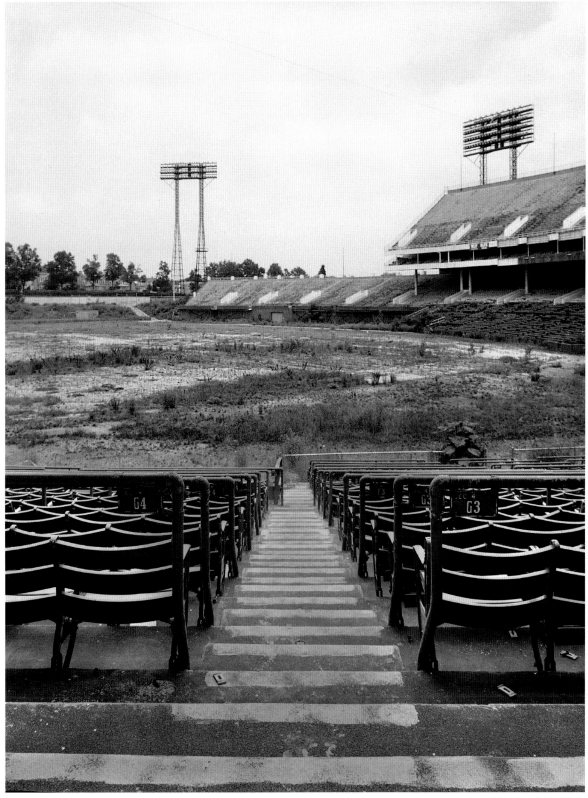

BALTIMORE, MARYLAND, 2000　　　　JAMES W. ROSENTHAL

ALAMEDA, CALIFORNIA, 1985

JOHN GRIFFITH

This is where the big ships were built during World War I and World War II.

The Union Iron Works Turbine Machine Shop was a key part of the huge Alameda Works Shipyard just south of Oakland, where it connected with San Francisco Bay. The shipyard built 58 ships between 1917 and 1923. After the war, the machine shop fabricated the structural steel used for both the San Francisco-Oakland Bay Bridge and the Golden Gate Bridge.

During World War II, the shop was part of what became known as the Bethlehem Alameda Shipyard, which repaired thousands of military vessels and produced eight huge transport ships that carried troops across the Pacific. During those years, more than 6,000 men and women worked on the docks.

The Union factory was the nucleus of the shipyard. It was huge: a city block long and 85 feet tall. The largest plant on the Pacific Coast, its vast interior supported by steel trusses could be adapted for just about any industrial job. It was designed by John Reid Jr., a prominent San Francisco architect who took his nineteenth-century École des Beaux-Arts training and built this straightforward twentieth-century behemoth.

Much of the Bethlehem Alameda Shipyard was torn down after the war. The machine shop, then known as the Red Brick Building, stayed open until 1972. New owners considered transforming the factory into an indoor shopping mall with a mix of apartments and condominiums in the early 1980s. However, their plans were obstructed by an Alameda law that restricted the construction of multi-unit residential buildings. A vote was held in 1984 to exempt the Red Brick Building, but the measure was defeated by a majority who feared the exception would jeopardize the law that was conceived to save vintage single-family homes.

The Union Iron Works Turbine Machine Shop was razed in 1985, a year after this photo was taken. That's when photographer John Griffith climbed atop a nearby industrial building to show the contextual view of the lonely machine shop.

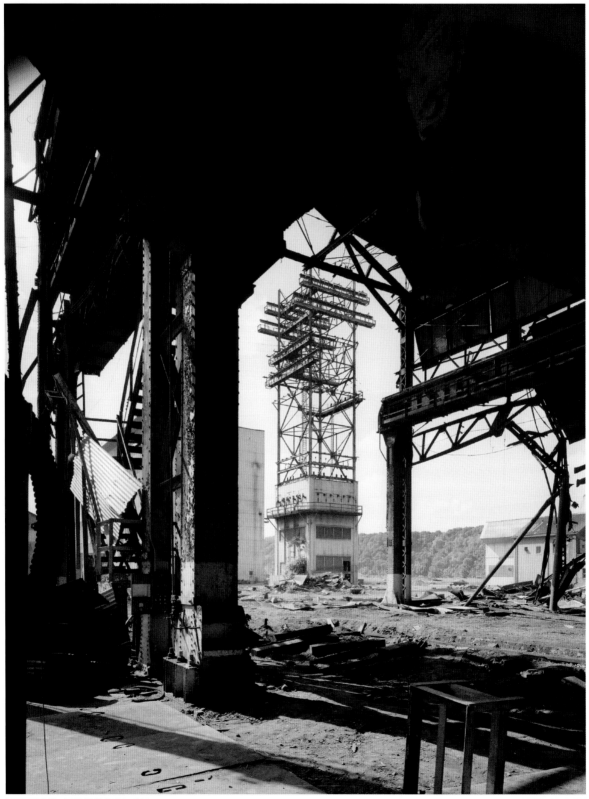

HOMESTEAD, PENNSYLVANIA, 1989　　　MARTIN STUPICH

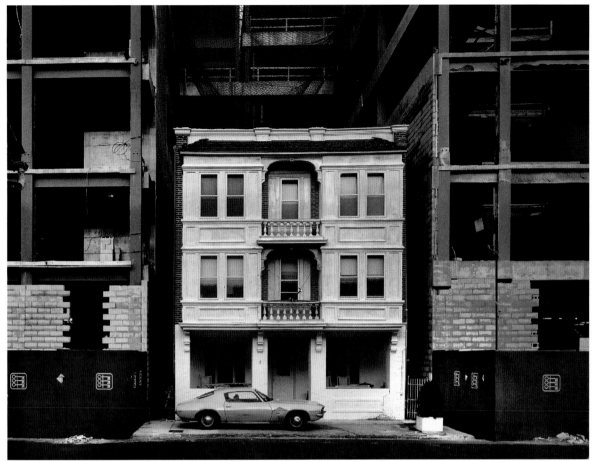

ATLANTIC CITY, NEW JERSEY, CIRCA 1991 — JACK E. BOUCHER

Above: A boarding house stands defiantly in the way of a huge new casino-hotel. Penthouse magazine publisher Bob Guccione bought the entire block just off the Atlantic City Boardwalk to construct his Penthouse Boardwalk hotel. Actually, he bought the entire block except for the small parcel owned by a woman named Vera Coking. When Coking refused his $1 million offer, Guccione built a massive substructure for his hotel around her property. The hotel was never completed, and the steel skeleton was torn down in the early 1990s. Next, Donald Trump attempted to buy the Coking property to use as a parking lot. Atlantic City tried to take the house in condemnation proceedings but Coking prevailed again. Her family eventually sold the property, a landmark in eminent domain law, in 2014. It was torn down less than four months later.

Left: A utility tower in the ruins of the Homestead Steel Works, once the largest steel mill in the world. About six miles southeast of downtown Pittsburgh, the factory was operated by Andrew Carnegie until 1901, when he sold it to U.S. Steel. Homestead was the scene of a violent labor clash in 1892 when the company sent hundreds of private Pinkerton security agents to put an end to a labor strike. Strikers and agents got into a twelve-hour gunfight. Thousands of state militia were eventually called to put down the unrest, in effect breaking the strike. Production peaked at the plant during World War II, when more than 15,000 workers worked multiple shifts around the clock at Homestead. It closed in 1986, the victim of less expensive foreign steel. Twelve towering smokestacks on the south bank of the Monongahela River mark the site, which is now a shopping center.

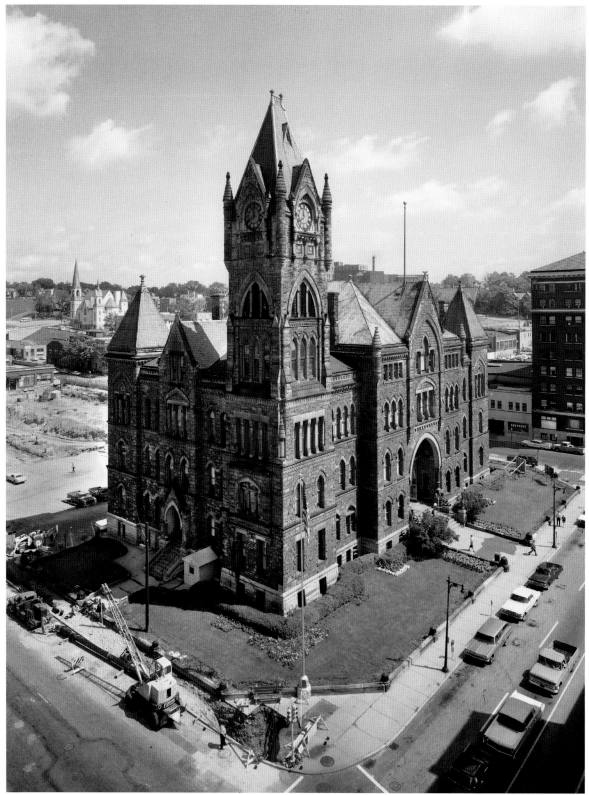

GRAND RAPIDS, MICHIGAN, 1965

ALLEN STROSS

CUMBERLAND, MARYLAND, 1970　　　　　　　　　　　　　　　　　　　　　　　　　　WILLIAM E. BARRETT

Above: Wreckers arrive at the Queen City Hotel [shown on page 94] in Cumberland, Maryland, in late 1970. After a two-year preservation fight, the Baltimore & Ohio Railroad offered to sell the hotel for $33,000. However, the Cumberland City Council rejected the deal and pushed for demolition. James Biddle, president of the National Trust for Historic Preservation, warned: "Once the Queen City hotel-station has been demolished, there will, of course, be no second chance to rectify such a mistake."

Left: The City Hall in Grand Rapids, Michigan, faced the same fate as the Queen City Hotel. Wreckers arrived at the building in 1969 in spite of a dramatic effort by Citizens to Save City Hall. The group was determined to stop the demolition of the 1888 City Hall and its clocktower. The building, designed by Elijah E. Meyers, was a classic, yet it had long been covered with grime.

　　　Preservationists saw possibilities. They argued City Hall could be recycled as offices, stores, a restaurant or a museum. They found engineers who showed that the clocktower could remain standing even if the rest of the building was razed. The organization persuaded the federal government to add the building to the National Register of Historic Places. Preservationists filed an injunction against the wrecking and dropped a 45-foot banner from an upper window of the clock tower reading "Help Save Me."

　　　When all else failed, leader Mary Stiles chained and handcuffed herself to the wrecking ball on October 27, 1969. She stopped the demolition, but only for an hour. Her photograph—"Mrs. Stiles Is Just Along for The Ride"—appeared in newspapers across the country. Her handcuffs are at the Grand Rapids Public Museum.

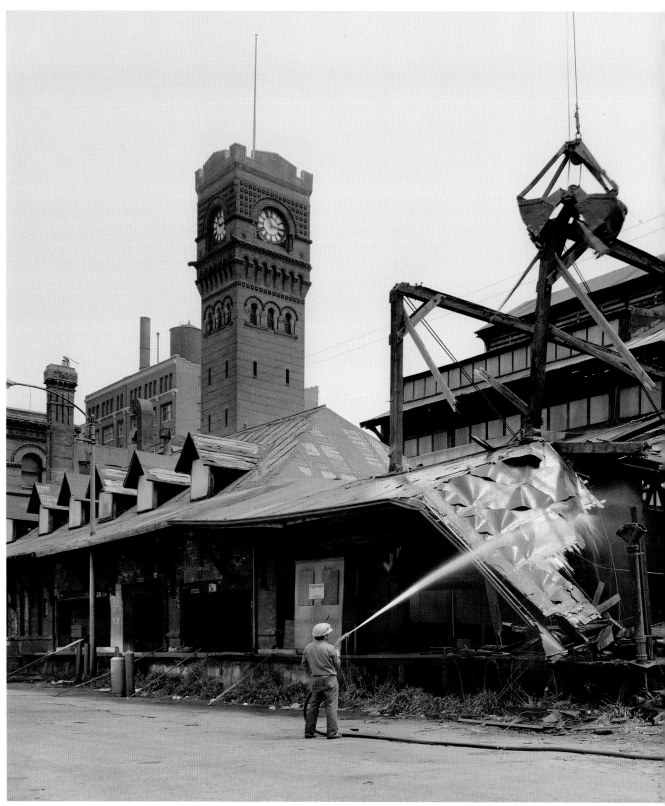

CHICAGO, ILLINOIS, 1976

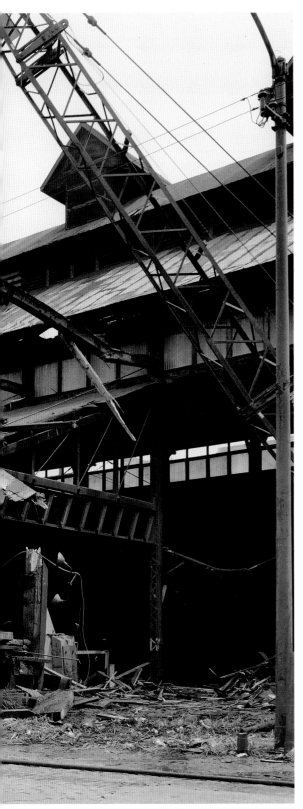

HEDRICH-BLESSING PHOTOGRAPHY

The day after *Chicago Tribune* architecture critic Paul Gapp wrote in 1976 that Chicago's Dearborn Station was endangered, railroad officials applied for a demolition permit.

"This is called the newspaper panic syndrome," wrote Gapp in response. "If you print something in a newspaper that the power people have been keeping secret, they start moving faster than one of Rommel's old panzer divisions."

The wrecking permit was issued immediately. Forty-eight hours later, "hard-hatted troopers from the National Wrecking Company were slamming away at the train shed," Gapp wrote. The 700-foot shed came down in a matter of days and its rail tracks were removed to make way for a planned housing development. Here, a member of the wrecking crew hoses down the roof of the damaged shed to prevent dust from wafting off site.

Preservationists had fought for three years to save Dearborn Station's main depot and its shed in the city's South Loop. The depot, which closed in 1971 when Amtrak took over passenger service, survived. It was converted into offices, stores and meeting spaces during the 1980s.

Gapp, who later won a Pulitzer Prize for architecture criticism, was aghast that the developers and city agents conspired to allow the shed to be torn down with such speed.

"We've seen Chicago officials make these maneuvers before," he wrote. "They've become famous for their bulldozer tactics in public works and urban renewal projects over the last two decades. Is anybody else out there getting sick of government by manipulation?"

The quick demolition proved effective for the developers. No train shed, no landmark dispute. But the arrogance of the new owners helped slow the pace of landmark destruction in the city.

The residential community was never built. A city park replaced the train shed. The depot sits alone.

Photographer Jack Boucher got only one day's notice that the Ulysses S. Grant Cottage in Long Branch, New Jersey, was going to be torn down.

He showed up at 9 the next morning at the house overlooking the Atlantic Ocean and saw a tractor "with its motor throbbing and smoke going out its back." A huge steel cable that wrapped around part of the house was attached to the back of the bulldozer. "If we had literally been there fifteen minutes later the building would have been down," Boucher said.

Large-format cameras are not made to record movement, but the photographer positioned his 4x5 on a tripod to show the tractor pulling the cottage off its foundation with the chains.

Boucher's photo, which showed the moment of impact, is one of only a few action shots in the HABS archive.

The cottage—a mansion, really—was President Grant's summer White House. Three Republican tycoons who summered nearby offered him the place after he won the presidency in 1868. The president turned down the gift because it might look bad, yet his new friends then presented the cottage to Grant's wife, Julia. She accepted.

The first family lived there up to three months a year during Grant's two terms. He held Cabinet meetings at what he called the "summer capital" and returned most summers until his death in 1885.

Decades later, the house was bought by a Catholic religious order and turned into a religious retreat. It was razed when the nuns could no longer pay for the upkeep. "Restoring a house is very expensive, and they couldn't afford it," said local historian Jim Foley. "It's cheaper to tear a place down." That's when wreckers were called.

"It's sad because it got torn down in my lifetime," said Foley. "We're a throwaway society."

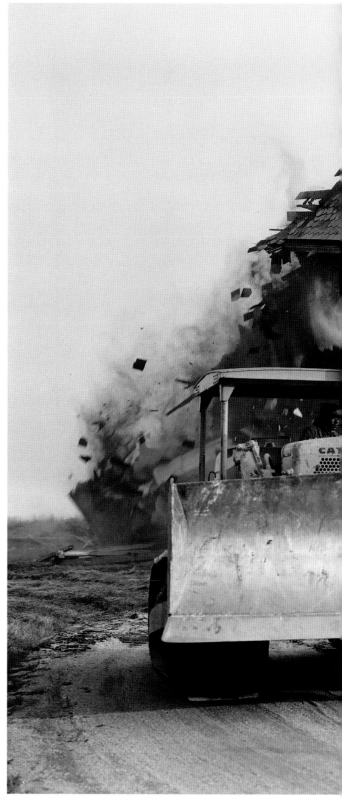

LONG BRANCH, NEW JERSEY, 1963

184

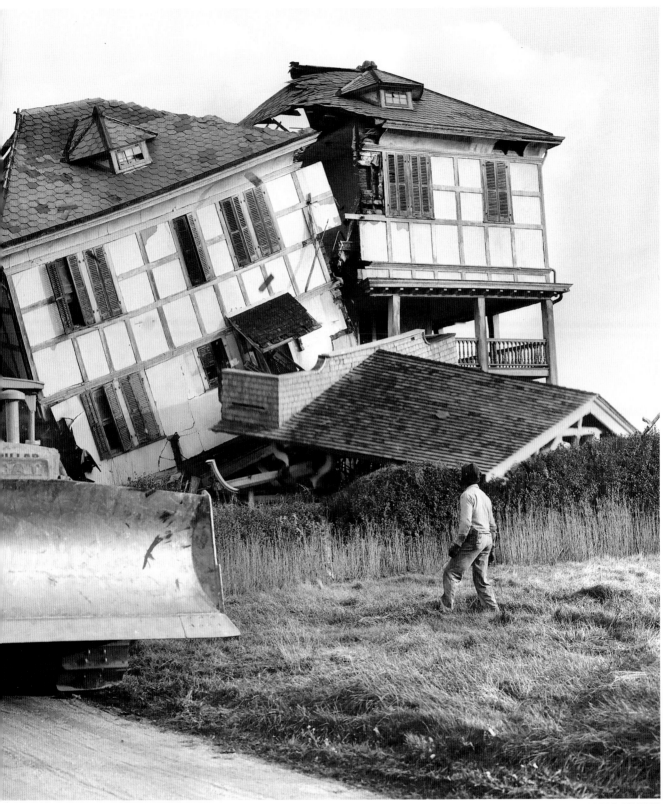

JACK E. BOUCHER

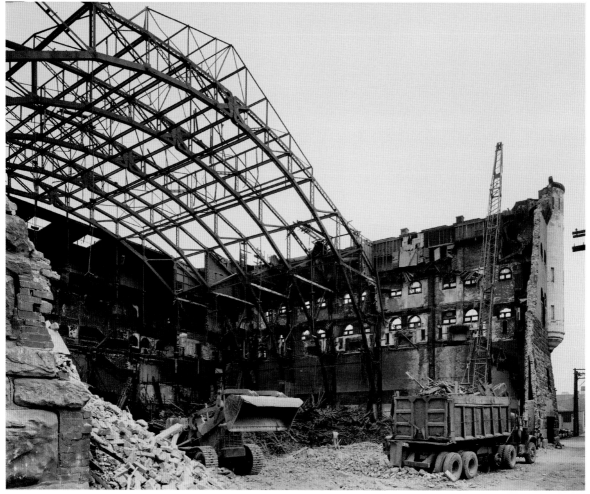

CHICAGO, ILLINOIS, 1967 — RICHARD NICKEL

Above: Richard Nickel, who documented nine projects for HABS, returned to photograph the Illinois Regimental Armory [shown on page 132] just south of Chicago's downtown Loop. He arrived after the interior of the building was exposed by wreckers. Nickel showed the iron frame that once supported the building's central skylight and the central drill area—both in ruins.

Right: First blows to the five-story Atherton Building, razed during the rush to redevelop downtown Louisville. City officials counted on an expensive, suburban-like enclosed mall to help the central city regain vitality. "Louisville's proposed Galleria is like motherhood and apple pie—it seems that nobody doesn't like it," wrote John C. Long of the *Courier-Journal* in 1979. Preservationists suggested that the Atherton be incorporated into the new mall, but the idea was rejected by developers. The city celebrated "the greatest day for Louisville in 100 years" when the Galleria opened. It lasted about twenty years.

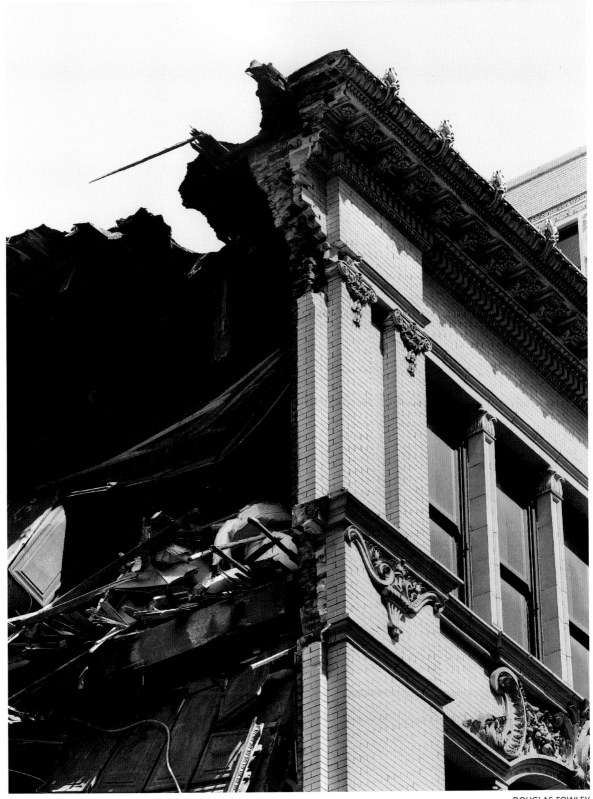

LOUISVILLE, KENTUCKY, 2000 — DOUGLAS FOWLEY

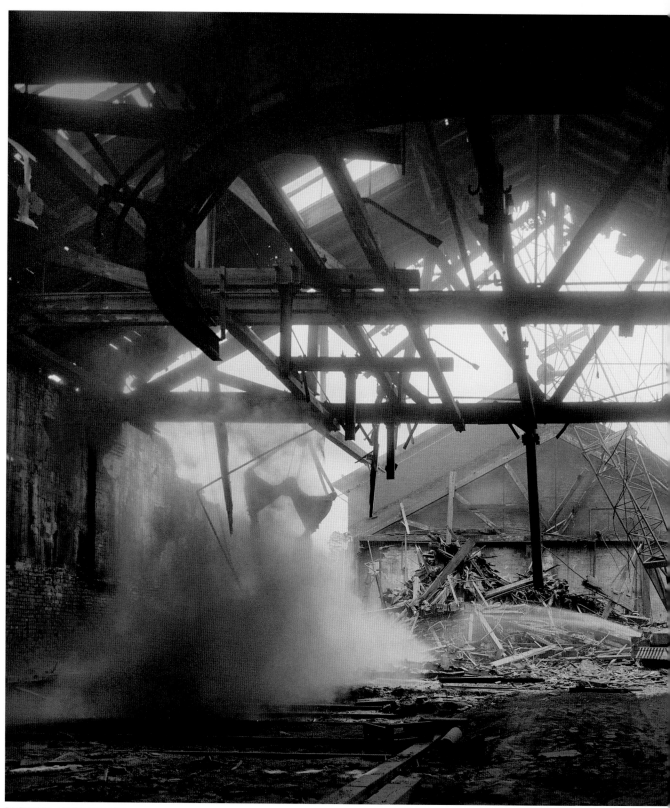

BALTIMORE, MARYLAND, 1976

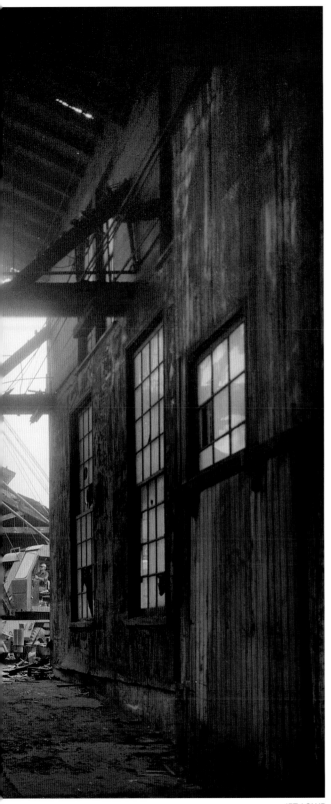

JET LOWE

The clamshell bucket of a wrecking crane chews up the foundry of the Baltimore & Ohio Railroad's Mount Clare Shops. The building was part of a huge factory that is considered the birthplace of American railroading.

Mount Clare Shops, which dates back to 1829, was America's oldest railroad manufacturing and repair facility. "At its height, it was the most comprehensive, self-contained shop complex producing everything from steam locomotives, freight and passenger cars, bridges, small hardware and building components for use throughout the system," according to the Historic American Engineering Record report that accompanied this photo. Thousands of locomotives were built or rebuilt in the shops from the first American-made steam locomotive, named the *Tom Thumb,* to streamlined locomotives of the late 1940s.

The factory network, southwest of downtown Baltimore, was decommissioned in 1974. Several buildings were being torn down in the mid-1970s when photographer Jet Lowe turned up at the site.

Today, about 40 acres of the once-sprawling rail facility survives as the B&O Railroad Museum. The museum is based in what was once the Mount Clare passenger car shop. When completed in 1851, the roundhouse was the largest circular building in the world and now houses one of the nation's most extensive collections of trains.

The Exchange Hall in New Orleans' Louisiana Sugar and Rice Exchange was demolished because its Neo-Classical design was not a priority to local preservationists.

The exchange was built in 1884 just outside the lively French Quarter. But during the 1930s, public interest in preserving old buildings in New Orleans was limited to colonial and antebellum structures, wrote geographer Richard Campanella. "Many old sugar buildings were razed before 1937, and those that remained went unappreciated."

The Sugar Exchange is now a parking lot. "The loss makes one ponder what elements of the built environment we dismiss today as mundane and worthy of removal," Campanella said, "and which of those we might someday come to regret."

The structure, designed by New Orleans architect James Freret, was built at a time when more than 1,100 sugar mills were operating across the state. The hall rose 65 feet, supported by four massive columns. "It is not likely that any other building in New Orleans has timbers of this size," wrote the 1936 *Rice, Sugar and Coffee Journal.* "Furniture of rosewood, mahogany and cypress was made especially for the Exchange 53 years ago. It is prized by the organization for its beauty and excellent workmanship."

However by 1963, the Sugar Exchange was bankrupt. The building was sold and soon demolished. "Had appreciation for historical architecture been more broadly construed in that era, we'd have a very different upper Quarter riverfront today," wrote Campanella. "It would look more like the warehouse district than a parking district, and the Sugar and Rice Exchange might have become iconic."

Photographer Dan Leyrer was not able to rescue the building. Yet he was able to capture the bones and scale of the lost city monument.

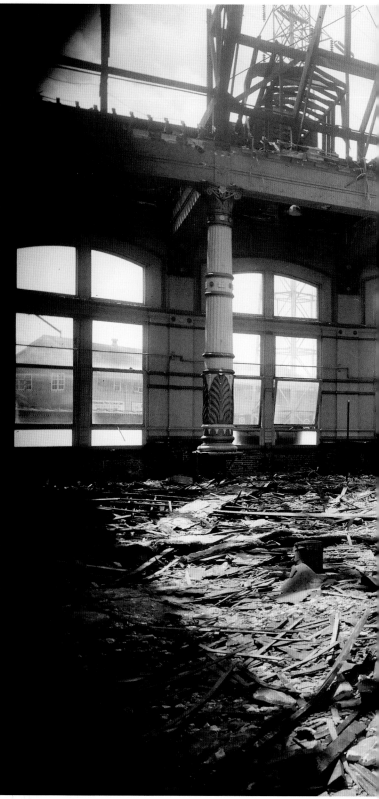

NEW ORLEANS, LOUISIANA, 1963

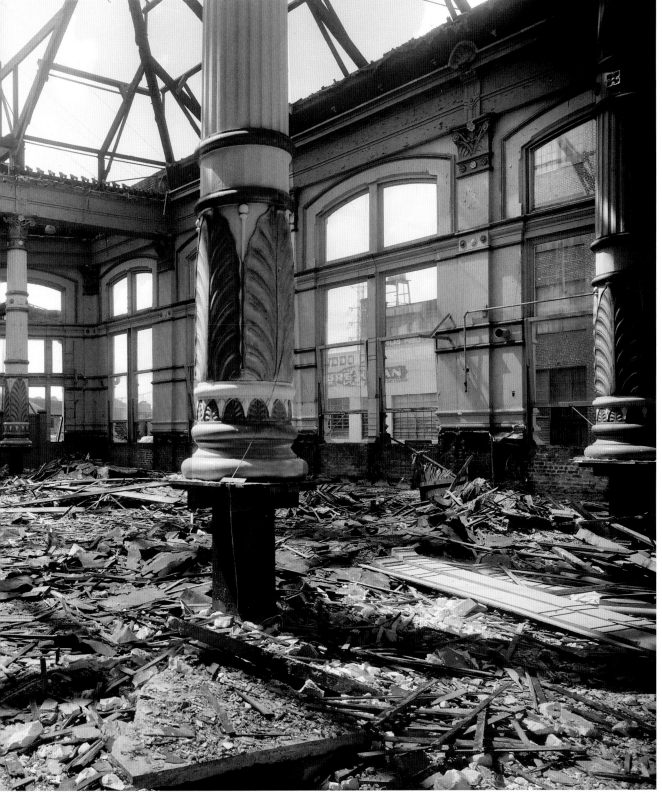

DAN LEYRER

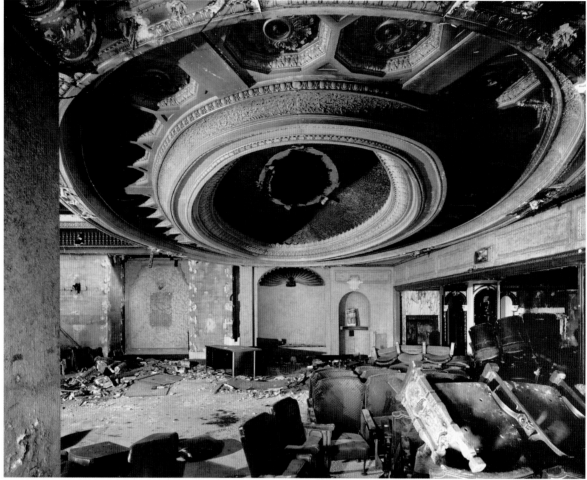

CHICAGO, ILLINOIS, 1989 — THOMAS C. YANUL

Chicago's Granada Theatre was one of the largest and most ornate movie palaces ever built. With nearly 3,500 seats, the theater was designed in 1926 by local architect Edward E. Eichenbaum. Stage shows ended in the 1940s, movies went dark in the 1970s and rock concerts followed in the 1980s. The building was in excellent condition until 1987, when it was largely abandoned. "It was left unattended, and the weather and vandalism were allowed to proceed unchecked," wrote architect Wilbert R. Hasbrouck for HABS.

When Thomas Yanul entered to photograph the theater on Chicago's North Side, he found a building in shambles. Windows broken, a tattered marquee. Inside, he roamed the first- and second-floor lobbies with their ripped-out bannisters, uprooted chairs and gang markings. However, the theater's auditorium almost looked like it was ready for the next show.

After years of abandonment, the end came swiftly. At the last minute, developers offered to keep the theater's facade pasted on the exterior of their new apartment building, but preservationists rejected the proposal. They wanted the entire building.

Scott Greig recalled the day demolition began. "There was a small crowd of onlookers, people from the neighborhood and fellow theater fans documenting things," he said. "I just had this real sense of sadness that this beautiful thing was being lost."

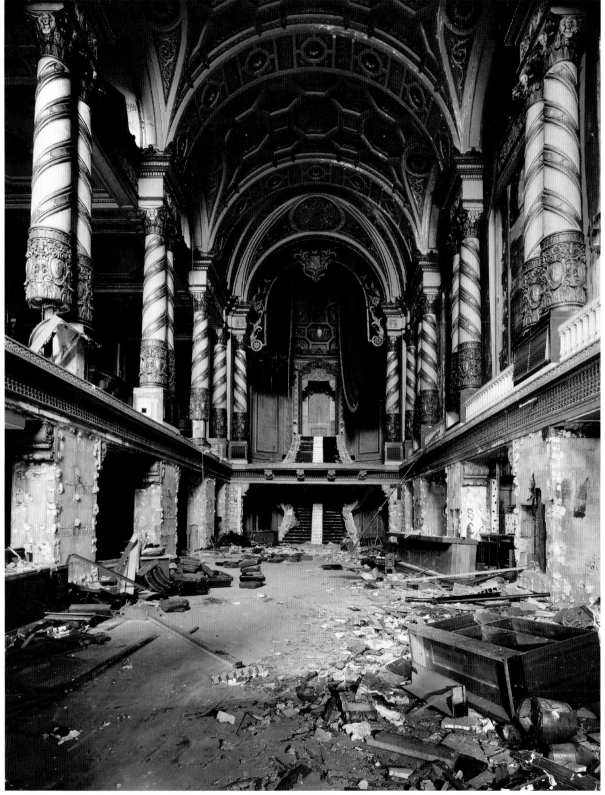

CHICAGO, ILLINOIS, 1989 — THOMAS C. YANUL

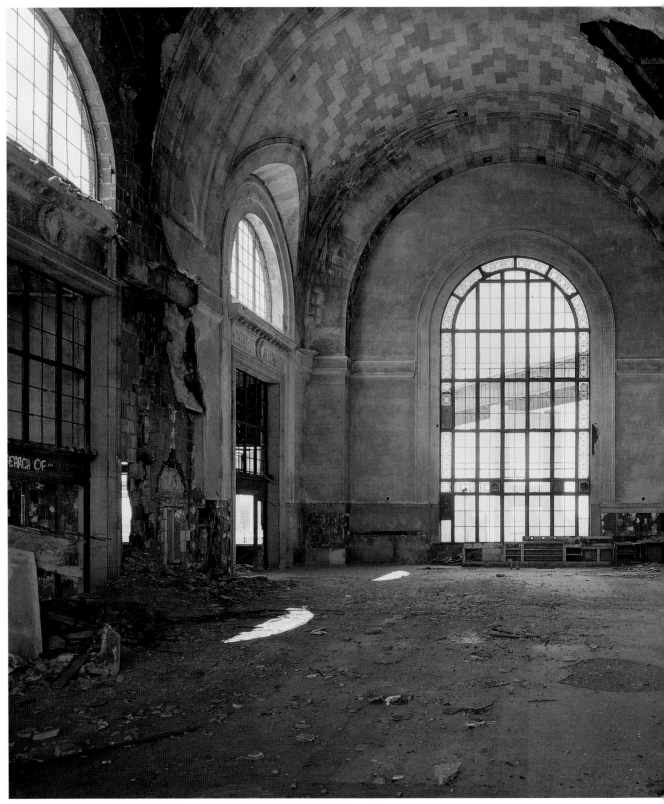

BUFFALO, NEW YORK, 1976

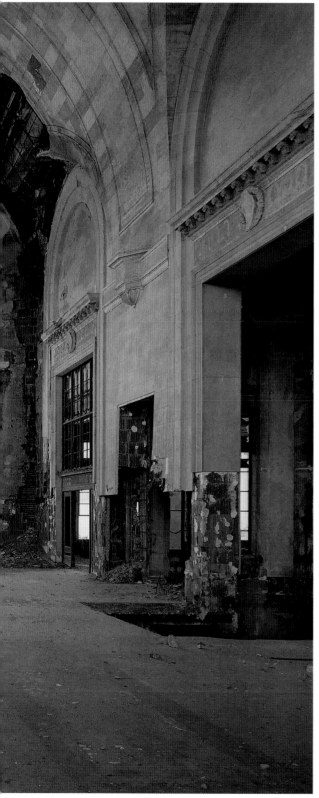

JACK E. BOUCHER

Abandonment then demolition is a common pattern.

Buffalo's suave railroad station, the Delaware, Lackawanna and Western Railroad Passenger Building, was deserted for nearly two decades before it was torn down. The terminal was built in 1917 to serve passengers of both trains and steamships. Trains headed east to Hoboken, New Jersey, to connect to New York City. Luxurious steamers, which docked at the terminal along the Buffalo River, headed west along Lake Erie and the Great Lakes to Detroit.

However, highways transformed transportation. Passenger boats were an early casualty and the last intercity trains pulled out of the Lackawanna station in 1962. The station was sold at auction in 1964, but the station continued to sit empty.

Deterioration of the structure, at the southern edge of downtown Buffalo, set in quickly. The ticket facility was gutted and the terminal's massive plaster walls and ceilings cracked. The *Buffalo Courier-Express* reported in 1974 that parts of the station had been reduced to rubble. "Many of the tiles have fallen from the high arched ceilings of its waiting rooms, vandals have broken almost every window, weeds have grown through the cracks in its roof and pigeons have become the building's principal inhabitants."

During its final years, developers floated ideas of a shopping and entertainment center, marina, apartment, restaurant, even a skating rink, yet no proposal was serious. The Lackawanna's grand waiting room, passenger concourse and railroad office were demolished in 1979. Only its long concrete train shed, used primarily as the rail maintenance yard for Buffalo's public transit system, remains. Coincidentally, 1979 was the year Buffalo Central Terminal, the city's other major station, was closed to train traffic. It is still waiting redevelopment.

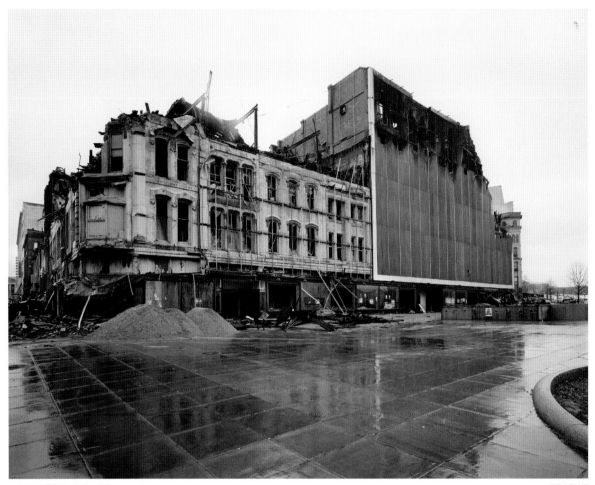

WASHINGTON, D.C., 1979 JET LOWE

The department store, invented in Paris, reshaped American cities.

Stores that sold everything from suit coats to zippers in the heart of U.S. metropolises prospered during the first half of the twentieth century. However by the late 1950s, the big, urban emporiums were in peril. Expressways changed the geography of cities. People were moving away from downtowns, and they were shopping at suburban malls.

So, many city store owners decided to cover their buildings in shiny aluminum cocoons and remove ye olde clock tower or anything else that seemed antique. They bricked wooden windows, dropped high ceilings and added air conditioning. The historic nature of city department stores was slipcovered to look . . . suburban.

Kann's Department Store, between the White House and the Capitol, was a classic. Built in 1897, Kann's was one of Washington's most forward-thinking stores. "Goods were offered at a single, fixed price—no haggling—and customers were welcome to return goods they didn't want," wrote local historian John DeFerrari.

But in 1959, Kann's owners modernized the building by enveloping it in metal. Business continued to plummet and by the 1970s the company announced demolition plans. The store was gutted by fire before wreckers arrived. The 1979 blaze revealed the ghostly nineteenth-century facade that had been entombed inside the new metal skin.

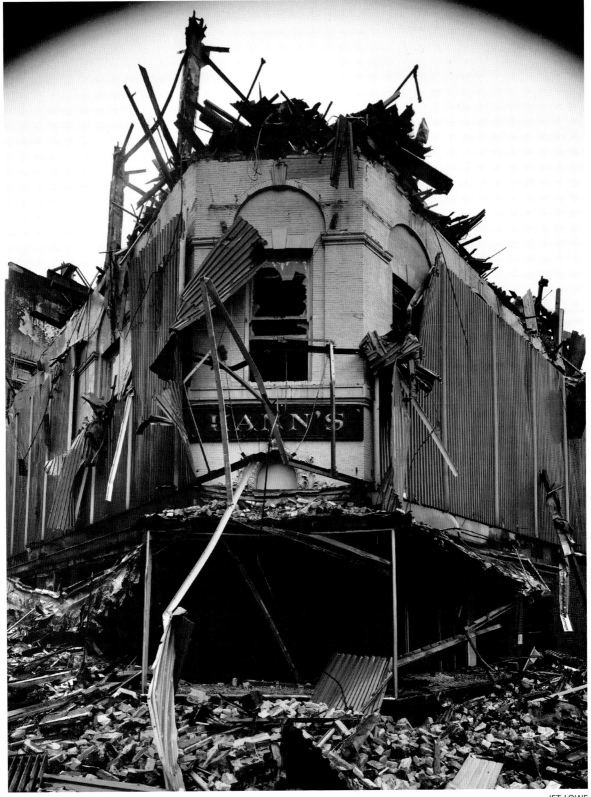

WASHINGTON, D.C., 1979

JET LOWE

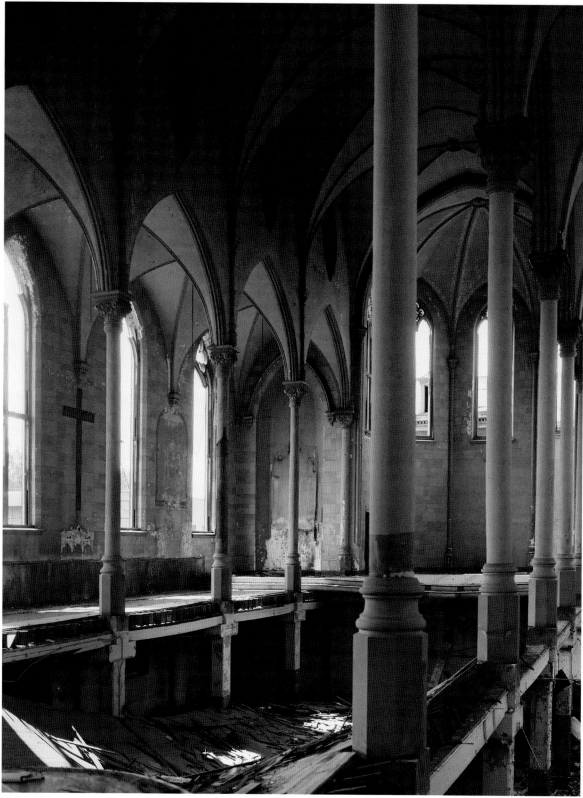

CINCINNATI, OHIO, 1979　　　ROBERT KELLER

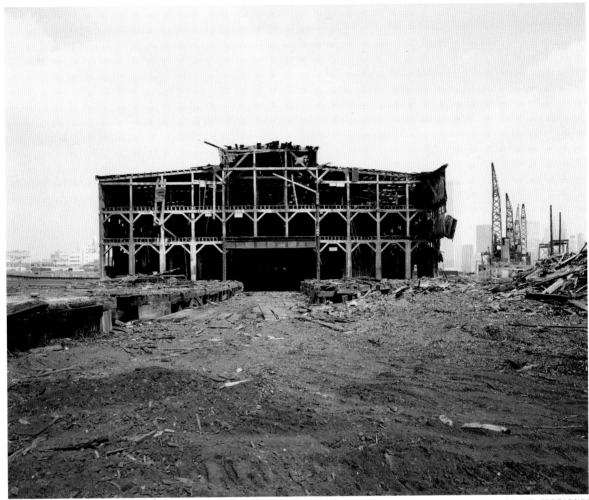

JERSEY CITY, NEW JERSEY, 1979 MICHAEL SPOZARSKY

Above: Destruction reveals how Pier G, one of the last freight piers on the Hudson River in Jersey City, was constructed. The pier, built in 1891, was used to ship freight across the river to New York City. A railroad line ran through the center of the building so that freight could be hoisted directly onto waiting ships and barges. Pier G was abandoned in the 1960s and started to deteriorate in the 1970s. Wreckers were salvaging steel and timber from the structure in 1979 when a fire, labeled as "suspicious," demolished what was left. The property, just north of Ellis Island National Museum of Immigration, is now part of Liberty State Park.

Left: St. Heinrich's Roman Catholic Church in Cincinnati's West End community was also demolished in 1979. Built in 1892, the church went by the name St. Henry's in later years. Much of its surrounding neighborhood was razed in the 1950s to make way for Interstate 75, which swept into downtown Cincinnati. "Its neighborhood is gone," wrote the *Cincinnati Enquirer* during the church's last years. "Urban renewal is here, and not a single house stands in its parish boundary."

CUMBERLAND, MARYLAND, 1970

WILLIAM E. BARRETT

The Queen City Railroad Station in Cumberland, Maryland, was torn down at the same time as the adjacent Queen City Hotel [shown on pages 94 and 181]. Rubble from the hotel can be seen through this bleak station scene.

A post office was built on the hotel property and the station was replaced by a small, utilitarian Amtrak facility. At one time, five railroad companies ran through Cumberland, which was considered the "Gateway to the West" because it was on the Baltimore & Ohio's mainline from Baltimore to Chicago.

Material from the old B&O station and hotel proved popular after both structures were razed. Timber beams were salvaged, bricks were sold, and a local jeweler advertised gavels that were handmade of wood from the station.

The Western Maryland Scenic Railroad has since built a large train station about three blocks west of the original station. It has been providing popular junket trains—the Frostburg Flyer, Spring Fling Express, Murder Mystery and Polar Express—through the Allegheny Mountains for more than three decades.

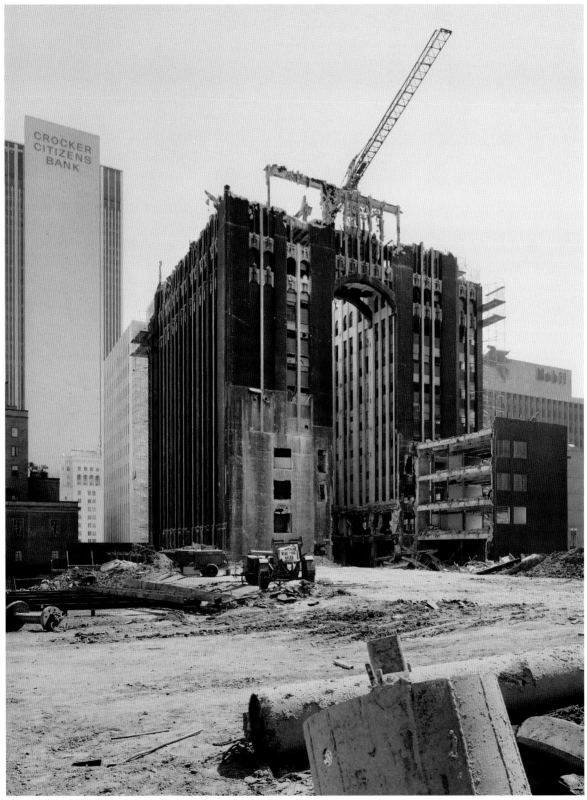

LOS ANGELES, CALIFORNIA, 1969 — MARVIN RAND

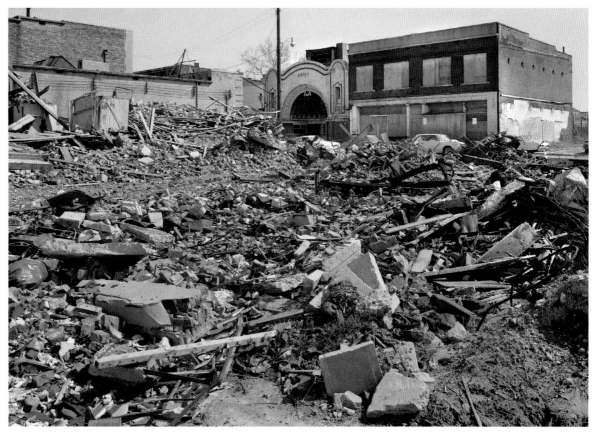

MEMPHIS, TENNESSEE, 1979 · JACK E. BOUCHER

Above: The historic Daisy Theatre was one of only a few buildings that survived the demolition of famous Beale Street. Beale, the heart of Memphis' Black community since the 1840s, was declared the "Home of the Blues" by Congress in 1977.

City planners, almost all white, plotted the redevelopment of Beale Street. When a four-block section of Beale from Main Street to Fourth Avenue was designated a National Historic Landmark in 1966, planners promised that the street and surrounding neighborhood "would not be a bulldozer project." But hundreds of buildings were eventually razed and more than 1,000 people were displaced. The Daisy Theatre and the New Daisy Theatre across the street were the only buildings left standing along the east end of commercial Beale Street.

"This project left a thin commercial district between Second and Fourth Avenues, where African American businesses were forced out through condemnation of buildings and high property resale prices," wrote historian Bobby L. Lovett. In 1979, the *Memphis Press-Scimitar* declared: "Urban renewal destroyed Beale Street."

Left: It took six months for wreckers in Los Angeles to lasso the Richfield Tower [shown on pages 56 and 57] to the ground. Richfield oil officials said they razed the skyscraper because the company had outgrown its home office. It had more to do with changing tastes, wrote Cindy Olnick in *L.A. Landmarks: Lost and Almost Lost*. "Landmarks are particularly vulnerable at around age forty—like the Richfield—and their style has reached its nadir," she wrote. "By the time the pendulum of popular taste swings back in their direction, it's too late."

WEST HOLLYWOOD, CALIFORNIA, 1970

MARVIN RAND

"This is like slashing a Rembrandt with a razor."

That's what Los Angeles architect Kurt Meyer said on the day the Dodge House in West Hollywood was torn down.

Meyer—and others—had worked for years trying to come up with a solution that would save the house, among the most meaningful structures ever built in the Los Angeles area.

Wrecking crews from the Roger Roy Land Clearing Company showed up unannounced on Monday, February 9, 1970, in the midst of a raging rainstorm. Mondays were a particularly good day for the demolition of landmarks, wrote Ada Louise Huxtable in the *New York Times*. "It has the obvious virtue of catching people napping, while avoiding overtime rates."

The Dodge House [shown on page 38] had changed hands several times before its demise. Equitable Savings and Loan Association, which acquired the house and three-acre property during the late 1960s, sold it to the Riviera Management Company on December 30, 1969.

For two months, the company was silent about its plans.

But after wreckers started slamming the walls of the Dodge House on that rainy February morning, a Riviera spokesman told a reporter with the *Los Angeles Times*: "We just wanted to get it down. It's just something that had to be done."

Ultimately, this book is about that drive. The illogical compulsion of Americans to "get it down." In the case of the Dodge House, there were apartments to build. The words "It's just something that had to be done" haunts every page.

Marvin Rand, who photographed the Dodge House so lovingly for the Historic American Buildings Survey in 1968, returned to the site hours after the wrecking crews were finished. He wanted to show what was left: rubble, fallen trees and a single crane.

BUILDING LIST

Endsheets:
Republic Building
Survey number: HABS IL-1004
209 South State Street Chicago, Illinois
Richard Nickel Photo

Preliminary Pages:
Monroe Block Entrance
HABS MI-329
74-78 Monroe Avenue
Detroit, Michigan
Carla Anderson Photo

Columbian School
HABS OH-2384
3415 Harvey Avenue
Cincinnati, Ohio
John Gerhardstein Photo

Republic Building
HABS IL-1004
209 South State Street
Chicago, Illinois
Richard Nickel Photo

Ellis Island Water Tower
HABS NY-6086-H
New York City, New York
Jack E. Boucher Photo

Foreword:
Richfield Oil Building
HABS CA-1987
555 South Flower Street
Los Angeles, California

Introduction:
Republic Building
HABS IL-1004
209 South State Street
Chicago, Illinois

Page 15:
Top right: Dawson House, HABS MD-55

Middle right: Elverton Hall, HABS MD-647

Bottom right: Rosewell, HABS VA-61

Top left: Fairview, HABS MD-86

Middle left: Bermondsey, HABS MD-671

Bottom left: Chinn House, HABS VA-138

Windsor Castle
HABS MS-26
Port Gibson, Mississippi
James Butters Photo

Iron Hitching Post
HABS ALA,49-MOBI,37B
Mobile, Alabama

Page 20:
Top right: Gothic Apartment House
HABS MA-669
47 Allen Street
Boston, Massachusetts

Top left: Schiller Building
HABS IL-1058
64 West Randolph Street
Chicago, Illinois

Bottom: Klauber House
HABS CA-1962
3060 Sixth Avenue
San Diego, California

Blenheim Hotel
HABS NJ-864
Ohio Avenue and Boardwalk
Atlantic City, New Jersey

Bellows Falls Arch Bridge
HAER NH-6
North Walpole, New Hampshire

Electric Furnace Melt Shop
HAER PA-186-D-6
Bethlehem Steel Plant
Bethlehem, Pennsylvania

World Trade Center
HAER NY-128-4
Bounded by Vesey, Church and
Liberty Streets
New York City, New York

Chapter 1:
York Bridge
HAER MT-2
On Route 280, 15 miles northeast of
Helena, Montana
York, Montana

Bunker Hill District
Likely the 300 block of South Olive Street
HABS CA-344
Los Angeles, California

Neighborhood Church
HABS CA-2116
South Pasadena Avenue and
West California Boulevard
Pasadena, California

Jewish Community Center of San Francisco
HABS CA-2724
3200 California Street
San Francisco, California

Walter Luther Dodge House
HABS CA-355
950 North Kings Road
West Hollywood, California

Republic Building
HABS IL-1004
209 South State Street
Chicago, Illinois

Old City Hall, Detroit
HABS MI-221
Woodward Avenue and Cadillac Square
Detroit, Michigan

Erie County Savings Bank
HABS NY-5615
16 Niagara Street
Buffalo, New York

Garrick Theater
HABS IL-1058
64 West Randolph Street
Chicago, Illinois

Chicago Stock Exchange
HABS IL-1034
30 North LaSalle Street
Chicago, Illinois

Tribune Building
HABS NY-5468
154 Printing House Square
Nassau and Spruce Streets
New York, New York

Broadway Subway Station
HABS NJ-928
30-32 & 33-37 South Broadway
Camden, New Jersey

Singer Tower New York
HABS NY-5463
149 Broadway
New York, New York

Pennsylvania Station
HABS NY-5471
370 Seventh Avenue
New York, New York

Equitable Building
HABS GA-2107
25 Pryor Street Northeast
Atlanta, Georgia

Richfield Oil Building
HABS CA-1987
555 South Flower Street
Los Angeles, California

Carnegie Library of Atlanta
HABS GA-1216
126 Carnegie Way
Atlanta, Georgia

John R. McLean House
HABS DC-24
1500 I Street NW
Washington, D.C.

Anglo & London Paris National Bank
HABS CA-2185
One Sansome Street
San Francisco, California

Immaculate Conception
Catholic Church
HABS MI-275-6
3414 Trombly Avenue
Detroit, Michigan

Pan Pacific Auditorium
HABS CA-2033
7600 Beverly Boulevard
Los Angeles, California

Canada Dry Bottling Plant
HAER OR-137
4370 Northeast Halsey Street
Portland, Oregon

Eduardo Giorgetti House
HABS PR-65
Ponce De Leon Avenue, Stop 20,
Hipodromo Street
San Juan, Puerto Rico

Parker Center
HALS CA-2923
150 North Los Angeles Street
Los Angeles, California

National Theater
HABS OH-23-7
312 Sycamore Street
Cincinnati, Ohio

Metropolitan Opera House
HABS NY-5486
1423 Broadway
New York, New York

Oriental Theater
HABS OR-55
828 Southeast Grand Avenue
Portland, Oregon

Fox Theatre
HABS NY-5554
20 Flatbush Avenue and 1 Nevins Street
Brooklyn, New York

Cyclorama Building
HABS PA-6709
125 Taneytown Road
Gettysburg, Pennsylvania

U.S. Post Office Building
HABS ALA-797
St. Joseph and St. Michael Streets
Mobile, Alabama

U.S. Post Office, Customs House &
Sub-Treasury
HABS ILL-1040
218 South Clark Street
Chicago, Illinois

Chapter 2:
Mayhew School
HABS MA-673
Poplar and Chambers Streets
Boston, Massachusetts

Shibe Park
HABS PA-1738
2702 North Twenty-first Street
Philadelphia, Pennsylvania

Third Avenue Elevated Line
HABS NY-68
Third Avenue south of 169th Street Station
Bronx, New York

Schuylkill Arsenal
HABS PA-1540
2620 Gray's Ferry Avenue
Philadelphia, Pennsylvania

Queen City Hotel
HAER MD-4
West side of Park Street at South Central
Avenue
Cumberland, Maryland

Philadelphia County Prison, Debtors' Wing
HABS PA-1097
Reed Street and Passyunk Avenue
Philadelphia, Pennsylvania

Bodine Castle
HABS NY-5465
4316 Vernon Boulevard
Queens, New York

South Bernville Hotel
HABS PA-257
Bernville-Robesonia Road
Bernville, Pennsylvania

Moses Yale Beach House
CT-269
86 North Main Street
Wallingford, Connecticut

Japanese Language School
HABS WA-209
1715 South Tacoma Avenue
Tacoma, Washington

Methodist Church
HABS AL-726
Near Walnut Street and
Second Avenue South
Cahaba, Alabama

Sonoran Row House
HABS AZ-20
Likely near Arivaca Creek
Arivaca, Arizona

Indian Dance Lodge
HABS ND-3
Near the submerged town of Elbowoods
beneath Lake Sakakawea
Fort Berthold Indian Reservation
White Shield, North Dakota

Robinson Mortuary
HABS MO-1251
1216-1218 Broadway
Hannibal, Missouri

206

U.S. Courthouse & Post Office
HABS WI-277
Northeast corner of Fourth and State Streets
La Crosse, Wisconsin

Pennsylvania Railroad Station
HABS PA-246
Market Street, between Matlack and
Franklin Streets
West Chester, Pennsylvania

Swaringen Wholesale Grocery
HABS NC-235
210-216 North Lee Street
Salisbury, North Carolina

Schenck Building
HABS PA-1078
535-537 Arch Street
Philadelphia, Pennsylvania

Massachusetts Charitable
Mechanics Building
HABS MA-672
Huntington Avenue and
West Newton Street
Boston, Massachusetts

Reliance Insurance Company
HABS PA-1465
429 Walnut Street
Philadelphia, Pennsylvania

Cotton Belt Building
HABS MO-272
408 Pine
St. Louis, Missouri

Kremlin Hall
HABS NY-5614
Southeast corner of Pearl and Eagle Streets
Buffalo, New York

Beck-Care Warehouse
HABS PA-1188
18-20 South Delaware Avenue
Philadelphia, Pennsylvania

Loyal Order of Moose Building
HABS PA-5149
628-634 Penn Avenue
Pittsburgh, Pennsylvania

Olympia Arena
HABS MI-252
5920 Grand River Avenue
Detroit, Michigan

Chapter 3:
Cary House
HABS NY-5613
184 Delaware Avenue
Buffalo, New York

Geneva Hotel,
HABS WI-283
101 Broad Street
Lake Geneva, Wisconsin

National Guard Building
HABS PA-1015
518-520 Race Street
Philadelphia, Philadelphia

First Regiment Infantry Armory
HABS IL-1069
1552 South Michigan Avenue
Chicago, Illinois

Eighth Street District
HABS OH-2208
515-529 Eighth Street
Cincinnati, Ohio

Dubuque Seed Company Warehouse
HABS IA-160
169-171 Iowa Street
Dubuque, Iowa

Manchester Hotel
HABS NH-120
50 West Central Street,
Manchester, New Hampshire

Lexaco Store
HABS MD-916-F
419-421 West Lexington Street
Baltimore, Maryland

Home Furniture Store
HABS PA-5638
316-318 Lackawanna Avenue
Scranton, Pennsylvania

Seventh Avenue Bar
HABS SD-10
628 Main Street
Rapid City, South Dakota

Charcoal Steaks Restaurant
HABS SD-10
626 Main Street
Rapid City, South Dakota

Deluxe Arcade
HABS PA-5152
635 Liberty Avenue
Pittsburgh, Pennsylvania

Warner Plaza
HABS MO-1893
3251 Main Street
Kansas City, Missouri

Monroe Block
HABS MI-324,
52-72 Monroe Avenue
Detroit, Michigan

Webb's Shoes
HABS DC-33
3115-17 M Street Northwest
Washington, D.C.

Clock Building
HABS DE-129-M
202 King Street
Wilmington, Delaware

Slipcovered Building
HABS DE-129-D
226-230 King Street
Wilmington, Delaware

Chapter 4:
Bogardus Building
HABS NY-5469
Washington and Murray Streets
New York, New York

Merchants Bank Building
HABS MO-1176
First and Locust Streets
St. Louis, Missouri

Old Post Office Building
HABS MO-1139
22-26 North Second Street
St. Louis, Missouri

Newark Athletic Club
HABS NJ-1055
16-18 Park Place
Newark, New Jersey

Coolot Building
HABS CA-2726
812 J Street
Sacramento, California

Preston School
HABS MI-402
1251 Seventeenth Street
Detroit, Michigan

Altman Farm
HABS CO-125
East side of Buckley Road, one-half mile
south of 72nd Avenue
Denver, Colorado

Holiday Bowl
HABS CA-2775
3730 Crenshaw Boulevard
Los Angeles, California

Old Carriage House Restaurant in Atlanta
Fixtures Building
HABS GA-1204
102-106 Pryor Street
Atlanta, Georgia

Belle Grove Plantation
HABS LA-36
River Road outside White Castle, Louisiana

Slave Quarters
HABS MD-459
315 West Cecil Avenue,
North East, Maryland

Rose Barn
HABS PA-5348
About two miles south of downtown
Gettysburg on the eastern side of
Emmitsburg Road (U.S. Route 15)
Gettysburg, Pennsylvania

TCI-U.S. Steel Bathhouse
HAER AL-97-C
Borah Avenue and Thirteenth Street
Bessemer, Alabama

Lawrence County Courthouse
HABS AL-310
Courthouse Square
Moulton, Alabama

Schoharie Creek Aqueduct
HAER NY-6
Schoharie Creek near Hartley Lane
Fort Hunter, New York

Roosevelt Stadium
HABS NJ-819
State Route 440 and Danforth Avenue
Jersey City, New Jersey

Baltimore Memorial Stadium
HABS MD-1111
1000 East Thirty-third Street
Baltimore, Maryland

Union Iron Works Turbine Machine Shop
HAER CA-43
2200 Webster Street
Alameda, California

U.S. Steel Homestead Works
HAER PA-200-P
149 West Bridge Street
Homestead, Pennsylvania

House Between Two Casinos
HABS NJ-1033
127 South Columbia Place
Atlantic City, New Jersey

Grand Rapids City Hall
HABS MI-243
35 Lyon Street Northwest
Grand Rapids, Michigan

Queen City Hotel
HAER MD-4
West side of Park Street at
South Central Avenue
Cumberland, Maryland

Dearborn Station Trainshed
HAER IL-6
47 West Polk Street
Chicago, Illinois

Ulysses S. Grant Cottage
HABS NJ-884
995 Ocean Avenue
Long Branch, New Jersey

First Regiment Infantry Armory
HABS IL-1069
1552 South Michigan Avenue
Chicago, Illinois

Atherton Building
HABS KY-137
466 River City Mall
Louisville, Kentucky

Mount Clare Shops
MD-6A
South side of Pratt Street between
Carey and Poppleton Streets
Baltimore, Maryland

Louisiana Sugar Exchange
HABS LA-1110
North Front and Bienville Streets
New Orleans, Louisiana

Granada Theatre
HABS IL-1156
6425-6441 North Sheridan Road
Chicago, Illinois

Lackawanna Terminal
HAER NY-63
Main Street and Buffalo River
Buffalo, New York

Kann's Department Store
HABS DC-365
Market Space, between Seventh and
Eighth Streets NW
Washington, D.C.

St. Heinrich's Roman Catholic Church
HABS OH-2203
1057 Flint Street
Cincinnati, Ohio

Pier G
HAER NJ-27-C
Audrey Zapp Drive and Freedom Way
Jersey City, New Jersey

Queen City Railroad Station
HAER MD-4
West side of Park Street at
South Central Avenue
Cumberland, Maryland

Richfield Oil Building
HABS CA-1987
555 South Flower Street
Los Angeles, California

Daisy Theater
HABS TN-60
329 Beale Street
Memphis, Tennessee

Walter Luther Dodge House
HABS CA-355
950 North Kings Road
West Hollywood, California

ACKNOWLEDGMENTS

You are looking at the great American road trip—pandemic style.

We started work on this book in 2020, when travel was more a memory than a reality. Research had us crossing the United States many times, though it was mostly online.

Our first challenge was to figure out which of the 45,000 structures photographed by the Historic American Buildings Survey are standing. The HABS website shows most of the buildings that have been documented but generally does not indicate whether a building still exists.

To figure this out, we used Google Maps and Google Street View. Once we had addresses, we "walked" slowly up and down an online street to ascertain if buildings remained. The results were often surprising. A pre-Civil War mansion, for example, in Tuscaloosa, Alabama, was hanging on as an auto parts store when HABS photographed it in the 1930s. Amazingly, it was reborn as a Baptist Church and is a fancy wedding venue today. To be sure, we often had to contact local experts—neighbors or historical societies—to confirm our findings.

We also got on the actual road to check a few sites. We couldn't determine online how much of the Rose Barn on the Gettysburg Battlefield was still standing (not much) and could not verify the exact location of the Loyal Order of Moose Lodge in downtown Pittsburgh (a plaque actually marks the spot) so off we went.

Once we had our preliminary list, we relied on books and newspapers to help us. The website newspapers.com, with about 850 million pages from U.S. papers, was most helpful. However, sometimes we turned to libraries and original microfilm. Thanks to many helpers, including Rhonda Hoffman of the Buffalo & Erie County Public Library, who unearthed information about a bunch of buildings in Buffalo, New York.

To better understand HABS, we talked to photographers Carla Anderson, Joseph E.B. Elliott, David J. Kaminsky, Jet Lowe, Dennis Marsico, Tavo Olmos and Stephen D. Schafer. To better understand their subjects, we spoke with building experts Robert Bruegmann, James F. O'Gorman, Jim Peters and Tim Samuelson.

Next, we pinpointed knotty photos. Karen Dougherty of the Port Authority Transit Corporation described the location of the old Broadway subway station in Camden, New Jersey; Héctor J. Berdecía-Hernández clarified the significance of the Giorgetti home in San Juan; Linda Derry of the Old Cahawba Archaeological Park told us about the Colored Methodist Church in Alabama; Mary Kasulaitis checked on Sonoran rowhouses in Arivaca, Arizona; Gary Dickens sought out information on the tribal dance lodge submerged on his North Dakota Indian reservation.

Jeff Newman, who runs Underground Birmingham, confirmed what happened to the Muscoda Mines in Bessemer, Alabama; David Brooks of the Schoharie Crossing State Historic Site helped us better understand the Erie Canal; and Tulane University Professor Richard Campanella explained the sugar and rice business in New Orleans.

Also assisting were National Park Service employees Katherine Arrington, John A. Burns, Christopher Gwinn, LueCreasea Horne, Scott Keyes, Christopher Marston, Mary A. McPartland and Christopher Stevens. Catherine Lavoie, who wrote the foreword, was supportive from the start.

Editing and fact-checking was by Lynn Becker, Caleb Burroughs, Cate Cahan, Mark Jacob, Stephen Schafer and Bill Stamets.

Financial support was provided by the Richard H. Driehaus Foundation. We would like to thank Anne Lazar and Brad White from the foundation. Snapshot Nation serves as our fiscal sponsor. Thanks go to Bernard Friedman and Mary Cullather. We also would like to thank Jonas and Betsy Dovydenas, who always support our work.

Most important, we thank our wives, Karen Burke and Cate Cahan, for making CityFiles Press possible for twenty years. Our families: Chris, Daisy and Caedan Jinks; Elie Cahan, Caleb, Madeline and Millie Burroughs; Claire Cahan, Schuyler and Evergreen Smith; Aaron, Valerie and Peter Cahan; and Glenn M. Cahan.

As you can tell, we love architecture. We believe buildings reflect our culture and mark our spot in the universe. We see great buildings as fine art. We see humble buildings as meaningful connections to our past.

We greatly appreciate the people who have spent their lives producing these photographs. Through their sensitivity and dedication, they have created more than a record. We know that a two-dimensional photograph does not replace a three-dimensional structure, but we are grateful that these buildings and communities will never be forgotten because of their work.